For G.B.T., I.V.T., J.P.T.
and their guardian Angel

†Peter Gooday
18th May 1948-12th February 1994
An early collector of Liberty pewter

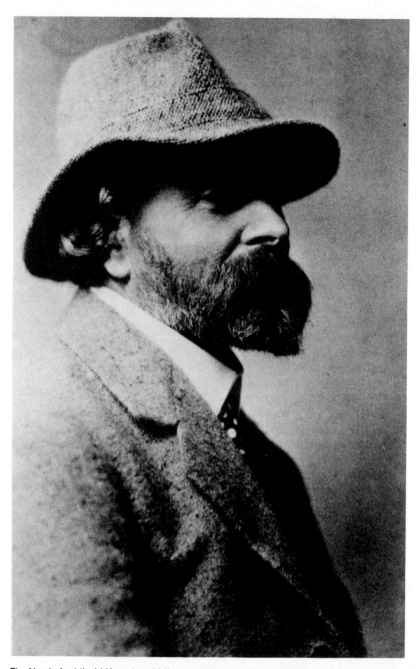

Fig. No. 1. Archibald Knox in middle age; the hat and tweed suit were particular favourites with him. This same pose was later used as a postcard of the artist on the Isle of Man. Courtesy Denise Wren.

The
Designs of
Archibald Knox
for
Liberty & Co

by
A.J. Tilbrook
edited by
Gordon House

RICHARD DENNIS
SOMERSET
1995

Photography by Prudence Cuming
Associates

Design by Gordon House

Production by Wendy Wort

Print and reproduction by
Flaydemouse, Yeovil, England

First edition published by
Ornament Press, London, 1976

Second edition published by
Richard Dennis, The Old Chapel
Shepton Beauchamp
Somerset TA19 0LE

ISBN 0 903 685 37 X

British Library Cataloguing in
Publication Data. A catalogue
record for this book is available
from the British Library.

Contents

Preface to the Second Edition

Almost two decades have passed since the publication of the First Edition of this volume. During the course of those years, interest in Knox has at times waned, been rekindled by new collectors and peaked with acquisitions of his designs by international Museums. Today Knox's reputation as a highly original talent amongst the avant garde of his period is fully recognised.

This was not the case twenty years ago. Had it not been for the endeavours of Denise Wren, one of Knox's students and subsequently a life-long friend, Knox would have remained relatively unknown, and I doubt whether other recorded documentation would have allowed for more than a long article. In the first instance she rescued an historically valuable quantity of Knox designs from a waste paper bin at Kingston School of Art, where they had been discarded upon his resignation in 1912. With her sister, Winifred Tuckfield, she persuaded his class to resign 'en masse' and together they formed the Knox Guild of Craft and Design, putting his theories, principles and examples to practical use. In 1928, Henry and Denise dedicated their book 'Handcraft Pottery' to Archibald Knox. In 1934 she completed the Hall Caine memorial which had been left unfinished upon Knox's death. Later in 1951, she acquired, at some personal financial discomfort, a Knox silver box with entrelac decoration, set with a large opal (fig. no. 155), which was subsequently, along with the aforementioned drawings, acquired by the Victoria and Albert Museum, London.

Though physically frail when I met her, Denise had lost none of her enthusiasm for her mentor, and I well remember how pleased she was to have, 'my book, my lovely book...it is very Knoxical – look how the darks and lights are arranged to make a pattern – he would have been delighted'. What could be better for an author than knowing his book would have pleased the master as well as it did the student.

Finally, I should like to thank the following: Phillipe Garner and Lydia Creswell-Jones of Sotheby's and Nicola Redway of Christie's; Richard and Sally Dennis for their help and enthusiasm with this project; Gordon House for all his advice and considerations; to his wife Josephine, I owe a long overdue acknowledgement for the regretful oversight of not crediting her efforts toward the production of the first edition of this book. I hope this belated apology will be kindly accepted. My thanks to my wife Judith for her comments upon the manuscript, and patience during this undertaking and Wendy Wort for her hard work and especially good temperament during the many meetings necessitated by this reprint.

A.J.T.

12.1.95

Prefatory Note and Acknowledgements

This work is intended as a brief study of Archibald Knox, with particular emphasis on his designs for, and in association with, the London based firm of Liberty & Co., Regent Street. Of Knox, the watercolourist, (as opposed to his work as crafts-man/designer), references if any, are concerned only with supporting or qualifying the text.

Anecdotal reminiscences and hearsay have been avoided, awaiting some personalised documentary evidence in the form of letters to or by Knox, which are sadly lacking in any quantity at this point in time (August 1974).

The two main sources for letters are first the Manx Museum, Douglas, Isle of Man which has five letters written to Knox relating to his design work while employed by Liberty & Co.; and second is Mrs Denise Wren (née Tuckfield) who with her sister, Mrs Winifred Broun-Morrison, founded the Knox Guild of Craft & Design in 1913, and were in regular correspondence with Knox until his death in 1933.

It is probable that Mrs Broun-Morrison took the bulk of Knox's correspondence after the closing of the Guild in 1939, and this was lost during the London Blitz.

What is left, therefore, is a group of some thirty letters, the earliest being ascribable to the period immediately following Knox's resignation from Kingston School of Art (1912), the latest concerning the building of the Wren family home, dated 1933.

Without access to these letters and the vast amount of material owned by Mrs. Denise Wren, the content of this publication would have been seriously diminished, and in this same context I should like to mention Peter Crotty and Rosemary Wren, who have shown me every consideration when my frequent and often seemingly unrelated questions and visits have interrupted not only their day-to-day life but also their business affairs. To them I should like to express my sincerest thanks and appreciation – especially to Rosemary who has made the reading of illegible Knox letters possible!

Wherever possible, contemporary evidence of sources that Knox would have been able to refute during his lifetime have been relied upon. Certainly, Knox's own reticence with regard to all his artistic capabilities and achievements, is the major hindrance in any attempted documentation. It would seem to be characteristic

of Knox that when major problems or public acclaim presented themselves, Knox withdrew from the particular dispute.

This attitude coupled with the policy of anonymity employed by Liberty & Co. with regard to their designers, craftsmen and manufacturers[1], even today keep certain facets of Knox's work, particularly the early designs (those prior to 1900), hidden behind a veil of speculation.

I should like to express my gratitude to the various Museum Staff and their respective Museums for assistance, particularly to those members of the Victoria & Albert Museum who, already burdened with their own exhibition of 'The Liberty & Co. Centenary',[2] have always graciously accepted and indulgently responded to enquiries; I should like to thank particularly Shirley Bury, David Coachworth, Sue Lambert and especially Janet Steen who, though inundated with work connected with the Museum exhibition, always found time for my numerous requests. Thanks are also due to Jessica Rutherford of Brighton Museum; while in the Isle of Man, Miss A. M. Harrison, the librarian at the Manx Museum has been a constant source of help, not only in her efforts to ensure that the Museum's Knox ephemera were readily at my disposal but also by communicating with, and eliciting from various parties, information and objects not directly involved with the Museum collection. Lastly my gratitude to the trustees of the Royal Society of Arts for the use of their Library.

Most of the objects and known references to Knox's design work are scattered, the bulk of objects being in various private collections throughout Great Britain. To the owners of these collections, my gratitude for the kind and willing help received. In particular thanks to John Jesse, E. Scott Cooper, Richard and Sally Dennis, Martins Forrest Antiques Ltd., G.G. Dry, Frau Beate Dry Von Zezschwitz (Munich), Clive Collins, Dr and Mrs Ken Smith, Peter and Debbie Gooday, M. John, Charlotte Gere, T.M. Whiteway, John Lyons, Dan Klein, E.G. Keys, Jon Gorman with especial gratitude to Mrs Joan Collins, George and Julie Hodder and those who wish to remain anonymous.

With regard to the chapter on Liberty & Co., I must crave indulgence for any shortcomings. Research in this area centred on the archives at present located at the Regent Street premises

[1] The cost books of the firm which would have contained valuable information were destroyed by fire.
[2] Exhibition at the Victoria & Albert Museum – July 1975.

of Liberty & Co. It seems, however, that this work coincided with a book commissioned by the Chairman and Board on a general history of the Company. In consequence and 'on the grounds of protecting the investment', all access to their records was denied.

Special thanks to all the people concerned either directly or indirectly with this publication, to both Miss June Cochrane and Miss Judith Maggs for their patience in endlessly retyping the corrections involved in the manuscript. To John Cox, for his help with regard to the section on designs in the Public Records Office. To Prudence Cuming for her understanding approach to the photography over a long period of time. To Bill and Vicky Waters, and to Graham Dry for their remarks concerning the manuscript.

Finally it should be mentioned that this work apart from its typographical form is the resulting idea from an obsession with the design work of Knox that has been with Gordon House since Art School student days. He wishes to acknowledge debts to Stuart Durant and to Graham Ovenden the painter who also shares this love for a number of the works listed and illustrated on the following pages.

Chronology

2 April 1864	Born Cronkbourne (Tromode) Isle of Man.
	The generally accepted date for Knox's birth is the 9th April 1864, though on an application paper for Douglas Boys School Knox gives the date as the 2nd April 1864. It is probable that although born on the 2nd, the birth was not registered until the 9th, this then being the date on the birth certificate.
9 April 1864	Christened Archibald Knox.
1873-1878	Educated at St Barnabas Elementary School, Douglas Grammar School, Douglas, Isle of Man.
1878-1883	Pupil Teacher at St Barnabas Elementary School.
1878-1884	Studying Art at Douglas School of Art.
1887	1st Class examination result in 'Principles of Ornament'.
1887	Passes examination in 'Design'.
1884-1888	Teaching Art at Douglas School of Art.
21 December 1889	Gains Art Master's Certificate. Group 1.
1892	Medallist in Historic Ornament (Design). Knox specialised in Celtic ornament.
September 1893	Article in 'The Builder', entitled 'Ancient Crosses in the Isle of Man'.
1892-1896	Probably working part-time in the recently established offices of M. H. Baillie Scott, Architect/Designer, Atholl Street, Isle of Man.
1896	Article in 'The Studio', volume VII, page 142 'Isle of Man as a Sketching Ground'.
1897	Leaves Isle of Man, presumably coming directly to London. Assumes teaching post at Redhill, Surrey where another Manxman, A.J. Collister, was principal. (In the same year a design by C. Carter for a Challenge Cup, won a Studio competition, and was subsequently produced by Liberty & Co.).
1897-1898	A. Lasenby Liberty's awareness of German advances in domestic metalwork, notably those of the Krefeld firm of J.P. Kayser and Son, triggered his arranging for its import and retail selling. Immediate success justified the company beginning their own range of silver, jewellery and plate; and possibly even experimental pewter production. Knox must have contacted the firm via his

	association with M.H. Baillie Scott who is known to have been designing fabrics for Liberty & Co. as early as 1893.
January 1899	Knox appointed Design Master at the Art School, Kingston-upon-Thames.
1899	First year of production of the 'Cymric' range of silver, ironically, even though it was all hand made, an attempt at machine finished appearances was given to several of the designs attributable to Knox. Knox moved to Fulham, and was paid £25.11s.0d. per quarter, by Surrey County Council for teaching.
1899	Liberty & Co. take part in the 1899 Arts & Crafts exhibition.
August 1900	Returns to Isle of Man, acqires a cottage at Sulby, in the north of the Island.
1900	Presumed introduction of the 'Tudric' range of pewter, aimed at a cheaper market than the silver, and as British competition for the Continental manufacturers. Knox submitted several designs on a piece-work basis. His involvement with the whole Liberty Celtic revival, however, must have been much greater.
September 1901	Article in 'Queen' magazine illustrating Knox Chalice fig. 124).
December 1901	Second article in 'Queen' magazine illustrating two items of pewter, and mentioning the trade name 'Tudric'.
1902	'Design for brooch, intended for presentation by Queen Alexandra and Edward VII to friends on the occasion of their Coronation'. It is more likely that this statement confuses the brooch with the Coronation spoons designed by Knox (fig. 108).
1903	Liberty & Co. take part in the 1903 Arts & Crafts Exhibition. Four items designed by Knox.
1904	Knox leaves Isle of Man and recommences teaching at Kingston, Surrey. A.J. Collister was head of Fine Arts.
1904-1906	Knox submitting large quantities of designs to Liberty's, ranging from ideas for silver, pewter, carpets, pottery, jewellery, textiles and possibly furniture. Still teaching at Kingston School of Art.
1906-1907	Takes up evening position at Wimbledon Art School, lecturing for $2^1/_2$ hours, at 10s 6d per lesson. A.J. Collister had been appointed principal of Wimbledon in 1904, and it was presumably his influence that drew Knox to add to his already burdened day.

1909	Several designs for pewter sold by Liberty & Co. to their competitors, James Connell of Cheapside, London, suggests that the demand for pewter and silver in the 'revivalist' style was waning.
1909-1912	South Kensington Examiners complain to Knox about the style and outcome of his teaching. Knox rejects their criticisms and resigns. Denise Tuckfield discovers Knox drawings (now in the Victoria & Albert Museum) in a waste-paper basket in Kingston Art School common-room.
	As a reaction against Kingston's acceptance of Knox's resignation Denise and Winifred Tuckfield, and six other students leave Kingston School of Art and take premises in Market Place, Kingston.
17 August 1912	Knox returns to Isle of Man.
21 August 1912	Knox leaves England from Liverpool on the four-masted schooner 'Dominion'. Destination Philadelphia.
2 September 1912	'Dominion' docks at Philadelphia.
3 October 1912	Knox writes to Denise Tuckfield from Philadelphia.
9 October 1912	Founding of the 'Knox Guild of Craft & Design', Kingston-upon-Thames, Surrey.
29 December 1912	Knox unable to find 'suitable employment', in Philadelphia, though he did some carpet designs for a firm called Bromley & Co., and for a while taught at Pennsylvania School of Industrial Arts. Moved to New York in search of a job.
1913	American adventure unsuccessful, Knox returned to the Isle of Man, and commenced teaching.
1914-1918	Knox spent the four war years working in the Aliens' Detention Camp at Knockaloe, near Peal, Isle of Man. Knox served as a censor.
1917	Memorial stone erected in memory of Arthur Lasenby Liberty (The Lee Church, Bucks.), designed by Knox.
1 February 1920	Knox begins to teach Art at Douglas High School, Isle of Man.
1924	Knox visited Italy, to study frescoes. Spent the summer months in Ravenna.
1926	One-man exhibition of paintings in the National Gallery of Ottawa, Canada.
31 August 1927	Leaves Douglas High School. Begins teaching Art on a part-time basis at Douglas High School for Girls.
22 February 1933	Sudden death from heart failure aged 69. He was buried in Braddon Cemetery, Isle of Man (see fig. 293).

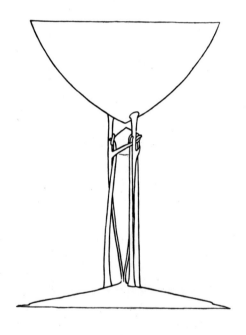

Introduction

It becomes increasingly clear that Archibald Knox, far from being an ordinary designer for Liberty & Co. was, in terms of design, the major driving force behind their 'Celtic Revival'. More important historically, he was a major innovator, not only in terms of metalwork, but in pottery, textiles, carpets, architectural faience and jewellery, all of which were executed by the company in accordance with Knox designs. Much of his work, especially the metalwork, appears surprisingly fresh today, nearly a century after his initial collaboration with the firm.

It is, therefore, due to Knox that the Celtic revival of Liberty & Co., which for a short time, was to exemplify English 'Art Nouveau' on the Continent, received any artistic credence at all.

In Vienna, 1900, the Secessionist movement, with its swing away from naturalistic inspiration towards the more rigid mathematical and geometric forms of decoration, reflected the Continent's growing appreciation of the Glasgow School, where Charles Rennie Mackintosh was demonstrating his incredible genius for architecture and related design.

Though the next decade was to see odd flourishes of what may loosely be termed 'Art Nouveau' design, the English isolationists lacked the freedom of expression that many of their French counterparts incorporated in their work. In England the Arts and Crafts traditions were visible in most of the artistically created objects; and by 1914 all feeling in the development of art and design was encapsulated in the foundation of the Design and Industries Association, with, as its figureheads, two Arts and Crafts mainstays, Harold Stabler and Ernest Jackson. Through the 1920s, design was to be influenced by three chief factors. First, by architects who stipulated that clarity, shape and structure should be the requirements of good design, brilliantly demonstrated by the Bauhaus School; second, by the relative emancipation of women after the First World War; third, and perhaps most importantly, by the materials industrial science had invented – such as laminates, tubular steel, substitute-lacquer finishes and varying plastics that could be marketed, almost overnight, in vast quantities. The period's absolute reliance upon the machine is aptly summed up by Le Corbusier's statement, "A House is a Machine for living in".

This total rejection of ornament, and the reliance on the intrinsic qualities found in the materials employed, largely contributes to what, in the 1930s and 1940s, was called the 'Contemporary Style'.

In 1970 the Victoria and Albert Museum held an exhibition devoted to Knox's work, this being the first major review of the designer's multifarious talents. At that time, lack of information meant that several facets of his work were overlooked and unfortunately no catalogue was produced.

Knox's education at the Douglas Grammar School would have imbued him with the traditional and crafts-like approach to design. By 1900, however, Knox was designing solely with machine mass production in mind. All the designs in the Victoria and Albert Museum are traced and retraced so that every inflection is a positive statement – never a suggestion; as Knox himself said (referring to a picture), "It is thinking in brush marks that has spoilt this – there is not a line going in one direction, that's bad. The composition must have some kind of unity". Knox's acceptance of the machine and mass production, was quite contrary to the Arts and Crafts beliefs and tastes of the day, and though Knox designs for metalwork invariably incorporate the flat machine-spun finish, company policy often dictated a hand-hammered appearance to the surface of several designs, in accordance with the generally accepted pinciples of the hand-made article, and to appease those critics of modernism in design.

Knox's evident use of the 'by-products' of machine manufacture, his 'principles of art', and his wide variety of designing capabilities are somewhat reminiscent of those same qualities in his Victorian predecessor, Dr Christopher Dresser, who had advocated the use of machine mass-production of domestic goods as early as the 1860s. Though there is no definite evidence to support any relationship between the two designers, the circumstantial evidence is strong. Both men designed for Liberty & Co., (though Dresser not directly)[1], and there is an apparent similarity between their respective 'Principles' in art and design, and also in several of the finished results. Finally, Knox chose to

[1] Dresser designed for James Couper & Son, glass manufacturers in Glasgow. Liberty's made a special feature of their 'Clutha' glass in their catalogues and in Liberty & Co. Interiors of the late 1890s (see Yule Tide Gifts 1900 page 74). By 1902 Clutha had been incorporated into the 'Tudric' range in the form of glass liners (see Fig. 96). Much of the Clutha glass range was created from used green glass wine bottles, melted down, and re-blown into shapes for domestic use.

A candlestick called by Liberty & Co. 'Cordofan' but designed by Dresser and manufactured by Perry and Co. appears in an early Liberty Catalogue (circa 1880), under the Eastern section.

live in Fulham, while teaching at Redhill. At this date (1897) Dresser was living just across the River Thames, in Barnes.

It was reflective of changing tastes, that when, in 1904, Dresser died in France in relative obscurity, Knox, though likewise unknown to the public, was enjoying the height of his design career with Liberty & Co.

In their approach to industrial design both men drew a large proportion of their artistic and creative achievements from historical sources and brought their idea to fruition with the aid of a machine. For a greater understanding of what mechanisation meant to the Victorian mind (and perhaps, therefore, the subsequent effect upon the following generation of designers) one should look at the beginnings of Victorian mass production.

In the 1850s, industrialisation and the subsequent commercial-isation of an object meant that a wide range of luxury and domestic machine-made goods became available to a more-monied, more taste conscious, and a more liberal minded public. That same public (6,201,856) paid £356,070[2] in entrance money alone to see the height of industrial achievement presented at the Crystal Palace Exhibition of 1851 where almost anything manufactured by a machine had a relevant position within the Exhibition.

In 1847 the Society of Arts received its Royal Charter. As a celebration, two men, Henry Cole and the Prince Consort (who had become its President in 1843), decided to stage an exhibition of 'well designed' manufactures. The show was such a great success that annual shows were decided upon with, in 1851, a National Exhibition based upon the French Quinquennial[3]. In 1849, Henry Cole and Mathew Digby Wyatt went to Paris to see and report on the Paris Quinquennial.

Cole was impressed and, upon his return, reported his feelings toward the exhibition to the Prince Consort, "I asked the Prince," said Cole, "If he had considered if the Exhibition should be a national or International Exhibition..." The Prince reflected for a minute and then said, "It must embrace foreign productions", to use his words – "International certainly". It was the first International Exhibition ever to be held.

[2] Multiply by twenty for a modern day equivalent.
[3] A large exhibition staged in Paris every fifth year.

In 1846, Cole designed a tea-service for Minton's and with other designers, namely Richard Redgrave, John Bell, J.C. Horsley and Daniel Maclise the painter, he set up an organisation known as 'Felix Summerly's Art Manufactures' (Felix Summerly was a pseudonym employed by Cole when writing and illustrating books for children).

Their idea was to 'revive the good old practice of connecting the best art with familiar objects in every day use. In doing this, Art Manufacturers will aim to produce in each article superior utility, which is not to be sacrificed to ornament, to select pure forms, to decorate each article with appropriate details relating to its use, and to obtain these details as directly as possible from nature'.

Having artists design objects was not without its drawbacks, and the Art Journal of 1847 remarked a little whimsically "...if our artists have much to teach, they have something to learn; this is, we humbly think, obvious to all who have examined the specimens referred to'.

By 1848, Cole was losing interest in Felix Summerly's Art Manufactures mainly as a result of the pressure of work caused by the Great Exhibition, and although odd designs continued to be produced, the company and its literary voice, the 'Journal of Design', came to an end in February 1852.

It was not until ten years later in 1862 that this artistic approach to designing was actually put to practical use and made viable. Then it was the joint efforts of Edward Burne-Jones, Phillip Webb, Dante Gabriel Rossetti, Ford Madox Brown, William Morris, Charles Faulkner and Peter Marshall; under the incorporating name of Morris, Marshall, Faulkner and Company.

Unlike Cole, and largely because of the artistic aspirations and commitments of the painters in the group, the company's themes, to begin with anyway, were largely revivalistic.

William Morris was aware of the reality and importance of a machine and a Machine Age, but he could not rectify the idea in terms of man, only in terms of Art. That is to say, his romantically inclined idea about the Arts, all Arts, did not allow for the mass production of supposedly artistic objects by those who neither understood, nor cared for, what the objects portended. Indeed, Morris realised that the worker,[4] far from becoming involved with the objects, would soon have more rapport with the machine he was operating, since it was this that now provided his livelihood, rather than the craft that he might have been following.

What Morris attempted, and in some way achieved, was a kind of Utopia[5] where every aspiring artist, having found the job or craft he or she could manage best, created and sold to an artistically educated market[6]. The immediate weaknesses of this approach were first, with especial regard to Morris and Company, as a commercial enterprise perpetuating this programme, that most of the artistic creativity in terms of production relied solely on Morris's personal relationships with his artist-designers; and second, the public was neither educated towards the artist-designer, nor in many cases was it prepared to pay the price for artistically achieved objects, when those made by machine cost perhaps only half as much.

Morris's intellectual successes were always greater than his commercial achievements. It was the manufacturers who copied his productions that were, to a great extent, unknowingly carrying out the ideas Morris had formulated, though, of course lacking in his integrity. They were in effect, bringing a wide range of semi-artistic products to a semi-artistically minded populous.

Morris had, however, set a certain stimulus free from the industrial entanglement and for the forty years following the founding of Morris and Company the idea of a 'return to Nature' for craftsmen, protected by the title of 'Guild' prevailed. By the

[4] "He gradually ceased to be a craftsman... Instead of a craftsman he now became a hand, responsible for nothing but carrying out the orders of his foreman... but in his working hours not even a machine, but an average portion of that great almost miraculous machine... the factory; a man, the subject matter of his labour, whose work had become employment, that is, merely the opportunity of earning a livelihood at the will of someone else. Whatever interest still clings to the production of wares under this sytsem has wholly left the ordinary workman, and attaches only to the organisers of his labour; and that commonly has little to do with the production of wares as things to be handled, looked at... used, in short, but simply as counters in the great game of the world-market. I fancy that there are not a few manufacturers in the great manufac-turing district* who would be horrified at the idea of using the wares which they manufacture, and if they could be witnesses of the enthusiasm of the customers when those wares reach their final destination of use, they would perhaps smile at it somewhat cynically"**.
*Liverprool.
**'Art and its Producers'. A lecture delivered by William Morris in 1888. Chiswick Press 1906.
[5] An address delivered in Edinburgh in October 1889 entitled 'The Arts and Crafts of Today' "in short, we artists are in this position, that we are the representatives of craftsmanship which has become extinct in the production of market ware. Let us therefore do our very best to become as good craftsmen as possible; and if we cannot be good craftsmen in one line, let us go down to the next; and find our level in the arts... make us free of that great corporation of creative power, the work of all ages, and prepare us for that which is surely coming, the new co-operative art of life...".
[6] Paradox of the Revolutionary Socialist and Conservative Artist'.

mid-1890s, although the machine was so firmly established in progressive Victorian Society as to be immovable, within the same Society an anti-machinist undercurrent of Morris-minded designers were flexing their abilities, and clearly it was now the turn of the 'Arts and Crafts' Movements to retaliate and allow people a wider selection of hand-made goods via the hundreds of various workshops[7] on a truly industrial scale.

Design became directly related, via the machine, to whatever the new fashions of the day dictated, from Anglo-Japanese experiments by architects such as Godwin, Jeckyll and to a lesser extent, Dresser, to the more sedately evolved, but just as progressive, productions of the Century Guild under A.H. Mackmurdo, whose abiding passion for marine biology was to be made obvious in several of his more outstanding designs. In all cases the machine, more than any other influence, made possible not only the rapid changes of taste required to keep pace with fashion, but also directly involved designers in the kind of relationships to industry which later groups such as the Bauhaus, and some of the associates of the *De Stijl* magazine, were to claim as their own.

The progressive Victorian designers such as Cole, Dresser, Jeckyll and Benson, all of whom utilised the machine for the machine's sake, often designed objects in which shape, function and intention pre-date Bauhaus and later Viennese designs by some twenty to twenty-five years.

These tastes and ideals were nowhere better epitomised than in the rapidly expanding shops of Liberty & Co., where, by the 1890s, through continued use of general and specialised advertising, a constantly changing mail order catalogue system, and Lasenby Liberty's own personal connections, the firm of Liberty & Co. had succeeded in establishing itself as the *arbiter elegantiarum* for middle class fashion aspirations.

Their new found artistic role, combined with continued financial success, drove Liberty & Co. closer and closer to machine mass production. By 1893 the Silver Fabric Studio[8] was designing almost exclusively for Liberty & Co., on machine looms. The fabrics produced were all jealously monopolised, the name of the company being inseparable from the material; thus 'Liberty' Silk,

[7] Since this volume is essentially concerned with A. Knox, it was felt unnecessary to mention Guilds, Workshops, Schools, Societies etc. in any great detail. The majority of those of interest are elsewhere mentioned in greater depth than this volume allows. A list at the back of those mainly concerned on a semi-commercial level, may be of use.

'Liberty' Woolcrepe, 'Liberty' Cashmere and 'Liberty' Velveteen became commonplace phraseology.

The experience gained by the Company with regard to fabrics and imports paved the way for the metalwork venture upon which the company embarked in 1898. In 1899, to announce the new wares, an extravagant catalogue entitled Cymric Wares, containing some coloured illustrations, was issued. It reflected, unlike its predecessors, only one aspect of the company's activities.The contents were devoted exclusively to Liberty's silver productions and a note in the foreword written by Judex[9] proudly announced "Messrs. Liberty claim its recognition as a charac- teristic innovation which may identify them with a new *fin-de- siécle* school of art silverwork". Liberty's commitment to the machine was finally sealed when, in 1901, they took a sixty per cent share in the metalworking firm of W.H. Haseler of Birmingham. The new venture combined the mass production of Haseler's with the retail outlet of Liberty & Co., in a partnership that was to be mutually beneficial until the mid 1920s.

[8] Founded by Arthur Silver circa 1889.
[9] 'Judex', was possibly the name assumed by the Chairman, A. Lasenby Liberty, from the Latin word for a judge 'Judex'. This would have incorporated a *double entendre*; firstly, Liberty was passing judgement on the relative merits of the various wares illustrated, and secondly he was the acting Justice of the Peace for the area of Buckingham.

Fig. No. 2. Archibald Knox as a young man. Photograph circa 1885. Courtesy Manx Museum.

Archibald Knox
The Early Years

Archibald Knox was born on 2nd April 1864[1]. His father, Robert Knox, was an engineer with an overriding interest in the sea and especially in boats. To support his family he combined his interest with his profession and by 1868 had a healthy business in Douglas as an engineer, designing and building machinery for both fishing and commercial sea trading vessels.

Robert William Knox was born in Kilbirnie, Lanarkshire, and his young wife, Anne, also a Scot, was born in Lismore Argyllshire. Archibald had three elder brothers, Robert, William and John, all of whom became engineers, and two sisters Christina and Ann. Carmichael, the youngest brother was drowned in Douglas harbour.

Like his other brothers, Archibald was expected to follow in his father's footsteps and enter the family business to train as an engineer. However, as early as 1871, Archibald had formed other views and experienced other emotions – all his spare time was devoted to sketching, and he was rarely to be seen without a pencil in his hand.

This self-enforced alienation not only from the authoritarian aspect of the family but also from his brothers due to their association with the family business, left Archibald as somewhat of and outsider; the discipline and solitude experienced at this early age remained with him throughout his life, and probably explains some of his seemingly more eccentric behaviour in later life. It was around this time, at the age of eight or nine, that he lost the top joint of the index finger on his right hand, in an accident at Tromode Mill. Some years later, Robert Knox concerned about his son's predilection for the pencil, and obviously worried about his future, remarked, "Why, he doesn't even know how to hold a hammer". Possibly his mother's assistance with regard to his art education meant that Archibald avoided both his father's business and his remonstrations about employment. In any event, surrounded on the one side by rural countryside, on the other by the harbour and clustering cottages shelved "one on top of the other", the young artist did not have to travel far for picturesque subject matter.

[1] On an application paper that Knox filled in, he gave the date of birth as the 2nd April 1864. On the birth certificate the date is given as the 9th April 1864. Possibly the birth was not registered until the 9th April – giving rise to the belief that this was the birth date.

Fig. No. 3. Page from The "Grammar of Ornament" by Owen Jones. This book was first published in 1856, and again in 1868 since most of the artistically inclined libraries held a copy it seems likely that Knox would have seen it during his Art School days.

Knox refers affectionately to these years in a memorial article on another artist and close friend, George Sheffield. He states: "Sheffield came to Douglas to Harold Tower about 1880 and stayed for about four years: his wife Miss Bridson once of the big house in front of the stone bridge: to a house with artists' traditions: Edward Henry Courbould, historical painter, married to a daughter of Wilson its occupier lived in it: John Martin, historical painter, his son-in-law, also made it a home...".

"In Wilson's time", says Knox, "I, a little fellow, had the run of Harold Tower, saw thence those as yet unvisited parts of the town; the tuscan tower on the red pier, the trees at Peveril corner, the backs of Sand Street, at Saana and beyond bushes and trees of the country".

Knox met George Sheffield and John M. Nicholson, a Manx artist and photographer both many years his senior, at the School of Art, Douglas, which in 1876 was opened and substantially influenced by Governor Loch, the British representative on the island. Nicholson visited the school often. He was enthusiastic about it: "Governor Loch's intention was, beginning with the school, to make Mann a place for art study, but beside that interest, the teacher who had come to start the school was of a like way of thinking in art matters with himself. He had painted under Dutch masters and came directly from the teaching of the notable French sculptor Dalou.[2] Sheffield then lived in Douglas, disposed towards German fashions and visited the school also; the students docile, I among them, started as venturesome modernists".

In 1873, at the age of seven, Archibald Knox was sent to St Barnabas Elementary School, Douglas, the elder brothers and sisters also attending. The young Knox's artistic talents did not go unnoticed and in 1878, at the age of thirteen, his name was put down for Douglas School of Art; the following year, 1879, saw his commencement as a student. Knox remained at the school for the requisite five years, finally combining his own learning with that of teaching; first at his old school, St Barnabas,1878-1883 and then as a student teacher at the School of Art, 1884-1888. In 1887 he had achieved a first class distinction in 'Principles of Ornamental Design'. Two years later, on 21st December 1889, he took his 'Art Master's Certificate' and obtained a Group One pass.

[2] Aimé Jules Dalou (1838-1902) studied under Carpeaux and Duret, settled in Paris but fled to England in 1871 when the Commune broke out. He was appointed professor of South Kensington, but returned to Paris in 1879 where he died in 1902.

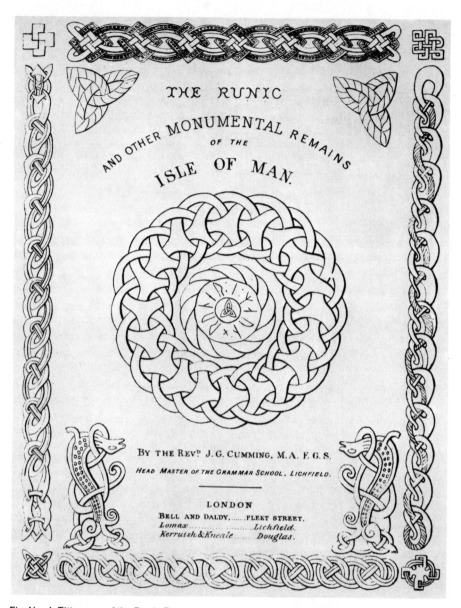

THE RUNIC

AND OTHER MONUMENTAL REMAINS

OF THE

ISLE OF MAN.

BY THE REV.ᴰ J. G. CUMMING, M.A. F.G.S.

HEAD MASTER OF THE GRAMMAR SCHOOL, LICHFIELD.

LONDON

BELL AND DALDY,......FLEET STREET.
Lomax......................Lichfield.
Kerruish & Kneale......Douglas.

Fig. No. 4. Title page of the Runic Remains of the Isle of Man circa 1860.

During the next two years, Knox worked progressively toward the final examination, that of 'Historic Ornament'. For this, much deeper research would have been required, since Knox had chosen Celtic design for his subject and although large quantities of source information were readily available on his own doorstep, a trip to Ireland to visit the Dublin Museum, wherein the 'Book of Kells', and other major Celtic artifacts were housed, would certainly have been necessary.

The British Museum records no publication specifically on or concerning the 'Book of Kells', between 1850 and 1892, when Celtic Ornament from the 'Book of Kells' was issued in Dublin by Hodges and Siggis. There were, however, a few publications on Monuments located in the Isle of Man, the most important being 'The Runic and Other Monumental Remains of the Isle of Man'.[3] In the introduction the Rev. Cumming refers to an earlier edition by 'Mr Kinnebrook' of etched plates of Celtic Ornament on the Isle of Man, "His work," he goes on to say, "is now out of print," and infers that the text is out of date!

Since both of these books are difficult to obtain, and not recorded in the British Museum Library, the initial sources which must have influenced Knox's thinking, interest and subsequent development with regard to Celtic ornament are therefore difficult to assess. Amongst his own books was a copy of 'The Art of Illuminating' by Tymns & Wyatt, though it is possible that this was obtained at a later date, since it ran to several editions, and was still in print as late as 1906.

What is evident, however, is that as a child Knox was surrounded by some of the finest achievements in Celtic crosses and grave memorials created between the seventh to the eleventh centuries.

While Knox was still a pupil at Douglas Grammar School, the Headmaster, the Rev. John Quine M.A., had taken a special interest in his education. John Quine was a keen amateur archaeologist and scholar who would have known all the Island's locations of Celtic antiquities. He would have been aware of the majority of publications on, or making reference to, Celtic Art, and would probably have known P.M.C. Kermode, author of: 'A Catalogue of Manks (sic) Crosses' 1887; 'List of Antiquities of the

[3] Published London 1851:
Bell and Daldy – Fleet Street.
Lomax – Litchfield.
Kerruish & Kneale – Douglas.

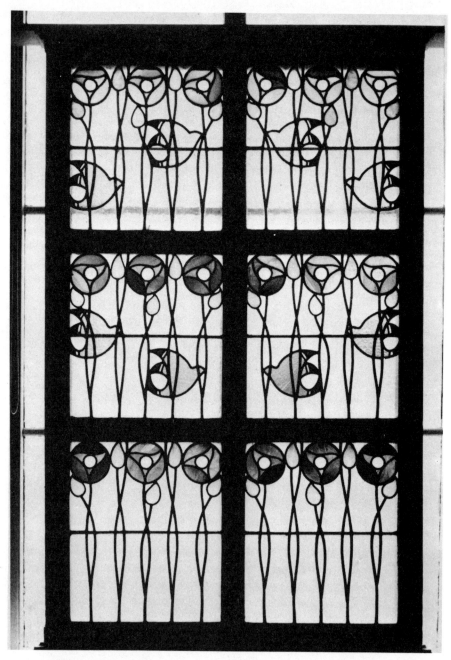

Fig. No. 5. Stained glass panel designed by M. H. Baillie Scott for "Glencrutchery" house, Isle of Man. Courtesy Manx Museum.

Isle of Man', 1895, and later in 1901, a 'List of Birds of the Isle of Man'.

More importantly, he would have been aware of the minor semi-revival of interest in Celtic art, form and ornament that took place in the 1850s. Notably those items produced by Messrs. Waterhouse & Co. of Dublin, being copies of anicient Celtic jewellery. But by the time of the Great Exhibition with its emphasis toward Egyptian, Greek and the European revivals, any impetus for a Celtic direction had largely been forgotten by the main manufacturers of the day, and although odd designers like Henry Hugh Armstead revived and used Celtic interlacing (of a very formal nature) on such items as the Doncaster Cup of 1860,[4] Celtic Ornament was largely relegated to design and pattern books such as Owen Jones's 'Grammar of Ornament', published 1856 (see Fig. 3), and J.C. Westwood's 'Mediaeval Illuminating', published 1866, and later, in 1876 'Studies in Design' by Christopher Dresser.

In 1892, Knox's enthusiasm, hard work and travelling was rewarded, for he became a prize medallist when he passed an examination with a distinction grade. Years later, on a return trip to Dublin, again to the Museum, he recorded, "I went to Dublin on Friday: it was a failure: It was a bad crossing flowing rough sea, dark mound of a cloud stretching right across the Channel: and at Dublin just as we were dying it found the quay, it came down like a shower before I could suspect it I was wet from my shoulders and legs, and with a soaked raincoat to carry I put in the day in the museum – that I went to see is in 'process of rearrangement' in the Irish way – so I went into the street to dry myself – and sample the innumerable *best* ales, that were to be had".

Perhaps the article which appeared the following year, 1893, in The Builder, on Celtic Ornament, was part of Knox's thesis. In any event probably by the date of this article, Knox had begun to put his knowledge to practical use in the design offices of M.H. Baillie Scott, then housed in Atholl Street, Douglas, Isle of Man.

Sometime in 1897, upon his arrival in London, Knox began to teach at Redhill School of Art. The Principal was a life-long friend, another Manxman, A.J. Collister. In January 1899, Knox was officially appointed as Design Master at the larger Art School of Kingston-upon-Thames (then located in Kingston Hall Road).

[4] Illustrated London News, Volume 37, page 274.
[5] Letter to Denise Wren, 19th VIII 1925.

M

Liberty & Co. Lim^{td.}

CHESHAM HOUSE, 142—152, Regent Street,
EAST INDIA HOUSE, 212—222, Regent Street, } LONDON.

TELEPHONE—Gerrard 3,658.

In reply please quote J/Z.

March. 6th 1902.

Mr. Knox

Sulby or Szilby

Isle of Man.

Sir,

We are having sent from "Cymric, B'ham" 2 glass claret jugs,
for which we require about ½ dozen designs for mounting in silver,
as these bottles have ~~have~~ to be made by the dozen to obtain them
at a reasonable rate. We are also sending you a coronation
spoon, being a copy of that used for the anointing of King Edward 1
and successive sovereign of Gt Britain.

We though something of this kind mught be made in the Cymric
ware as a souvenir for the Coronation of Edward Vll . The
designs would have to be very clear so that it could be easily
recognized by the ordinary individual as a commemerative spoon
of the Coronation year.

We should require it in 3 sizes one as enclosed, one 6½ ins.
long, one 8 ins.

The form of bowl we of course leave to you, but should like
it practical and in the larger sizes applicable as a fruit or jam
spoon.

Your early attention in this matter will greatly oblige as we are
anxious to produce the spoons as quickly as possible. The
designs you have on hand for silver work might stand on oneside
till this are completed, with the exception of the revised hair brushes
which are very special.

We are, Sir,

Yours obediently,

LIBERTY & CO LTD.

Fig. No. 6. Letter from Liberty & Co. to Knox regarding design work, and particularly that of Coronation spoons (see fig. 108). It is interesting to note the historical reference to the annointing spoon of Edward I.

During the time that Knox was teaching, art schools as such were in their infancy with the exception of the more notable London institutions. Most schools or colleges normally comprised one or, at the most, two unwanted rooms within a Technical or Scientific College. In certain cases the Art Instruction was on an 'alternate day basis', allowing the tutors to move from school to school within the confines of a Borough; this was certainly so with Knox, who taught for a while concurrently at Wimbledon and at Kingston.

It was not until the Local Government Acts of 1888 and 1894 gave effective powers of government to the people in their own localities (for the first time), and the Technical Education Acts made available through grants in aid, money derived from Probate and Excise duties, that local councils could afford to think about higher education. An interesting contemporary account of the Science and Art Department Building at Kingston, states: "The building provided on the ground floor three large classrooms, a Secretary's room, Strong room, Cloakroom, Porter's room, Hall and vestibule and at the rear a cookery room fitted with all the necessary appliances".

The School of Art occupied the first floor, which was divided into a large room for elementary subjects, designed to accommodate one hundred students, a room equipped for instruction in the higher brands of Art, a Modelling room, Masters' room, and a Cloakroom, a caretaker's residence is provided in a suite of rooms on the second floor. This building was completed in 1899, and the Surrey Technical Instruction Committee employed Knox from August 1899 to August 1900 at a salary of £25 11s per quarter.

Later, in 1900, Knox returned to the Isle of Man, and purchased a small cottage in Sulby. It was from here and surrounded by the Celtic artifacts of his homeland, that Knox was to create most of the designs used by Liberty & Co. with regard to their Celtic Revival.

Knox employed a housekeeper, Miss Quayle, to look after the cottage and to keep his personal affairs in order. As one might have expected many of the fixtures were Knox's own designs including Liberty & Co. curtains, carpets and furniture.

In 1904, complications of an undisclosed nature, arose with regard to the cottage and its purchase. Knox gave all he possessed to friends and locals, locked up the cottage and left for London. It is possible that the cottage was only leased, and that an extension was not granted.

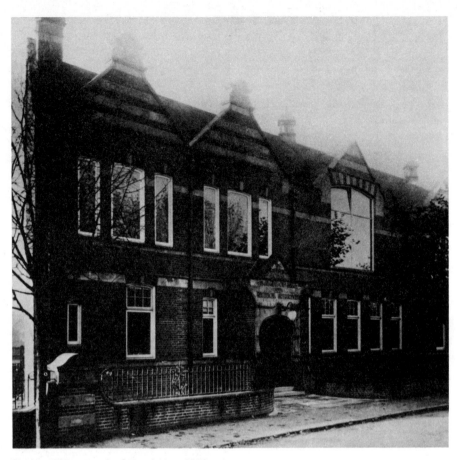

Fig. No. 7. Kingston Art School. circa 1900.

Unfortunately, there are few letters from this period (1900-1904), the only ones remaining relate to Knox's professional work (Fig. 6 and Fig. 10). These are, however, illuminating with regard to the way designs were conceived; and company policy toward the creation, production and subsequent exhibiting of finished designs.

By September 1904, Knox was back in London and resumed his old teaching position as Head of Design at Kingston.

In 1904 A.J. Collister was appointed Principal of the Art School at Wimbledon (housed within the Technical College), and it was presumably at his request that in March 1906 Knox began lecturing and taking evening classes at the school, for which he received "10s 6d per lesson of two and one half hours".

In an article in 'Mannin'[6], Miss Winifred Tuckfield, then a student recalled his first morning: "In a light grey Manx tweed, with spotless linen, with his longish hair and brown beard he quietly entered the room saying, 'Good morning to you', we did not know then that this was a Manx manner of words". She goes on to say, "Knox lectured with the aid of photographic slides, and dictated *principles* around which the students could formulate their individual ideas". Later in the same article: "The lectures were usually divided into different groups such as colour, window types, chimney pots, etc. Comparing one example with another 'Mr Knox' would show which had the greatest thought in it, which was the most suited to its purpose and the material used – teaching that there were two natures, outside nature and our own, the last being Art, Art, the outcome, or the reward of practice and study. Style or Art, he explained came to the artist as to the musician, only after long and continual application to the paint box or the keyboard, application with resolution and thought. Not until this Self Nature was expressed was the work produced complete, distinctive by its individuality, glowing as a stone mined from the recesses of the unknown".

It was here then, at Kingston, that the two Tuckfield sisters, Denise and Winifred, began their long association with Knox, his teaching and ideals, an association which was to be physically expressed until four years after Knox's death in the form of the 'Knox Guild of Craft and Design'.

[6] Mannin, journal of the Manx language, 1913.

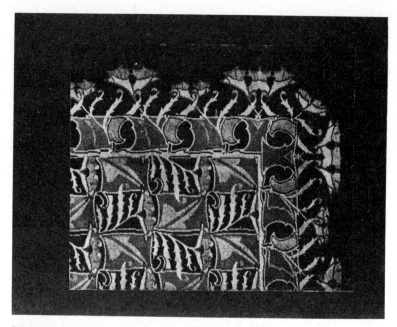

Fig. No. 8. Corner of a machine made woven fabric, possibly an early Knox design. Courtesy Manx Museum.

Fig. No. 9. Knox in later years standing in front of his Atholl Street home (now no longer standing). Courtesy Manx Museum.

Archibald Knox
London 1897-1912

Knox was to make full use of his interest in Celtic ornament, not only in his teaching career, but also in his designs for Liberty & Co., for whom he began to supply work between 1895 and 1898.

Knox's rare imaginative talents combined his intimate knowledge of Celtic Ornament with carefully considered shapes fully suiting the purpose for which they were intended. With Knox at his best, however, his interlacing ornament is more stylised, more personalised and contains a symbolic combination of the nineteenth century revivalist spirit with a true understanding of 'modern' conception. The choice of pattern is subject to the shape, the shape in turn being dependent upon the object. In this way Knox would create designs for object after object each differing radically from the previous one, but being created out of the same strictness of thought, or as he himself would have termed it, 'principle', "The best forms are those that suggest numbers of forms, and therefore are the best to use in design." The eventual outcome in many cases being shapes and decoration far in advance of their period.

Even within the obvious but necessary lines of enquiry pursued with regard to his work, it becomes increasingly clear that Knox with his predilection toward the Celtic and Runic art forms was the designer responsible for most of the major contributions that Liberty & Co. made to this particular revival, both in England and in Europe, where in Italy, the period is still referred to as 'Stile Liberty'.

Knox, however, did not begin his career with Liberty's as the designer of the objects with which, today, his name is associated. Instead, like many others, namely, Harry Napper, M.H. Baillie Scott, Arthur Silver[1] and Lindsay Butterfield, he probably began by designing fabrics and wallpapers, for which Liberty's were well known, and upon which commercial success depended. Lasenby Liberty was both a staunch defender and promoter of English fabrics. In 1893 he had written an article for 'The Studio' entitled 'Spitalfield Brocades', and in a Royal Society of Arts lecture upheld his choice of fabrics for a 'middle market'.[2]

It was probable that Knox's introduction to Liberty & Co. came through the architect/designer Mackay Hugh Baillie Scott who

[1] Father of Reginald 'Rex' Silver.
[2] Journal of the R.S.A. disc. Volume 40, page 585.

M

Liberty & Co. Lim^{td.}

CHESHAM HOUSE, 142–154, Regent Street,
EAST INDIA HOUSE, 212–222, Regent Street, } LONDON.

TELEGRAMS—"LASENBY," LONDON.
TELEPHONE—Gerrard 3,658.

In reply please quote J/Z

December 24th 1902.

Mr. A. Know,

Sulby,

Isle of Man.

Sir,

We are desirous of exhibiting at the forthcoming "Arts & Crafts Exhibition" some examples of Cymric silver jewellery of your designing .

Clause 5 of enclosed rules reads "Work not submitted by the designer must be accompanied by a permit from him" will you therefore send us per return such a permit so as to avoid any complication that might arise, the committee being somewhat particular on this point.

Yours faithfully,

LIBERTY & CO LTD.

Fig. No. 10. Letter from Liberty & Co. to Knox regarding the firm's entry into the 1903 Arts & Crafts exhibition. Courtesy Manx Museum.

had, since 1889, been actively engaged in his own architectural practice in Atholl Street, Douglas, Isle of Man and was resident in the Red House, Douglas, designed for his own use and occupied by him until 1901. Baillie Scott was to remark some years later "I went to the Isle of Man for a holiday. I was so seasick I couldn't face the journey back, so I set up practice there".

If this was the case, it was surely fate, for as early as 1893, Baillie Scott was employed by Liberty & Co.,[3] and through him, Knox was to begin a long and eventful design career with the firm.

John Betjeman, in an article for the Manx Museum wrote: "One of his (M.H. Baillie Scott's) early jobs in the Island was to supervise for J.L. Pearson the mosaic pavements in the chancel of St Matthew's, Douglas. It was about his only church work. Perhaps it was there that he met Archie Knox who was a worshipper at St Matthew's. They certainly knew each other, for Baillie Scott's daughter, Mrs Wallis, has some Archie Knox metalwork and remembers that he worked on designs in Baillie Scott's office and was associated with him in a Manx guild of craftsmen".[4]

Certainly, there would seem to be visual evidence that an association of this nature existed, for the stylistic similarity of certain Baillie Scott designs to several of those by Knox, both typographically, and in the 'clear' sharp style of drawing employed and the use of 'hard' often brash colour, would suggest that the work of one was not unknown to the other.

This kind of 'apprenticeship' was not uncommon, and it served not only as a training in the technical requirements, but also as a very good point of departure; already half-way, as it were, up the ladder to success. To the twenty-five year old Knox this must have combined congenial employment with a pecuniary addition to his schoolmaster's salary. One way or another, Knox was to balance this 'part-time' artist/designer existence with teaching until his death in 1933. Neither the teaching nor the design work brought the acknowledgement due to him.

As far as the designs were concerned, the main reason for Knox's neglect was that Liberty Company policy dictated (at least, while designs were still in production or economically viable) a strict secrecy with regard to the manufacturers, decorators and technicians, and a policy of 'blanket' anonymity was maintained with regard to designers.

Liberty & Co. were regular exhibitors in the various Arts and Crafts

[3] Studio Volume XXVI, page 4.
[4] Journal of the Manx Museum Volume VII, page 19, 1913.

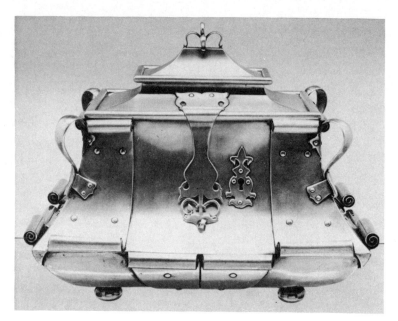

Fig. No. 11. Silver casket designed by Oliver Baker circa 1900. Private Collection London.

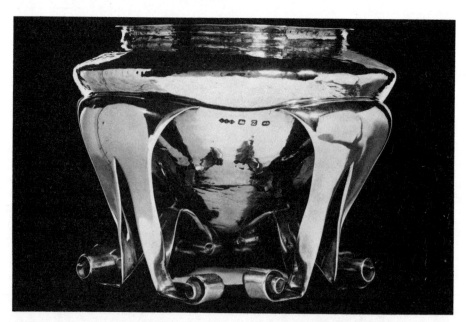

Fig. No. 12. Silver bowl designed by Oliver Baker circa 1898/99. Examples like this were included in the Arts & Crafts exhibition of 1898. Baker's Renaissance style designs were just another facet of the historical experimentations produced by Liberty & Co. The heavy leaning of the designs upon the hand worked appearances, serves to disassociate them from the futuristic qualities found in the majority of Knox designs. Private Collection London.

Society Exhibitions beginning with a stand at the New Gallery[5] in 1893. The company exhibited a large selection of fabrics designed by Arthur Silver, Thomas Wardle, E.G. Reuter and W.R. Lethaby.[6] It is from this source (i.e. exhibitions), and not the company that the names of the various designers were made known.[7] (Presumably, exhibiting firms were required to name their designers, where known). It is also probable that for a commercial firm to gain entry into the Arts and Crafts Exhibitions, a certain amount of rule bending was required, that is, anything produced by a machine would obviously not have been acceptable. These difficulties were outlined in a letter sent by Liberty & Co. to Knox relating to the 1903 Arts and Crafts Exhibition: "We are desirous of exhibiting at the forthcoming 'Arts and Crafts Exhibition' some examples of Cymric silver jewellery of your designing. Clause 5 of enclosed rules reads 'Work not submitted by the designer must be accompanied by a permit from him' will you therefore send us *per return* such a permit so as to avoid any complication that might arise, the committee being somewhat particular on this point'. (Fig. 10).

Liberty & Co. therefore had their exhibition pieces made by either the students at Birmingham School of Art, such as those pieces executed by Arthur Owen to Oliver Baker designs, or as in the case of Knox, Harry Femmis and Walter Newhall were credited with the manufacture.

Certainly, in those pieces designed by Knox, it is somewhat ironic that although produced by hand, they were given the surface (i.e. polished) that machine production would have created, as in Figs. 40 and 125.

By this date, 1903, however, the Arts and Crafts Exhibitions had become social occasions, as much as artistic gatherings, and although a certain amount of Arts and Crafts integrity annually presented itself in the New Gallery, by 1903, commerce had adopted a leading artistic role. All the time Liberty & Co. exhibited, nothing had changed with regard to the internal policy of anonymity shown toward their designers.

It was P.G. Konody in an article written on the 1903 Arts and Crafts Exhibition for the Austrian periodical 'Kunst und Kunsthandwerk' who made one of the few mentions of Knox and

[5] The New Gallery was located in Regent Street and started by Phillip Comyns Carr and the artist Charles Halle after they had argued over policy with Sir Coutts Lindsay of the Grosvenor Gallery.
[6] The Studio, Volume 3, page 94, 1893.
[7] It must also be that as with Celtic, Gothic and Moorish ornament in the original, rarely were objects signed, 19th century art critics had the romantic notion that all Pre-Renaissance art (other than painting) was anonymous – that, as it were, the artist concealed himself behind his work. That was not so.

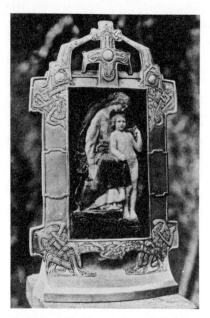

Fig. No. 13. Enamelled plaque mounted in a frame showing the extensive use of Celtic interlacing. Both the plaque and frame were designed by Alexander Fisher (see page 41).

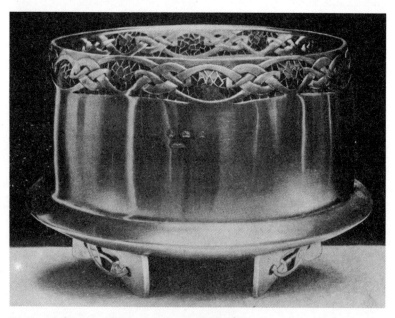

Fig. No. 14. Silver and Plique à Jour bowl designed by Knox, and exhibited in the 1903 Arts & Crafts exhibition. (Photo "Der Moderne Stil" 1903.)

illustrated two pieces designed by him[8] (Figs. 124 and 149). ('Der Moderne Stil' illustrates these two pieces and a bowl with plique à jour enamel, by Knox. Fig. 14).

Unfortunately, the Kunsthandwerk text is not very complimentary. Konody was obviously impregnated with Arts and Crafts traditions. He began by contrasting the style of Alexander Fisher's objects d'art (see Fig. 13) with the 'hypermodern' creations of Liberty and Son (sic). 'The curious curves, which Liberty & Co. were the first to introduce and which have had such ruinous influence on the whole of European applied art, make a pleasant enough first impression on the eye. One soon grows tired of them, however, and it must be said in all honesty that today, in England at least, the Liberty style is in its death throes. It is a fleeting phase, that is already passé. Only the influence and the loyal support of the popular Art magazine, 'The Studio', have enabled the Liberty style to attain any significance. Understandably enough such pieces as the two cups (see Figs. 124 and 149) designed by Archibald Knox for Liberty have found many admirers. What a terrible prospect, though, of having to spend one's life surrounded by these and similar shapes!'

It may well have been, however, that Konody was making a deliberate reference to the adaptations and modifications that the Liberty & Co. full-time studio 'designers' made to several of those designs submitted to them. To state that the creations were already passé in 1903, leads one to believe that the designs must have been in production for longer than the now generally accepted date.

It is probable that the company had every intention of altering the finished designs of professionals, mainly with the purpose of promoting their own name at every available opportunity. Thus, in their advertising, 'Designed and made by Liberty & Co.', becomes standard phraseology and is again found throughout the company retail catalogues. From a letter Knox wrote to Miss Denise Tuckfield (upon her possible engagement with Liberty & Co. in 1913) he makes it evident that designers, presumably himself included, were not aware of this eventuality, nor other internal company happenings, "Make it your business to please whoever is your boss and in six months you may feel yourself secure: you will find Philistines in that very citadel of 'Art' but I think they know when they have a good thing: their aim is to get someone who has capacity for development: study Liberty – think it – put it on: see

[8] Volume 6, page 71, 1903.

Fig. No. 15. Extract of a letter written by Knox to Denise Wren relating to her possible engagement at Liberty & Co. in the capacity of a designer (see page 43). Courtesy Denise Wren.

what the other girls do and what wages they get: if possible learn how they are engaged: I have heard it said by many, how badly 'L' treat their hands – in the matter of wages that is; but my experience of them is that it was of consideration and compliment; and I think that is the character of the establishment; so wish and wait: but when you are engaged let there be no misunderstanding about the number of designs that you are expected to produce weekly for the pay you will get! and that the designs are not to be used outside the department in which you work, you must be paid for it. And I think it would be advisable to retain the right to alter a design that was to be such under a new condition: you must not allow your work to be mauled(?) by anybody.

In a more light-hearted but typically dry remark, Knox goes on, "My work was recognised: America – through the illustrations in 'L' catalogues – one firm called it 'the art of the drug store'".

Knox's own experience, with regard to Liberty and Co. seems to have been much as the text of the preceding letter suggests, and basing judgement upon the objects now remaining, a great many appear as obvious adaptations. (Compare Figs. 21 and 97).

This combination of secrecy and plagiarism makes accurate assessment of finished designs, in all but a handful of cases, almost impossible, though by reference to the designs in the Victoria & Albert Museum and a knowledge of the work and styles of individual designers that worked for the firm, a large amount of whole designs, shapes and ornament may be credited to Knox. This policy of anonymity was employed even in the case of designer/painters who had achieved some repute within their own particular idiom, and with whom the association of objects designed for a 'taste and fashion' conscious 'middle class' buying public would, presumably, have been commercially successful as in the cases of Jessie M. King (see Figs 19, 20), Christopher Dresser (see Fig. 18), Bernard Cuzner (see Fig. 17), and Eleanor Fortescue Brickdale (see Fig. 16) all of whom had designed objects for Liberty & Co.

On the Continent most metalwork manufacturers, far from bringing the cloak of secrecy to the objects they produced, allowed the designer the latitude of his own monogram next to the firm's trade mark, a privilege for which the public were made to pay up to, in certain cases, one hundred per cent more.

The over zealous caution, on the part of Liberty & Co. was perhaps born of a fear, not that the designers the company had gathered together would ally themselves at greater salaries to

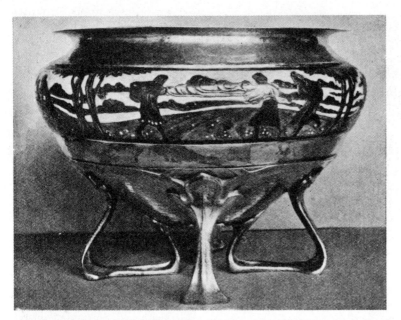

Fig. No. 16. Silver bowl designed by Oliver Baker, the enamel frieze was designed by Eleanor Fortescue Brickdale. Photograph "The Studio" 1906.

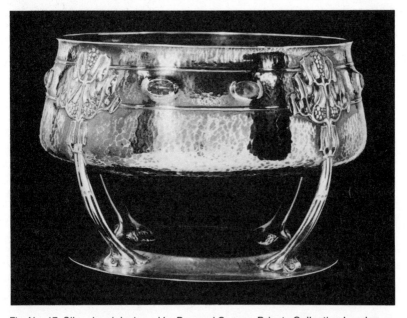

Fig. No. 17. Silver bowl designed by Bernard Cuzner. Private Collection London.

44

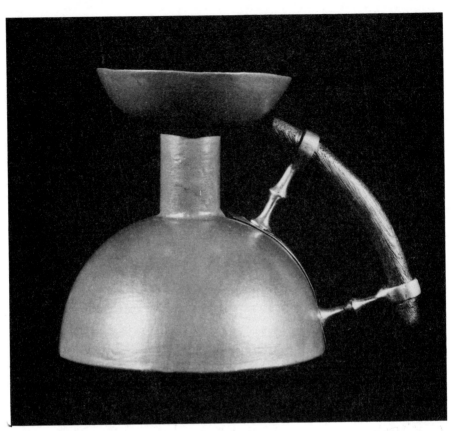

Fig. No. 18. Candlestick designed by Christopher Dresser and sold by Liberty & Co., under the name of Kordofan, these candlesticks were produced by a firm called Perry & Co. who had showrooms in Bond Street. It would seem unlikely that they were sold from both places particularly in view of the trade name given it by Liberty & Co. Possibly they had managed to obtain sole franchise after 1883. Courtesy Haslam & Whiteway.

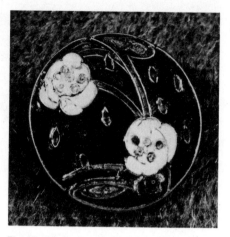

Fig. No. 19. Large brooch designed by Jessie M. King. Though unmarked this piece was almost certainly produced for Liberty & Co. Collection Sally Dennis.

Fig. No. 20. Button designed by Jessie M. King. Collection Beate Von Zezschwitz Munich.

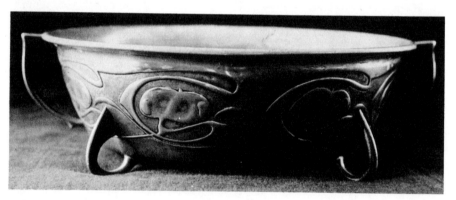

Fig. No. 21. Tudric pewter bowl incorporating the entrelac design found in Fig. 97, and the legs found in Fig. 82. Collection Dr. and Mrs. K. Smith.

competitive firms attempting the same enterprise, but more because of the likelihood that designs may have been pirated, and an inferior product created, only to be sold to an unsuspecting public, under the name of the originating company, i.e. Liberty & Co.

As early as 1842, registration 'lozenges' had been introduced to prevent pirating by unscrupulous manufacturers. In 1883 a serial number form was introduced beginning at '1' in 1884; the numbers had reached some 368,000 by the end of the century. Liberty & Co. had registered first all their silver designs, then with the introduction of the 'Tudric' range of pewter about 1900, these designs were subsequently registered, though as with the 'Cymric' range, not until later when the success of the venture was assured (circa 1902-3).

This secrecy obviously appealed to Knox's reserved nature. His name was never mentioned in English periodicals that illustrated designs attributable to him, although inferior designs by his colleagues for Liberty & Co. are often credited.

A secondary problem with regard to attribution of Knox items is the obvious division in styles; the earlier (1898-1899) style, a literal interpretation of Celtic forms, it was probably this style that led P.G. Konody to make a comparison with Alexander Fisher (see Fig. 13). Certainly there is a superficial similarity but in Fisher's work the ornament is always added decoration, whereas even in these early Knox designs the ornament is an integral, often structural feature; decoration and effect, to quote his own principles was being, "achieved by the colours of jewels and enamels". The latter style after 1901 was exemplified by the elegant shapes, clever use of glass (where required), the inventiveness of the Celtic interlacing patterns, and the original conclusions of many designs; for example the handles on the Rosebowl (see Fig. 97).[9]

More of an impasse, however, is the fact that all the records (cost books, etc.) housed at Liberty's in the Regent Street building, pertaining to these formative years, were destroyed by fire.

It is possible, however, that the designs were sent by all designers to the buyer of the particular department for which they were intended (i.e. jewellery designs to the buyer of the jewellery department; fabric designs to the buyer in the textile department, etc. – a practice which is still extant today). The initial selection, therefore, was made at this point. All designs rejected by the buyer were returned to the designer[10] whilst those accepted, were

[9] Rex Silver claimed this design as his own; however it seems unlikely – and unrelated to other designs that may be credited to him.

Fig. No. 22. Extract from one of the first letters Knox wrote to Denise Wren upon his return from America (see page 49). Courtesy Denise Wren.

passed to the filing office/studio for possible use at some later stage. (Freelance designers, like Knox, would have been paid on a 'piecework' basis).

It appears that Liberty & Co. actually employed full-time designers, though what function they served is somewhat obscure; certainly, when, for a short while in 1913, Miss Denise Tuckfield joined the firm as a designer she was amazed to find other members tracing the body of one design, combining this with the handle from another and the spout from still a third design!

Apart from objecting to her salary being equivalent to the 'adaptors', Miss Tuckfield felt morally and artistically obliged to inform Lasenby Liberty of these 'goings on'. His reply was a polite but effective 'brush-off'.

Knox was obviously aware of these plagiarisms for in a reply (from Douglas dated 27.8.13), to Miss Tuckfield concerning the same criticisms he states, "Sir A. kind and as good as gold is notwithstanding his experiences still a shopman: he has seen the best in the world, is friends with the best in England: but the man(?)[11] Sir A. the shopman seems never to have been received." (See fig. 22).

There can be no doubt that Knox wrote this with a slight element of self-interest for, though he had left Liberty & Co. in 1912, his own designs had often been altered while he was working for the company. Eventually several of the designs were sold (c.1909), many in a much adapted form to Messrs. Connell of Cheapside, who had attempted somewhat unsuccessfully to compete with the 'Tudric' range of pewter (see Fig. 24). Their shapes, however, were always traditional and the use of blue and green glazed ceramic tablets (Ruskin?)[12] was seldom as effective as the electric blue and marine green enamels so often employed by Liberty & Co.

Knox was in many ways an innovator, but originality does not by itself create a reputation. What he lacked was a desire for his own publicity. Few of his English contemporaries had either his flair for the creation of simple outlines, or the experienced assessment for controlled and restrained decoration.

[10] All the designs at present recorded are presumed to have been rejected by Liberty & Co., since no objects have been found which would show that the designs were actually carried out. Some designs however bear a close resemblance to existing items as do the design of Fig. 204 and the illustration Fig. 80.

[11] Indistinctively written.

[12] Ruskin pottery was founded by William Howson Taylor, 1898, at West Smethwick, Birmingham. Noted for the variety of high-temperature glazes, the factory ceased production in 1933, though Taylor continued experimenting until 1935.

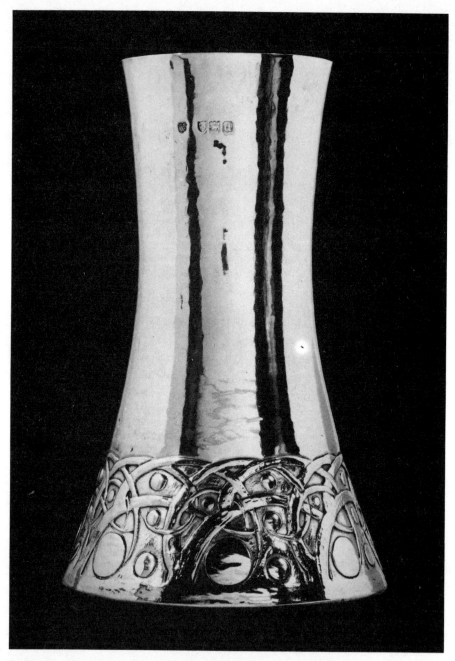

Fig. No. 23. Silver vase designed by C. R. Ashbee, and executed by the Guild of Handicraft. The date of 1899 indicates that the Celtic revival conceived by Liberty & Co. was not restricted to their designers alone. Private Collection London.

ceramic tablets (Ruskin?)[12] was seldom as effective as the electric blue and marine green enamels so often employed by Liberty and Co.

Knox was in many ways an innovator, but originality does not by itself create a reputation. What he lacked was a desire for his own publicity. Few of his English contemporaries had either his flair for the creation of simple outlines, or the experienced assessment for controlled and restrained decoration.

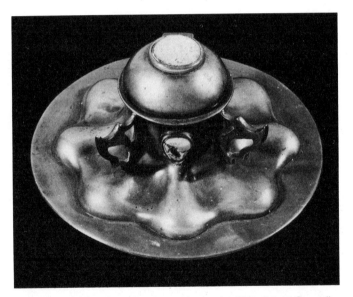

Fig. No. 24. Pewter inkwell produced for, and sold by James Connell & Co. in direct emulation of the Liberty metal productions. Most of the more unsuccessful Liberty pewter designs were sold to Connell & Co. circa 1909.

[12]Ruskin pottery was founded by William Howson Taylor, 1898, at West Smethwick, Birmingham. Noted for the variety of high-temperature glazes, the factory ceased production in 1933, though Taylor continued experimenting until 1935.

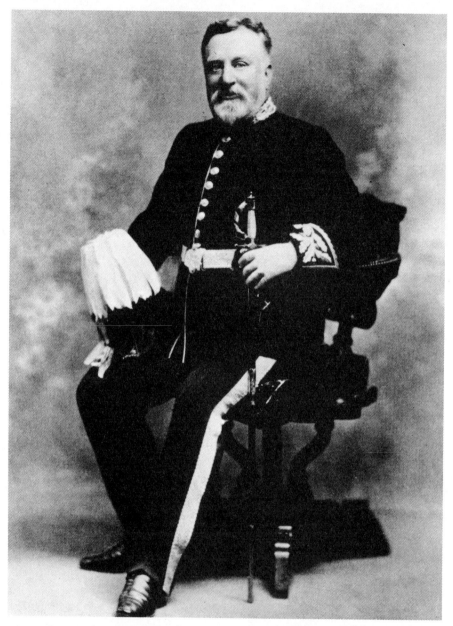

Fig. No. 25. Arthur Lasenby Liberty, D.L., J.P. in his uniform as High Sheriff of Buckinghamshire.

Liberty & Co.

Arthur Lasenby Liberty was born at Chesham, Buckinghamshire, in 1843, his father, Arthur Liberty, described himself as a Nottingham yarn merchant, and it was presumably through him that in, 1863, Lasenby Liberty joined the company of Farmer & Rogers in Regent Street as a manager, at the early age of twenty.

Farmer & Rogers ran an Oriental Warehouse at 171-175 Regent Street. The firm mainly handled imports from the Far East which included some of the exhibits from the 1862 Exhibition. The sixties were good years for Farmer & Rogers who began to supply an increasing public demand for objects such as lacquer and lacquered screens, porcelain, embroidered screens and colour prints. Such items were to have a profound effect on art and artists, beginning with James McNeill Whistler and culminating with the 'japonesques' of Aubrey Beardsley in the late '90s.

Japanese objects were, not altogether unknown. As early as 1854, there had been an unsuccessful exhibition at the Old Watercolour Society in Pall Mall East. The February edition of the Illustrated London News had this to say, "A singular cargo of curiosities, furniture, bronzes, porcelain silks and paintings, very curious and very attractive".

These 'curiosities' were to a greater or lesser degree, influencing the work of all the more avant-garde designers: the most notable being the architects E.W. Godwin, Thomas Jeckyll, William Burges and Christopher Dresser, all of whom introduced elements of 'Japonaiserie' into their designs.

After producing numerous successful Japanese influenced designs for the iron-founding firm of Barnard, Bishop and Barnard of Norwich, Thomas Jeckyll so completely surrendered his spirit to the new style, that when, in 1876, Whistler altered certain of his designs,[1] Jeckyll, bitterly disappointed at the loss of credit to himself, reacted by painting his bedroom floors gold and a few weeks later he died in a private lunatic asylum.

[1] These designs were, in fact, the commission to decorate the dining room of F.R. Leylands. Princes Gate House in London. Murray Marks, a porcelain dealer, had suggested to Leyland that Jeckyll should design and decorate a room to house his collection of blue and white porcelain. In 1876 the work was begun; Whistler was to hang his portrait, 'La Princesse du pays de la Porcelaine' (a portrait of Miss Christine Spartalli), in a recess over the mantlepiece. Whistler, upon examining the room decided that some red flowers on the dark walls did not harmonise with his painting, and suggested some touches of yellow. Whistler had his way, and while both Marks and Leyland were away on extended travels, Whistler not content with harmonising, completely changed the interior, the chief features being peacocks and their feathers.

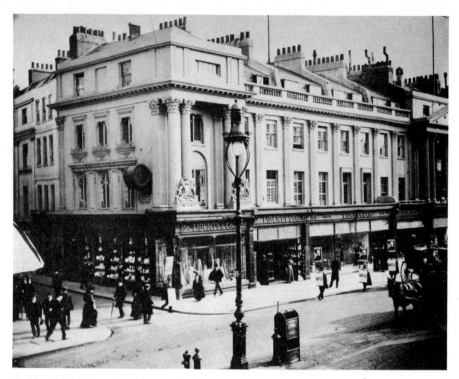

Fig. No. 26. The East side of Regent Street circa 1890, showing Liberty & Co, Chesham House. Courtesy Radio Times Hulton Picture Library.

By the early '70s the 'intellectualising' about fashions, taste and design had given rise to the term 'Aesthetic Movement' which George du Maurier was so ably to parody in the pages of Punch until the mid 1890s.

In 1875 the Oriental Warehouse of Farmer & Rogers closed down and Liberty found himself unemployed. However, his knowledge of Farmer & Rogers' customers (who had included Rossetti, Burges and Whistler), and his own experience in the administration of a West End London retail outlet, proved invaluable when in the same year his own newly founded company, Liberty & Co., took small premises at 218A Regent Street with a staff of one assistant and one porter.

Lasenby Liberty was already, therefore, attuned to market trends, and to catering for the whims of his fashionable 'aesthetically' minded customers. At first, the firm stuck religiously to imported fabrics, then proceeded to allow objects of far eastern origin such as silver kettles, cutlery and smaller furniture to be sold but only if overstamped with the appropriate Liberty & Co. mark and label. This was to be a company policy almost without exception until Lasenby Liberty's death in 1917.

By 1881 the company must have been flourishing (mainly due to the publicity given to the varying oriental wares that the company sold), for certainly, A. Lasenby Liberty felt confident enough in that year to invest £300 in a recently started company,[2] The Art Furnishers Alliance of Bond Street.

This company was founded with the intention "to carry on the business of manufacturing, buying and selling high class goods of artistic design", and Christopher Dresser was appointed as 'Art Manager'. Dresser and Liberty almost certainly knew each other, as they were both fellows of the Royal Society of Arts, but it is probable that it was Liberty's association with The Art Furnishers Alliance that led his own company, Liberty & Co., to handle objects designed by Dresser, in particular the 'Clutha' glassware. But metalwork was evidently also sold. An early catalogue has an illustration of a candlestick designed by Dresser, and manufactured by Perry & Co. (who had shop premises at 17 Grafton Street). The candlestick was sold by Liberty & Co. under the brand name of 'KORDOFAN' (see Fig. 18).

[2] The Art Furnishers Alliance was founded in 1880.

Fig. No. 27. Liberty & Co. advert suggesting designs for bedroom furniture, circa 1900.

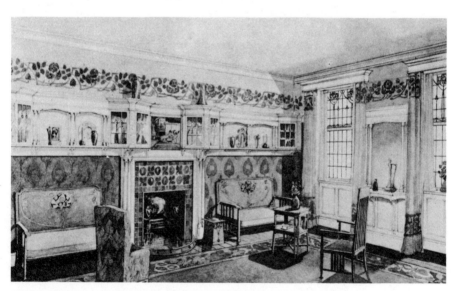

Fig. No. 28. Projected watercolour for a Liberty & Co. interior circa 1900.

By 1882, Lasenby Liberty began a programme of expansion, slowly moving up Regent Street toward the premises now occupied. In that year, Lasenby Liberty took on 142 and 144 Regent Street, Chesham House (see Fig. 26), transferring all the household and decorative furnishing to the new premises while leaving the fabric and dress departments in the old premises at East India House.

At these new premises, studios were set up to study and create designs for anything ranging from 'eastern influenced' fabrics to whole rooms in either 'Moorish' or variations of Oriental styles, Leighton House in Kensington being the prime example of this style of decoration.

In 1893 the first issue of an illustrated magazine 'The Studio' appeared. An article by Joseph Pennell the illustrator, on the recently discovered Aubrey Beardsley, no doubt helped to sell copies and popularise the magazine. In the same issue an article appeared by Lasenby Liberty on Spitalfields Brocades, written in a very business-like manner primarily for the benefit of shareholders rather than readers: "In this, silk, for the most part is worked up in skilful combination with less costly materials, such as wool and cotton, frankly and without any pretence that the resulting mixture is other than an admixture. Some of these combinations are really beautiful both in design and colour, and open out a field for the supply of charming tissues at modest cost".

The success of articles such as these in directing and controlling public tastes, the catalogues and the constantly revised programmes of advertising, led, in 1894, to the business becoming a public company with a share capital of £200,000. Both of Lasenby Liberty's parents, in particular his father, figured as large shareholders as did his wife's family, the Stewarts. Lasenby Liberty himself maintained the controlling shareholding.

Possibly as early as 1888 (certainly by the date of the Studio article mentioned above), Liberty's began to commission designs for their own fabrics. Designers such as M.H. Baillie Scott, Arthur Silver, Harry Napper, Lindsay Butterfield and Sydney Mawson had all been involved with the designs for these same "charming tissues at modest cost", and for wallpaper designs along similar lines.

Messrs. Liberty and Co. were the patrons of a competition in the September 1893 issue of The Studio entitled 'Designs for a Woven Fabric'. "The design is to be for a woven tapestry in four colours in the style of the Italian Rennaissance; a broad treatment

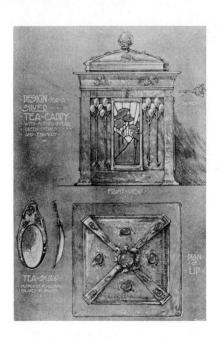

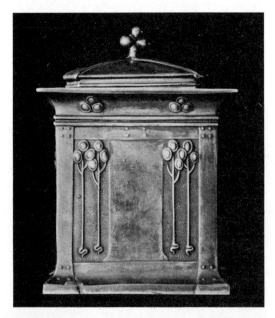

Fig. Nos. 29, 30. The original design and the same object, subsequent to Liberty & Co purchase and production. Design, "The Studio", 1899. Object, Collection John and Diana Lyons.

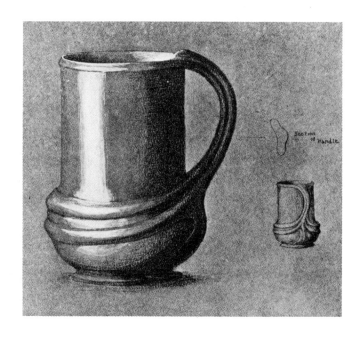

Section of Handle

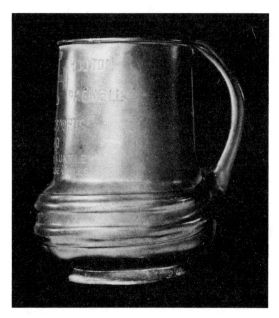

Fig. Nos. 31, 32. The design for a tankard, and the same tankard as produced by Liberty & Co. Design, "The Studio" 1900. Object, Collection of Peter and Debbie Gooday.

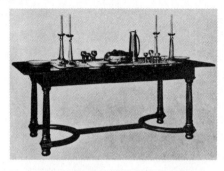

Fig. No. 33. Lutyens style table and setting as shown by Liberty & Co. On the table are two pairs of Kayserzinn candlesticks, a Tudric fruit dish, and a decanter in pewter and glass designed by Knox. Photograph Studio 1908.

Fig. No. 34. Englebert Kayser in his studio. Unlike the Liberty productions, most of the Kayserzinn range was modelled in plaster, before being put into production.

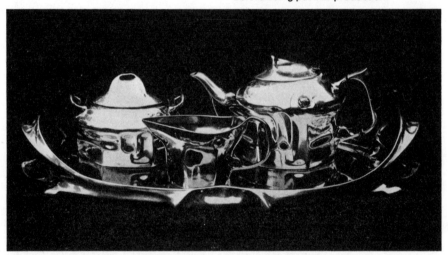

Fig. No. 35. Kayserzinn pewter tea and coffee service designed by Hugo Leven circa 1896/7. Collection Peter and Debbie Gooday.

of the design and detail is most desirable". The competition was assessed not only by The Studio, but by Messrs. Liberty & Co. who had the option of purchasing the winning design for "a sum not exceeding the amount awarded" (three guineas).

The utilisation of unknown designer/craftsmen, maintained the *patron-like* artistic approach so in keeping with the Liberty & Co. tradition. Not only fabric designs were purchased in this way, but at a later date, after the inception of the 'Cymric' and 'Tudric' ranges, several designs for applied art objects were purchased and subsequently put into production, for example the Tankard (Fig. 32) designed by Charlotte E. Elliot under the pseudonym[3] 'Parnassus', which gained the second prize (no first being awarded) in a competition appearing in the 1900 number of The Studio. A similar case appears in the issue in which a design for a silver tea-caddy by 'Tramp' (David Veazey)[4] has been freely translated by Liberty & Co. into a pewter version of the same (see Figs. 29 and 30). Several other adaptations of Studio competition designs occurred throughout the Liberty range; however, the precedent was always the same and this mode of obtaining designs was more or less discontinued after 1901 when Liberty's began to employ several freelance designers on a retainer basis.

Sometime between 1896 and early in 1898, Lasenby Liberty must have come into contact with a catalogue issued by the German firm of J.P. Kayser and Son of Krefeld. Their chief designer was the young Hugo Leven (1874-1956), whose tea-set (Fig. 35) shows a revolutionary adaptation of organic plant forms, as well as a masterly use of the Mackintosh rose. It was designed around 1896-97.[5]

J.P. Kayser had been producing traditional pewter articles for the domestic market since its inception in 1885. Apparently, as early as 1894, the first piece of 'Art Pewter' was created, though this probably consisted of the application of plant or floral motifs to a quasi-traditional shape (see Fig. 37). So aware was the firm of its conservative history, that early catalogues bear the cover illustration of a bearded craftsman studying a traditional beer-tankard whilst the inside illustrates the varying new 'Art Pewter', alongside objects like punch bowls of traditional shapes bearing

[3] A requirement of entry to all The Studio competitions.
[4] Presumably in these early days, Lasenby Liberty would have been more closely connected with design and designers than he appears to have been in 1904-1916, for it seems unlikely that he would have sanctioned the apparent and all too often absurd cross-fertilisation of designs which occurred.
[5] Deutsche Kunst und Dekoration, March 1899, page 245.

Fig. No. 36. Advertisement for "Orion" pewter, in which is stated the various finishes given to the pewter, namely, matt, polished, silver plated, gilt and patinated. Liberty & Co. would no doubt have followed the Continental lead in this respect. Photograph Die Kunst. 1903.

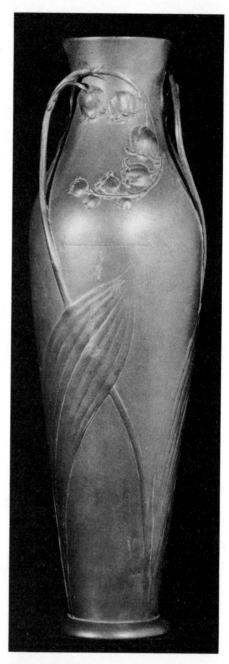

Fig. No. 37. A more traditional Kayserzinn vase. Though these continued to be sold alongside the avante-garde, they were never as popular in either Germany or England.

naturalistic boars, deer, or other animals as decoration. The catalogues always stated object, measurements, price and the order number.

There is no certain date when Lasenby Liberty commenced production of his "Novelties in English Pewter Wares". However, to judge from his own allusion to a lecture given by J. Starkie-Gardner to the Royal Society of Arts in 1894,[6] "would it not be pleasant and memorable to be able to bring back a piece of pewter engraved or embossed on the spot with old Celtic patterns', the seed had been germinating for some while, with the confident knowledge that Knox could cope with the brunt of any multifarious design-work; and with Liberty & Co.'s impressive sales of Kayserzinn (and pewter by the less notable firms of Osiris, Orivit and E. Hueck of Ludenscheid as well as the plated wares of W.M.F.[7] from Geislingen, all of which the company had imported from c.1896), in 1898 Liberty felt assured enough to commence the project of producing silver, plate and jewellery. But it was not until much later on May 17th, 1901, that this venture was registered as Liberty & Co. (Cymric) Limited.

In a lecture given to the Royal Society of Arts, 1904, Arthur Lasenby Liberty refers directly to the conception and commencement of the Celtic revivalist theme, commenting particularly upon the pewter. "And here again I would allude to the notable paper on pewter read by Mr. Gardner, ten years ago (1894), and the interesting fact that no sooner had the echoes of his words of lamentation died away, than the cloud which threatened extinction to the industry slowly lifted, and from that day the erstwhile moribund craft has been struggling back to life. Among the controlling influences tending towards this result, a certain firm, whose name I need not mention, had shortly after this time, adopted for designs in silver, plate and jewellery, the motif and lines of ancient Celtic ornament. The results proving fairly satisfactory the question arose, 'Why not apply the like forms and designs to the manufacture of pewter?' Thus, rightly or wrongly the pioneers of the revival of Celtic ornament decided to work in pewter on somewhat parallel lines with silver, and came to the conclusion that nothing is produced by the silversmith which may not, as occasion arises, be made in pewter, but with the distinct proviso that any attempt to imitate the precious metal should be avoided".[8]

[6] Royal Society of Arts Journal 1894
[7] Württemburgische Metallwarenfabrik.

Fig. No. 38. Liberty & Co. advertisement from The Studio showing the same brooch featured in a Murrle Bennett & Co. advert (see fig. 179).

The Society of Arts annual schedule would dictate that this article was written in 1903, approximately one year before required. Certainly the fact that neither Liberty nor the chairman, Sir George Birdwood, were aware of the exhibition of antique pewter in Cliffords Inn (February to March, 1904) when Liberty was asked to prepare the lecture, would support an earlier date. Since the lecture is essentially retrospective it can be assumed that Lasenby Liberty refers to the years 1900-1901, when he states in the same lecture: "For pewter, however, only modifications of Celtic forms were used, and these were soon supplemented by floral and plant motives to which the distinguishing name of 'Tudric' was given". This statement seems to indicate that prior to the introduction of the trade name 'Tudric', pewter of a Celtic revivalist nature had been produced by Liberty & Co. This would possibly indicate that certain pieces in the Celtic style lacking the familiar punchmark 'Tudric' are of an earlier date. Certainly the pieces one assumes to be earlier, because of their individual 'mould'[9] numbers, could all be classified as 'modified Celtic forms'. (See Figs 41, 42 and 44).

At the end of the lecture Lasenby Liberty gives his thanks to John Llewellyn, "under whose fostering care the new developments in English pewter have been nursed into being'.

The Lewellyn family had been shareholders in Liberty & Co. since 1897,[10] some time before 1900, John Llewellyn had joined the company as an employee, and on January 16th, 1901, he was officially appointed a director, presumably in readiness for the merging of W.H. Haseler & Co. of 16 to 26 Hylton Street, Birmingham, with Liberty & Co. under the joint trade name of 'Cymric' Limited, on the 17th May, 1901.

Certainly by 1901, both the 'Cymric' and 'Tudric' ranges had received the usual Liberty publicity treatment. An article in 'The Queen, the Lady's Newspaper' states enthusiastically: "The very name of Liberty & Co. brings to the mind a vista of things artistic, original, and certainly beautiful, and many English people, and the visitors in our midst, will hail with delight the important departures in gold and silver work which the firm include under the wide

[8] Pewter and the Revival of its Use' R.S.A. Journal May 17th, 1904.
[9] The punched numbers always with an 'O' prefix are presumed to be model numbers and/or internal order numbers.
[10] Companies House, Liberty & Co. Vol. 1 press mark 42342. .

Fig. No. 39. "The Old Studio" sideboard in a Liberty & Co. interior, circa 1903. On the centre is an early piece of Tudric pewter. While at either end to the back of the cabinet are two pottery vases designed by Professor Max Lauger. The plates and decanters are "Orivitt" pewter.

Fig. No. 40. Large silver cigar box designed by Knox circa 1900. Collection The Museum of Modern Art, New York. (Gift of A. A. Rockefeller).

embracing term 'Cymric'. It is associated with a complete breaking away from conventionality in the matter of design. The metal is not burnished, except here and there in some decorative detail, and the soft natural sheen of the metal has a special beauty. The forms are all distinctly original and hand hammered, the hand of the artist being individually traceable".[11]

The three Haselers, father W.H. Haseler, and two sons, William Rabone, and Frank Haseler had between them a forty per cent shareholding in the new £20,000 company. Though the company records state that all the Haseler machinery was mortgaged to the new company of Liberty & Co. (Cymric) Limited, (in return for shares), William H. Haseler continued to manufacture and sell items of his own in both silver and jewellery and several of these bear more than a passing resemblance to Liberty pieces particularly those pieces of Celtic inspiration, which suggests that he was not altogether honouring his side of the agreement. The pieces, however, always carried his W.H.H. makers mark (see Fig. 181). Presumably Lasenby Liberty turned a blind eye to this aspect of his friend's business enterprise.

The inception of the 'Cymric' venture in 1899 was a very cautious first step. Silver and gold both being expensive (so much so that C.R. Ashbee, founder of the Guild of Handicraft in 1888, was often forced to utilise copper which, upon completion, was plated in imitation of silver), it is probable that orders for larger pieces of silver were undertaken on a commission basis. The standard of workmanship in these early pieces of silver was always high and from one of the pieces attributable to a maker, a box[12], designed by Archibald Knox and manufactured (by hand) by William[13] Craythorne, it is obvious that the 'flat machine-made' appearance is of primary importance to the success of the overall design. The box is not so successful particularly where the 'cut-out' terminates. This would suggest that (as the date of the box, 1900, would uphold) it is in a transitional style between the already mentioned 'literal interpretation of Celtic ornament', Figs. 42 and 44 and the modified designs of Figs. 74 and 103, which are clearly of a later date.

[11] In most cases the hammered surface was applied to the pewter by machine, however the items were hand finished.

[12] Museum of Modern Art, New York. Rockefeller Bequest. See Fig. 40.

[13] Shirley Bury of the Victoria & Albert Museum suggests that William Craythrone is in fact a mistake, and that it should be H.R. Craythorne one of the Birmingham students, who is known to have manufactured other Liberty silver work.

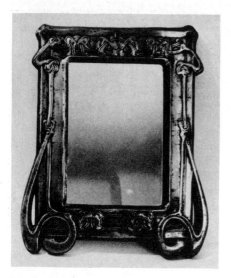

Fig. No. 41. Unmarked toilet mirror in pewter. Probably an early design by Knox for Liberty & Co. Collection Beate Von Zezschwitz, Munich.

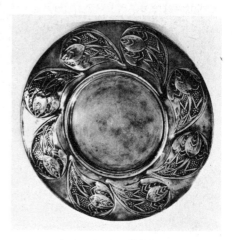

Fig. No. 42. Early Tudric pewter salver, this style, where marked, normally bears the distinction of being "Hand-wrought", (see page 270). Collection Beate Von Zezschwitz, Munich.

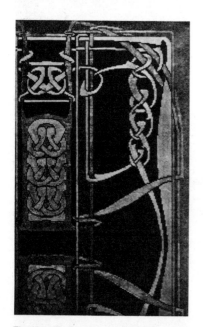

Fig. No. 43. Corner of a Donegal carpet designed by Knox for Liberty & Co. and executed by Alex Morton & Co, Carlisle. Photograph "The Studio" 1906.

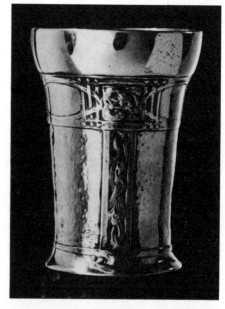

Fig. No. 44. Unmarked pewter beaker probably an early design by Knox for Liberty & Co. (Compare the vertical decoration with that in Fig. 45). Collection Jon Gorman.

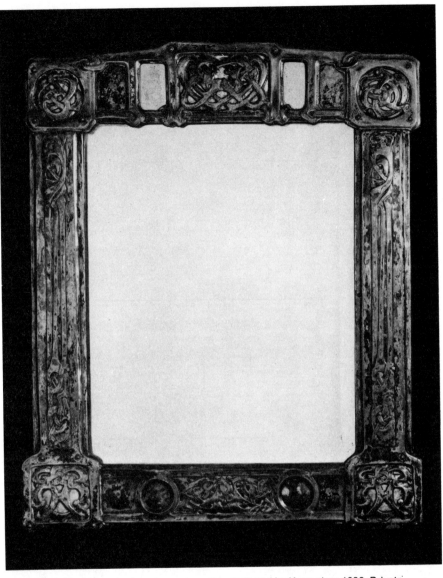

Fig. No. 45. Silver plated mirror frame, possibly designed by Knox circa 1898. Private
Collection London.

Fig. No. 46. Double page from a Liberty & Co. catalogue showing silver tea and coffee services probably designed by Knox, grouped together with the more traditional of Liberty Productions.

Fig. No. 47. Double page from a Liberty & Co. Catalogue showing varying designs for silver tea, serving and caddy spoons.

The application of either coloured enamels or various semi-precious stones to these pieces, was normally the customer's choice, the objects being tailored to the customer's requirements. These extras, of course, affected the overall price.

Since the early 1880s, Liberty & Co. had been issuing catalogues of their various stocks and imports, their most notable being the Christmas issue under the title of 'Yule Tide Gifts'. Their adoption of catalogues devoted solely to metalwork, however, involved a change in format and was a direct emulation in all but name and stock of those issued by the Continental firms particularly the Kayserzinn catalogues.

In the Liberty & Co. exhibition catalogue for the Modern Celtic Art exhibition of 1903 at the Grafton Gallery, C.J. Ffoulkes reviewing the pewter, states, "A compound of such possibilities and in colour rivalling silver itself in the soft lustre of its sheen, must, of necessity attract the producer and artist craftsmen by reason of its adaptability to practical uses. In the present collection of modern pewter will be found many interesting examples of a quite recently founded industry, and working for the time being only on a modest scale... Naturally in its price it has a distinct advantage over silverware, and also in the practical side of everyday life, it is to be recommended because of its cleanliness and freedom from corrosion of verdigris. Being a metal that melts at a lower heat than enamel, this form of enrichment can only be used in the form of applied panels, but to give the new pewter a distinctive note of its own, the irridescent beauties of the pearl shells have been used with great effect. The shell is let in in small bands or plaques, and sometimes the additive of copper is made with the most happy results.

"The future uses of this new pewter for domestic purposes are practically innumerable, and with the exception of spoons and forks it can be used in place of elctro-plate save only where it would come into contact with great heat. Its name 'Tudric', gives us a key to an aim and purpose – the encouragement and maturing of an art that is purely national, something that will speak for itself as the indigenous product of our own country. For, while not neglecting the commercial aspects of their new venture the exhibitors are endeavouring to combine with them an artistic ideal of which they may well be proud".

These catalogues combined with exhibitions and large advertising campaigns in the various art and household periodicals of the time kept the name of Liberty & Co. and their more fashionable goods focused in public attention.

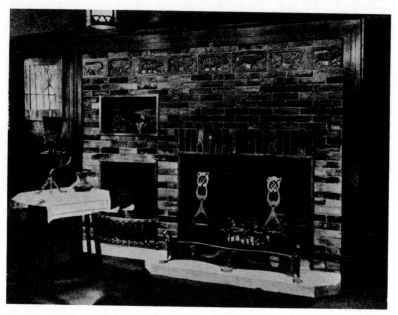

Fig. No. 48. Liberty & Co. Fireplace showing the use of Celtic entrelac in wrought iron. Photograph Studio 1906.

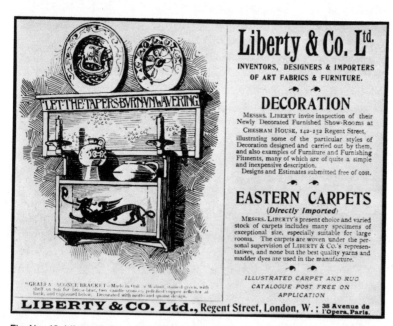

Fig. No. 49. Liberty & Co. advert circa 1899. The use of Medieval sounding titles for ranges and individual items included whole suites of furniture such as "The Athelstan", or as in this case "The Graefa".

Thus, A. Lasenby Liberty was to run his company for the next decade; internally, the employment of mainly unknown artist designers, a policy which had a two-fold benefit, first in terms of the cheapness and adaptability of this kind of labour, and second the 'patron-style' approach appealing to Lasenby Liberty's personal ideas of the grandiose; externally, appearing as a supporter of the arts, for the benefit of the public. Liberty had, however, always been an astute businessman, and would always, during his practising years with the firm, remain such.

Fig. No. 50. Photograph by Bedford Lemere of Liberty & Co., Regents Street, circa 1910. Photograph courtesy Royal Commission on Historical Monuments.

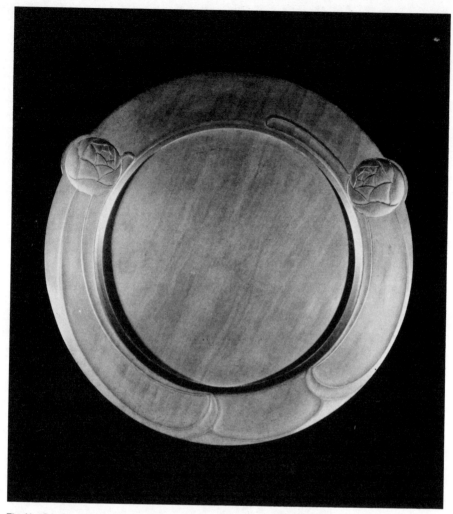

Fig. No. 51. Pewter plate deigned by Joseph Maria Olbrich circa. 1900. Private Collection London.

Knox and the Designs for Liberty & Co. Metalwork

To attempt to arrange the Knox designs housed in the Victoria & Albert Museum presents innumerable trials. The biggest problem is that the designs are assumed to have been rejected by Liberty & Co. as not suitable for production; this means that all reference to those pieces actually put into production must be one of pure visual assessment and, by the same token, an unsatisfactory method, relating a portion of one design to a similar portion of an object which bears, in many cases, more than a passing resemblance, as in Figs. 81 the teapot and 213 the design.

With regard to these designs, Knox worked in the same manner throughout his career with Liberty & Co. All the designs show signs of having been created by the same strict use of formulae applicable to something as simple as a spoon, or the more complex form of a presentation cup. In all the designs there is the same logical sequence of events from the beginning to the finish of the design.

In practice, the original and very rough sketch was crudely drafted, worked and re-worked, until the beginnings of the familiar Celtic interlacing appeared through the grey smudges: The creation thus far was drawn and re-drawn, rubbings-out were frequent, and only at this stage when the design looked appropriate, did Knox employ a transfer method by tracing the design, and re-drawing, using the sharpest lead pencil, for the tightest possible outlines. In several cases the drawing is picked out with touches of water-colour which were intended to signify either semi-precious stones or, as termed by Knox, 'floating' blue and green enamels.

Most of the designs bear, in Knox's hand, details of shape, size and, where applicable, stones or enamel etc. Several of the drawings bear further additions of a numerical sequence enclosed in the familiar *square leaf motif*. In certain cases, these follow a sequence according to the designs contained on one sheet as in catalogue No. 15[1], but in other cases Nos. 2, 39, 61[2], the three designs, though intended for use as a unit (i.e. tea service) are all on separate sheets. These numbers probably related to a stock-book that Knox maintained while at Kingston, a reference which

[1] Victoria & Albert folio M.26 accession No. E.348-1969, E.349-1969.
[2] Victoria & Albert folio M.26 accession No. E.307-1969, M26a E.312-1969.

enabled him to know which designs Liberty & Co. had purchased, of what the design consisted, the date and any other relevant information, a method also employed by Christopher Dresser.

Some of the numbers on the designs bear an 'M' prefix, which is possibly a shortened representation for *metalwork,* or model number. Certainly none of the designs is intended for anything other than production in either pewter or silver, and from the choice of semi-precious stones, and the restrained use of water-colour representational of enamel, it is probable that the majority of designs were intended for the Cymric range of silver.

It is also probable that the designs catalogued are not earlier than 1900, if one accepts the objects illustrated in Figs. 42, 44, to be Knox designs of between 1898 and prior to 1900; i.e. those which Lasenby Liberty referred to in the 1904 lecture: "A certain firm, whose name I need not mention, had, shortly after that time (1894), adopted designs in silver plate and jewellery, the motif and lines of ancient Celtic ornament". Later in the same article he states: "For pewter, however, only modifications of Celtic forms were used"[3] and those items previously mentioned bear out Lasenby Liberty's statement: stylistically, then, all the catalogued designs must be of a later date.

It appears that in practice, these 'modifications' were seldom marked 'Liberty & Co.', or 'Tudric', leading one to suspect that they were very much experimental items allowing not only the manufacturers valuable practical experience with regard to mass production, but also the company to test whether the designers could keep up a good standard of design, and whether their combined efforts particularly in *'English Pewter'* appealed to the public as much as the creations of Continental pewter manu-facturers. By 1900, output must have caught up with demand. Several competition designs in the 'Studio' magazine of this date, however, were purchased, and subsequently produced, proving that Liberty & Co. were constantly on the look-out for new and adaptable sources as well as designs.

In the case of the 'Studio' design for a 'Silver Tea Caddy' (No. AL.1), the winning design by 'Tramp' (David Veazey), was purchased and produced in pewter (see Fig. 30). The design for a pewter tankard (No. AL.11), was also purchased though the magazine had this to say: "The first prize in this competition cannot be awarded as the designs sent in are unsatisfactory. Indeed they prove that very little attention has been given to the

[3] R.S.A. Journal 1904.

kind of ornament that is applicable to pewter, a soft alloy, mainly of tin and lead. 'Tramp', 'Theseus', and two or three other competitors may be commended for the great care bestowed on their designs, but the results of this care are not in accord with the peculiar qualities and the limitations of pewter".

"The first prize (two guineas) withheld".

"The second prize (one given) is awarded to 'Parnassus', (Charlotte E. Elliott, 111 Chatham Street, Liverpool)".

Notwithstanding the 'Studio's' harsh criticism, Liberty & Co. purchased the design and that too was subsequently put into production. Neither of the pieces is particularly startling; indeed they exemplify the general poor standard of design with regard to domestic objects. An interesting point to note, however, is that the first design by 'Tramp' for a Tea Caddy, the competition for which appeared in the June issue, bears the number 049, while the second design by 'Parnassus' for a Tankard, which appears in the following month bears the number 050, making it likely that the mould numbers, at this date anyway, indicate a chronological sequence.

By 1901, an article in the 'Queen, The Lady's Newspaper' stated with regard to 'Tudric' pewter that "the jugs, flower vases, bowls, and tea caddies, are a delight to those whose artistic instincts have been duly cultivated. The tone and sheen of pewter accord well with the present school of decoration, and the variety is great". The article illustrates two items, a cigar box, and a tray, Fig. 82, which would appear to be in the 'early' Knox style (i.e. 1899). Of rivets, Knox had this to say.

"Rivet as much as you can:

don't countersink the rivets:

give them a firm head so they may have a firm grip:

complete them that they cannot hold dirt:

give them desired form: they are sin clipped:

flattened: too obviously: ..."[4] (see also bomb-shaped vase in Fig. 39).

Though on a pewter tray (the whole being moulded) there would have been no structural need for rivets, on a design intended for silver the rivets could have been employed, and would have had a great deal in common with the style of Arthur Dixon, and the Birmingham Guild of Handicraft who were at this date creating silver objects which utilised rivets as both a structural and aesthetic feature.

[4] Letter to Denise Tuckfield, 1913.

To sum up, 1898 saw the introduction of the silver plate and jewellery, subsequently registered as Liberty (Cymric) Ltd. (May 1901). Whether due to the success of this venture, or, as is more likely, because of the commercial successes of the imported Continental pewter, Lasenby Liberty initiated, around 1900, the company's excursions into pewter production, albeit on a somewhat limited scale. It is into this excursionary bracket that those designs, having a more fastidious or literal interpretation of Celtic ornament, belong; in effect they form a 'transition', as in Fig. 75, a bridge, so to speak, between Figs. 42, 45 and the obviously later, more sophisticated designs which dominate the catalogue of designs (page 247).

The majority of these designs, must have been produced between 1900 and the period while Knox was teaching at Kingston. By 1909, however, not only was the demand for this style of pewter waning, but also Liberty's had taken the step of selling several designs to Messrs. Connell of Cheapside (see Fig. 73).

Knox's confrontation with the South Kensington Examination Board had taken place in 1911 after the student examinations. His resignation was immediate. It would, therefore, have been at the close of the term 1911-12 that Knox discarded the drawings which now form the Victoria & Albert Museum collection.

By the following August 1912, Knox had settled his affairs in London and had booked a passage to Philadelphia, U.S.A. By October the same year, he had reached his destination.

Thus, although it is possible that some designs were executed after 1909 (in fact the number of wholesale adaptations and modifications presumably executed within the Liberty & Co. 'studios' increased dramatically at about this date), the quantity would have been drastically reduced, both in Knox's output and Liberty & Co.'s purchasing of his designs.

Only in terms of visual assessment and analogy, can any of the metalwork designs be arranged in chronological order. This applies to the early objects such as Figs. 42, 44, for which no designs are as yet recorded, the 'transitional' (1899 to late 1900), designs and objects which generally include those bearing inscriptional mottoes as in Figs. 200 and 210, and finally, to the bulk of objects and designs, which were produced between 1902 and 1909, which adopt surprisingly severe shapes in outline, and become much more abstracted where ornament is concerned as in Figs. 91 and 79.

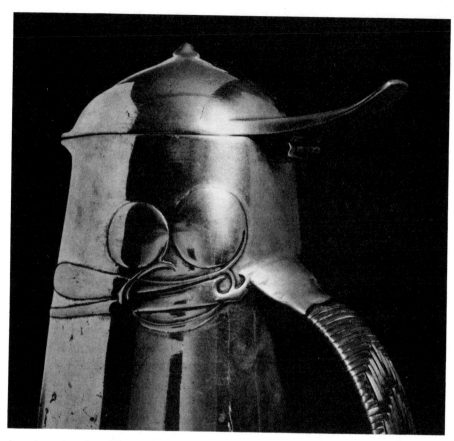

An enlarged section of Fig. 102.

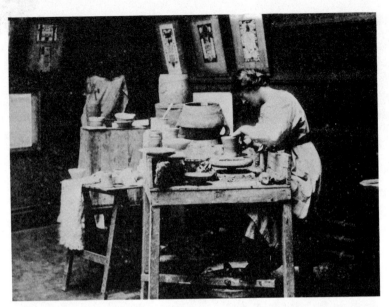

Fig. No. 52. Denise Wren at work in the Knox Guild of Craft & Design, Market Place, Kingston upon Thames. The style of pottery produced is shown in Fig. 57. All her designs, at this stage showed her understanding of complex Knox theories on colour and design. Photographed circa 1914. Courtesy Denise Wren.

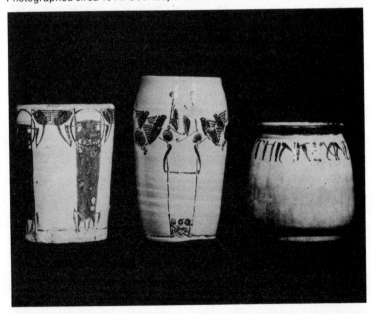

Fig. No. 53. Three pottery vases designed and executed by Denise Wren circa 1913. Collection Denise Wren.

Archibald Knox and the Knox Guild of Craft and Design

Knox's decision to go to Philadelphia was sudden and unexpected. In a letter to Denise Tuckfield he states his own misgivings with particular reference to the 'Rennaissance architecture' of Philadelphia – a style which Knox had always disliked, "Rennaissance Architecture is a scholar's work – Gothic is work done by a man of sentiment and feeling". Notwithstanding his own inclinations, on the 21st August 1912 Knox left Liverpool on the 'Dominion' bound for Philadelphia.

For a short while communications between Denise Tuckfield and Knox ceased. When at last Knox did write, his letter was not one of satisfaction, nor art, and may be classed as one of the most introspective Knox communications at present recorded; he was obviously feeling the attendant strains ever present to the single traveller.

"I have begun many letters to you they have all ended in their beginnings: and now when I look over them to see what I have been writing to you I cannot read them: I must write to you however because I am leaving here for New York and so I will have no address except what my mother will have at Douglas: I have given up for the time the hope of being started on my own. Here I cannot find suitable work otherwise. So I am trying afresh in N.Y. I may have to travel about but travelling is costly and it can't last very long".

This letter was written from Philadelphia where Knox was teaching at the Pennsylvania, School of Industrial Arts, though as the letter suggested, presumably only for one term. Possibly an introductory letter from A. Lasenby Liberty assisted Knox in obtaining work with a large retail firm called Bromley & Co., though he seems to have only managed to execute carpet designs. He obviously took Liberty and Co. catalogues as representative examples of his work for later, when writing to Miss Tuckfield came the remark, "My work was recognised... through the illustrations in 'L' catalogues – one firm called it the art of the drug store". Presumably New York also proved unsuccessful, or Knox's financial worries caught up with him. By 1913 he was back in the Isle of Man.

As a result of Knox's resignation from Kingston School of Art and his subsequent explanation of his action, Denise and Winifred

Fig. No. 54. Knox looking across Douglas harbour from the second storey window of his Atholl Street home. Courtesy Manx Museum.

Fig No. 55. Knox posing for a photograph portraying him as the watercolourist. Courtesy Manx Museum.

The Knox Guild at 24 Market Place, Kingston upon Thames, circa 1913. From *left* to *right*, Winifred Tuckfield, Phyllis Tuckfield, Norah Black, back standing, Denise Wren.

Tuckfield headed a small group of fellow art students in protest. This took the form of all of the students dismissing themselves from the school, uniting themselves under the incorporating title of the 'Knox Guild of Craft and Design' and, as a real snub to the authorities, renting premises at 24 Market Place, Kingston, where the Guild set about selling the various productions they created. The Guild exhibited annually from 1913 to 1939 at both Kingston Public Art Gallery and at the Whitechapel Art Gallery, London. At most of the exhibitions Knox was asked to show some of his watercolours, and though he rarely allowed his watercolours to be viewed, his relationship to the Guild, as its mentor, obliged him to accord with the Guild's wishes. He supervised and attended several of the Whitechapel Exhibitions, and invariably wrote an introduction for the catalogue.

Knox's commitment to the Guild had been present since its inception; while he was still in America the Tuckfields had informed him of their actions and requested his advice and assistance. On the 3rd November 1912, Knox had sent them an illuminated document which became known as the Knox Creed, and was worded as follows:

<div align="center">

The Knox Guild of Design and Crafts

24 Market Place

Kingston-upon-Thames

Standard of Work by Archibald Knox

</div>

1st Colour–

For its own sentiment.

The Greys of the imagination.

There is no other mode by which colour can be taught with success than by design.

2nd Form–

Of the Imagination of Suggestion.

Limited always by the Materials used.

3rd Style–

Your feeling in colour and form.

Disciplined always by the sentiment of Simplicidness (sic) of Breadth.

Founded October 9th, 1912.

During its lifetime the Guild received acclaim on both a local and national level, particularly when, in 1919, the Guild chose not only to exhibit the objects, but also to demonstrate how they were

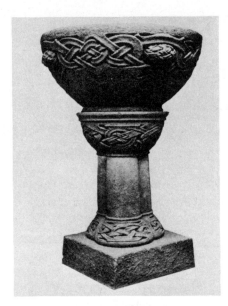

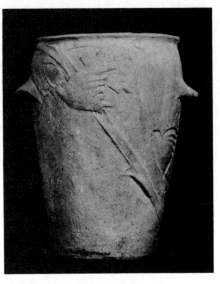

Fig. No. 56. Garden Jardinière and stand produced by the Compton pottery.

Fig. No. 57. Terracotta garden vase designed & executed by Denise Wren while still at Art School. This type of vase had been made by the Watts pottery, in accordance with Knox designs since 1904/5. Collection Denise Wren.

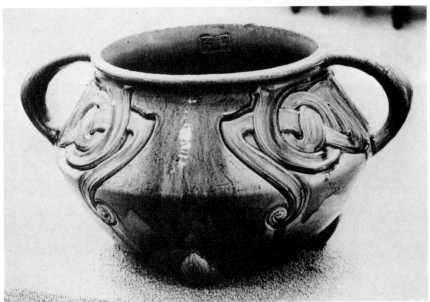

Fig. No. 58. Garden urn manufactured at the Watts pottery, Compton, to a Knox design. This example is glazed turquoise, the punchmark on the inside stating, "Designed and manufactured for Liberty & Co." Courtesy Manx Museum.

made, entailing the moving of potting wheels, looms and other items of bulky equipment to the particular exhibition hall. This action was repeated in 1924 at the Empire Exhibition.

During the period 1913 (America) until his sudden death in 1933 of heart failure while asleep, Knox did not produce any designs for an industrialised domestic market. Six years later, in 1939, as a direct result of the outbreak of war, the Knox Guild of Craft and Design ceased. Denise Wren continued with the Oxshott pottery, which is today run by her daughter Rosemary Wren and Peter Crotty.

The Knox Guild of Craft and Design, like its mentor, was never a publicity-orientated co-operative, consequently a record of its work can only be gained via the numerous objects produced, from the various catalogues and some personal reminiscences of the few remaining members.

With Knox, there is really only the record of a few years output (between 1897 and 1912) and that is mainly directed toward metalwork designs, all the credit having been assumed by Liberty & Co.

It is with that period in Knox's life that this volume has concerned itself, and particularly with his designs for objects. As a parting comment, therefore, it is perhaps fitting to quote Knox regarding design.

"It is difficult for want of names, to define, even to name, the things used in the designer's mental stock in trade. Art is selfishly occupied with her own perfection only, and the artist, inexperienced in words, too often allows his art to be covered in pretences of mystery, imagination and genius.

"It is easier to explain than define design in decoration. Of two pieces of cloth, we will choose one texture rather than the other; or a piece coloured with dye, rather than its native colour as from the sheep's back.

"The exercise of choice, commonly called 'Taste' is design; It is the imagination of choosing, endeavouring to bring by aid of art, things of nature into harmony with the things of the mind. The imagination will do more than make choices; it will add form to its colour; form in a group of two; colour and counter colour, in stripes as its elementary condition and with form and counter-form; in checks in groups also of two colours; counterpanes repeated side by side continuously; The colour grey; That grey that is in the condition of changing into other unnameable greys; form

Fig. No. 59. Alphabet designed by Denise Wren. Courtesy Denise Wren.

Fig. No. 60. Celtic style alphabet designed by Knox and executed by Miss Winifred Tuckfield, while at the Knox Guild. Courtesy Denise Wren.

Fig. No. 61. Top and side view of a table designed by Knox and executed by a local craftsman. Courtesy Manx Museum.

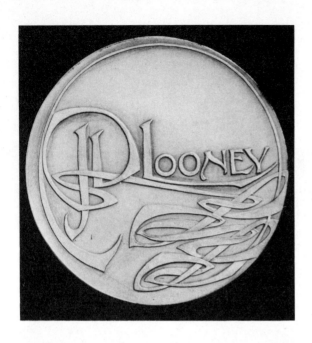

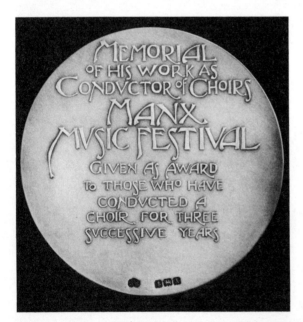

Fig. No. 62. Obverse and reverse of a silver medallion designed by Knox and executed by Elkington & Co. Courtesy Manx Museum.

containing always material for now and other form; suggestive, incomplete; the imagination never rests; positive articulate fact is material only for renewed effort for colour and form.

"Choosing and exercising its choice in sentiment of order and symmetry; consciously certain accurate and with well-balanced intention; and with style.

"And this journey from the exercise of taste to the product with style of the capable craftsman is in an 'assiduity unabated by difficulty and a disposition eagerly directed to the object of its pursuit'. There is no other way; All traverse it; All may reach the same end.

"The imagination has no special place for what is called Historic Congruity – the National character of English Art; It is impossible now to say whey the art that produced the Cross of Cong disappeared completely in the 12th Century; a reason may be divined why the art of Henry VIII's Chapel also disappeared in the 16th century,: there is no doubt" why the Italianised Art that followed its disappearance in turn also disappeared in the 19th Century; nor need we speculate why National Character is expressed yesterday Georgesquely, today William and Mariannely, tomorrow what the shopman may devise".

A.K.

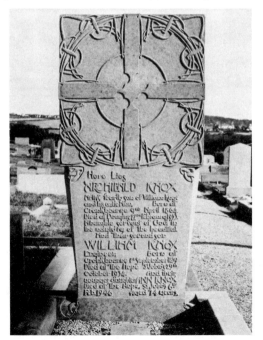

Fig. No. 63. Knox's tombstone at Braddon cemetery.

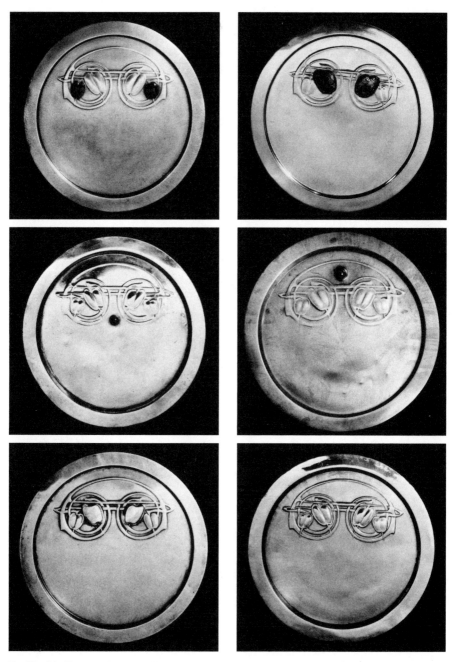

Fig. No. 64. Six variations on a Knox design for a card tray, circa 1902. Private collection, London.

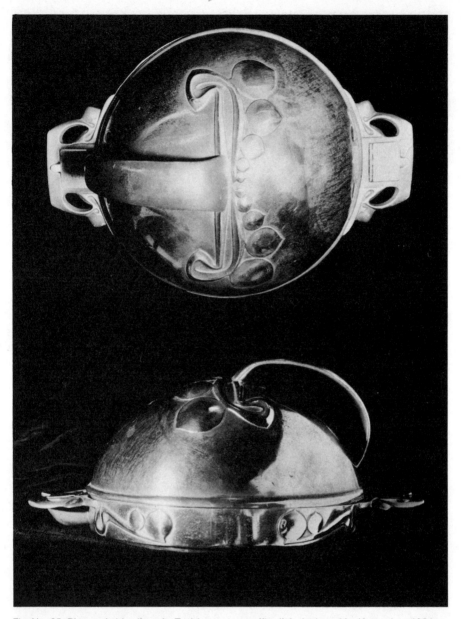

Fig. No. 65. Plan and side view of a Tudric pewter muffin dish designed by Knox circa 1901. Collection Bill and Vicky Waters.

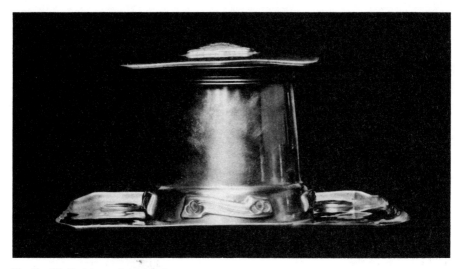

Fig. No. 66. Tudric pewter inkwell.

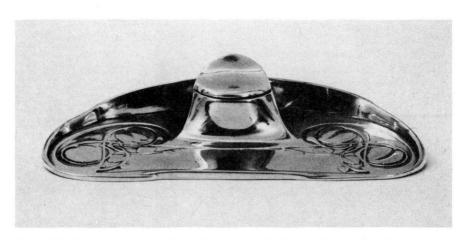

Fig. No. 67. Kidney shaped inkwell possibly designed by Knox. Collection Beate Von Zezschwitz, Munich.

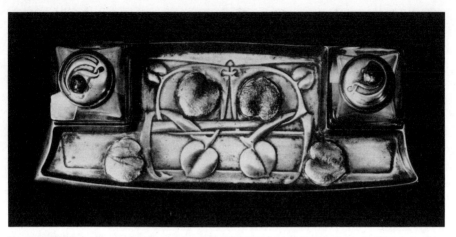

Fig. No. 68. Plan view of a Tudric pewter desk inkwell designed by Knox circa 1902. Private Collection London.

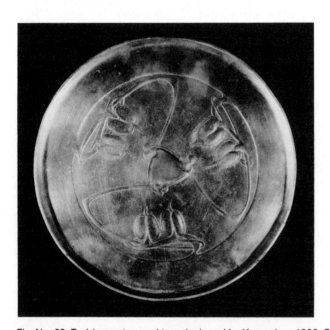

Fig. No. 69. Tudric pewter card tray designed by Knox circa 1902. Collection M. John.

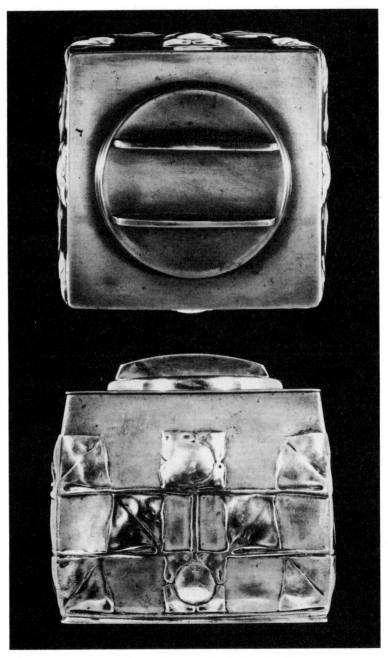

Fig. No. 70. Tudric pewter biscuit box possibly designed by Knox.
Private Collection London.

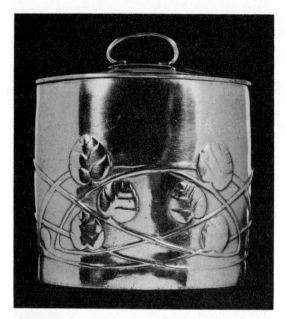

Fig. No. 71. Cylindrical Tudric pewter biscuit barrel. Private Collection London.

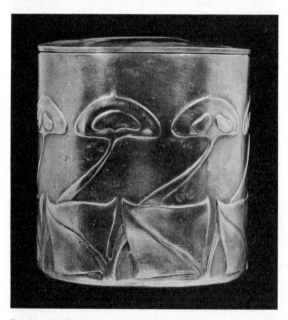

Fig. No. 72. Cylindrical Tudric biscuit barrel designed by Knox circa 1902/3. Private Collection London.

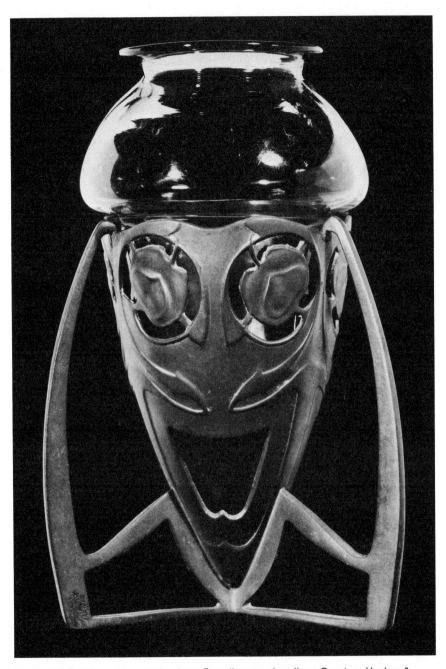

Fig. No. 73. Tudric pewter vase having a Powell green glass liner. Courtesy Haslam & Whiteway.

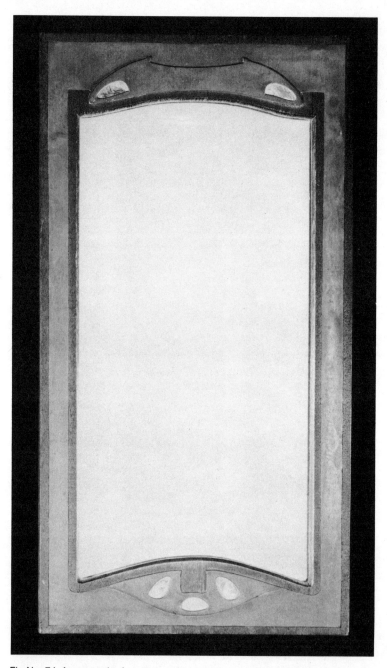

Fig No. 74. An unmarked pewter and wood mirror probably designed by Knox circa 1902. Private Collection London.

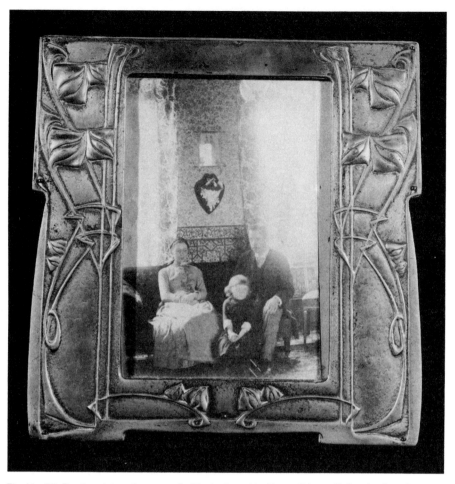

Fig. No. 75. Pewter picture frame probably designed by Knox. Private Collection London.

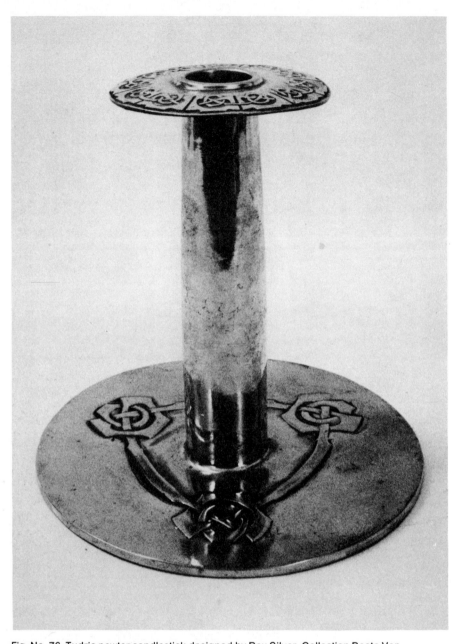

Fig. No. 76. Tudric pewter candlestick designed by Rex Silver. Collection Beate Von Zezschwitz, Munich.

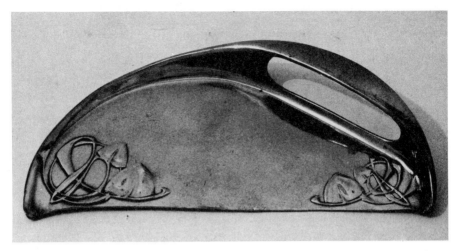

Fig. No. 77. Tudric pewter crumb scoop designed by Knox circa 1900. Collection Beate Von Zezschwitz, Munich.

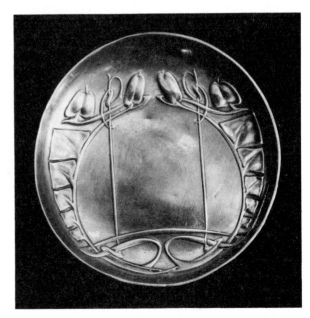

Fig. No. 78. Tudric pewter circular dish, designed by Knox circa 1900. Private Collection London.

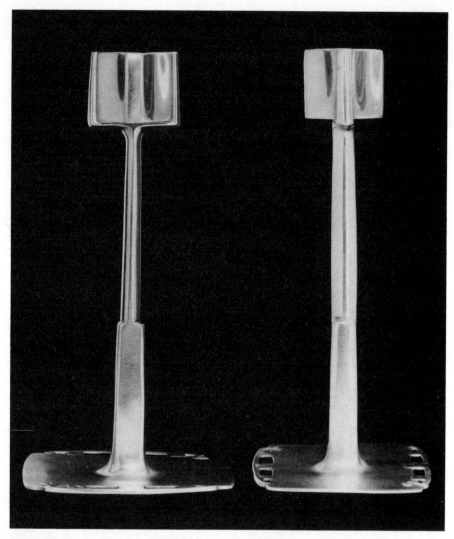

Fig. No. 79. A pair of Tudric pewter candlesticks probably designed by Knox. Private
Collection London.

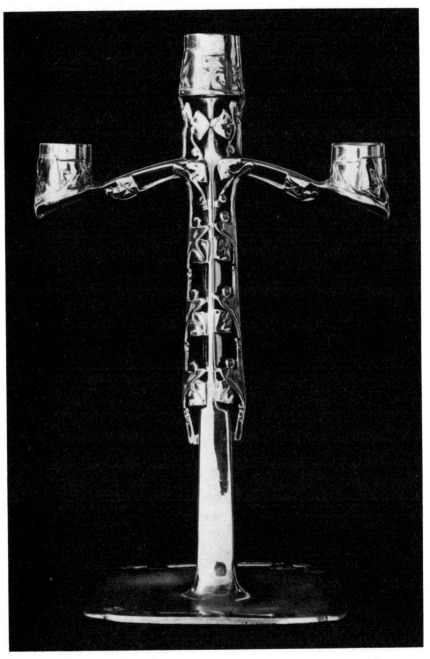

Fig. No. 80. Tudric pewter candlestick designed by Knox, the central cup is a Liberty adaption. Private Collection London.

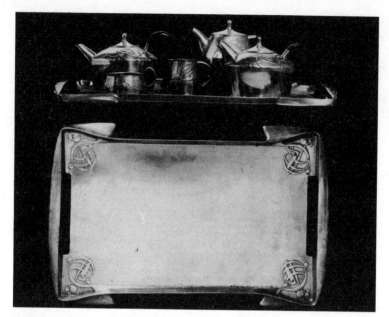

Fig. No. 81. A Tudric pewter tea service designed by Knox circa 1903. Private Collection London.

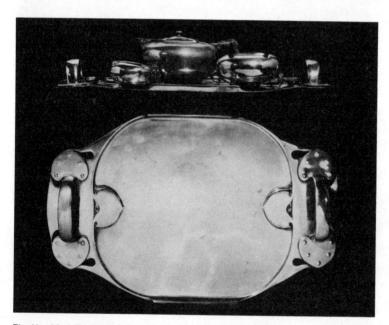

Fig. No. 82. A Tudric pewter tea service probably an early Knox design. Private Collection London.

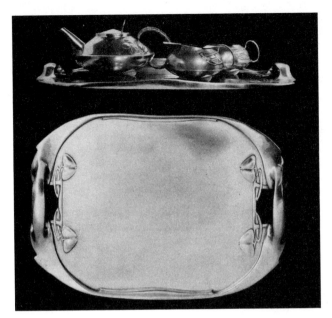

Fig. No. 83. A Tudric pewter tea service designed by Knox circa 1901.

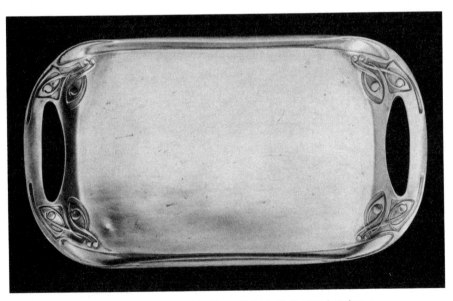

Fig. No. 84. Tudric pewter tray designed by Knox. Private Collection London.

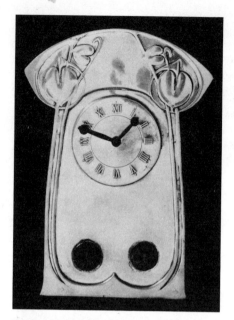

Fig. No. 85. Tudric pewter clock. Private
Collection London.

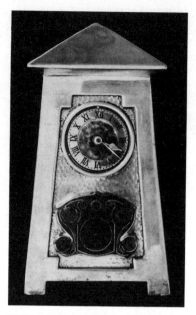

Fig. No. 86. Tudric pewter "architectural"
clock. Private Collection London.

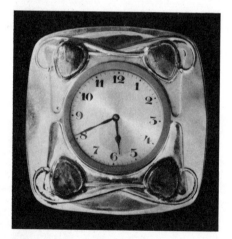

Fig. No. 87. Tudric pewter desk clock.
Private Collection London.

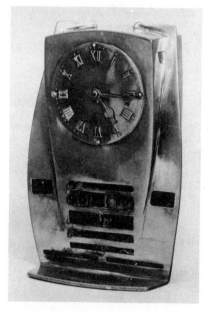

Fig. No. 88. Tudric pewter clock designed by
Knox circa 1902. Collection Dan Klein.

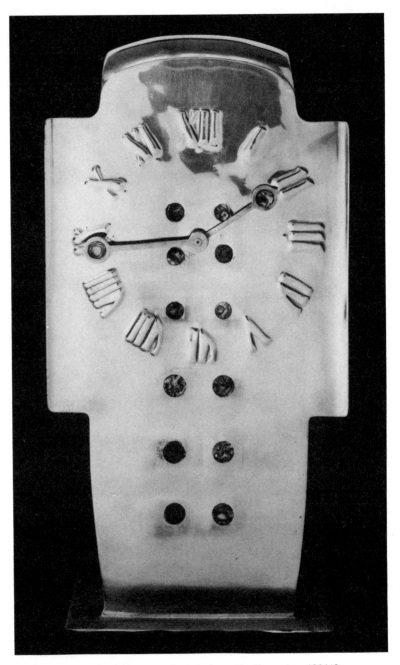

Fig. No. 89. Large Tudric pewter clock designed by Knox circa 1901/2.
Private Collection London.

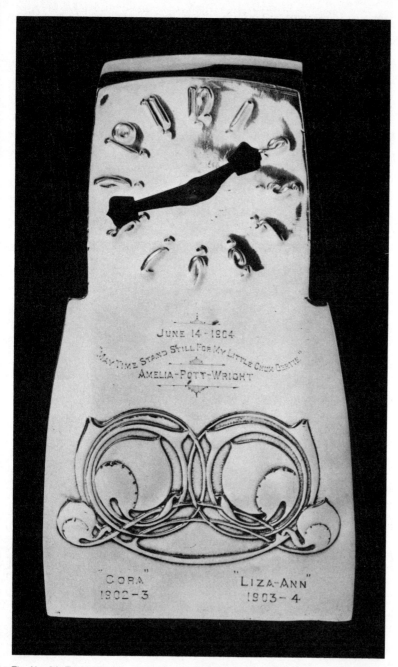

Fig. No. 90. Tudric Pewter clock designed by Knox circa 1902. Private Collection London.

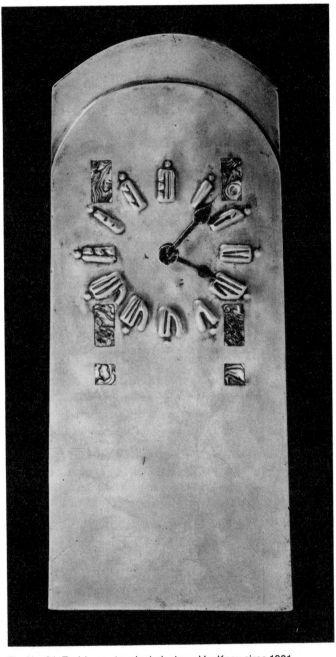

Fig. No. 91. Tudric pewter clock designed by Knox circa 1901. Private Collection London.

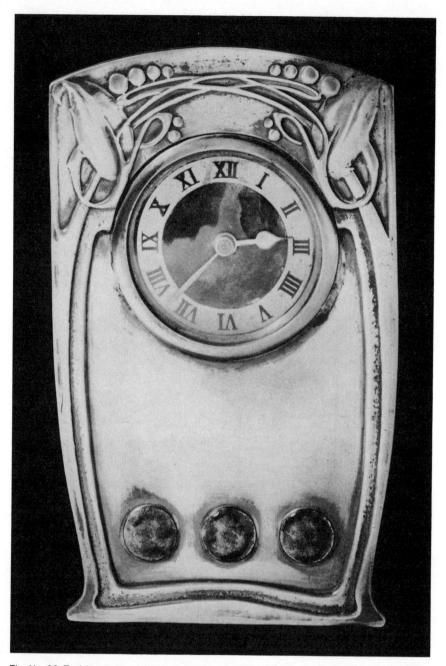

Fig. No. 92. Tudric pewter clock, an adaption of a Knox design. Private Collection London.

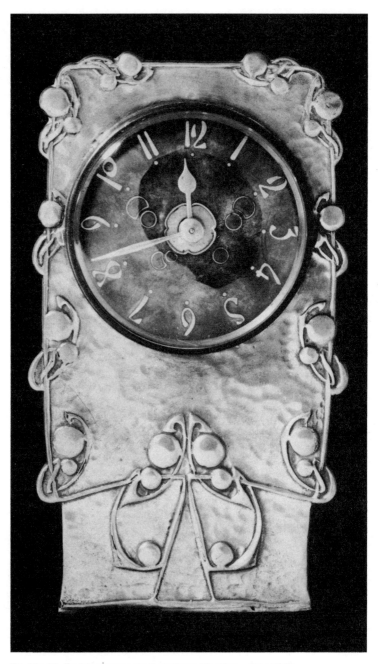

Fig. No. 93. Tudric pewter clock designed by Knox circa 1903.
Private Collection London.

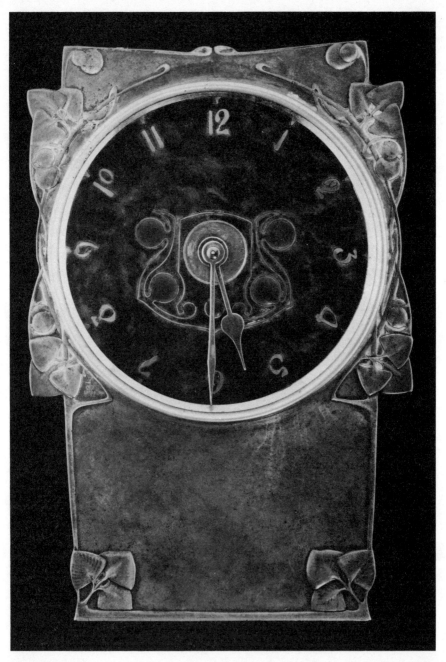

Fig. No. 94. Large pewter clock with enamelled dial, designed by Knox circa 1903. Collection Sally Dennis.

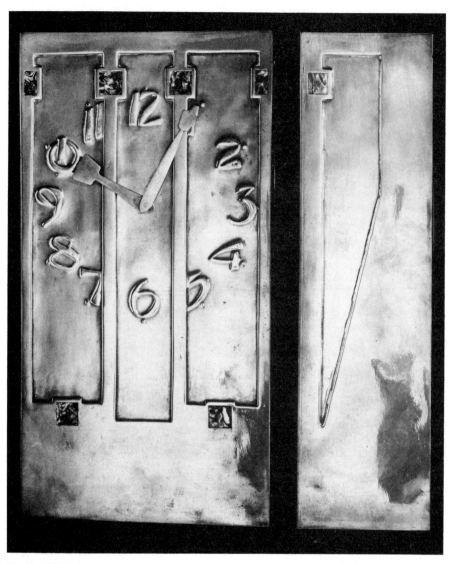

Fig. No. 95. Tudric pewter clock designed by Knox circa 1903. Private Collection London.

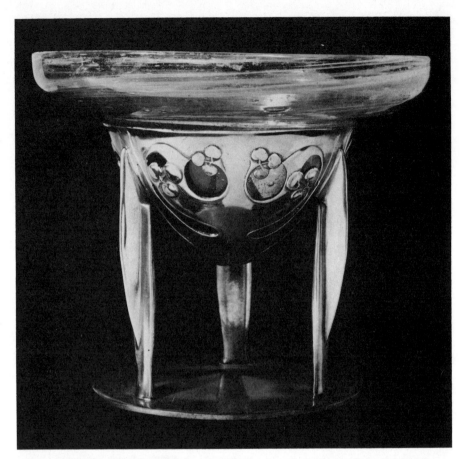

Fig. No. 96. Tudric pewter fruit bowl, having a Clutha glass liner. Private Collection London.

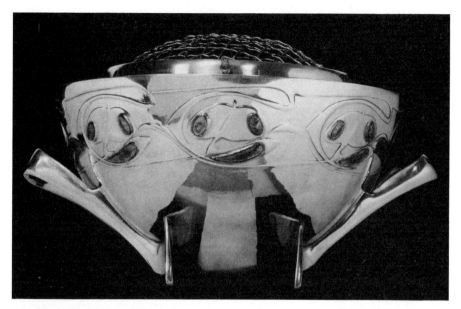

Fig. No. 97. Tudric pewter rosebowl. Though Rex Silver claimed the design to be his, the structural elements incorporated in the handles/feet combined with ever present idiosyncratic decoration suggests that this was in fact of Knox origination, circa 1901. Private Collection London.

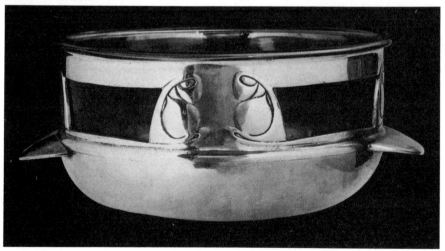

Fig. No. 98. Tudric pewter rosebowl designed by Knox circa 1902. The green glass liner was produced by James Powell & Son. Private Collection London.

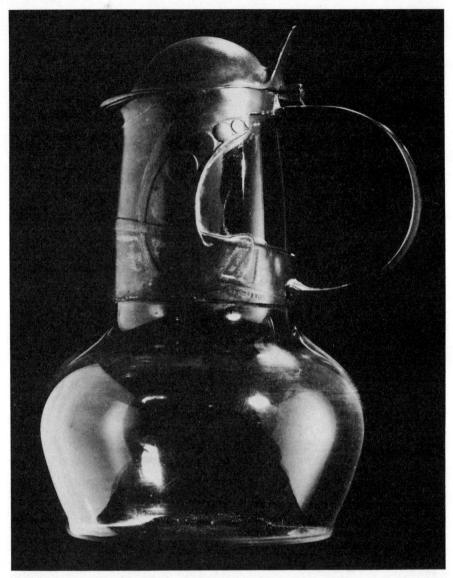

Fig. No. 99. Tudric pewter decanter having a green glass liner by James Powell, designed by Knox circa 1903/4. Private Collection London.

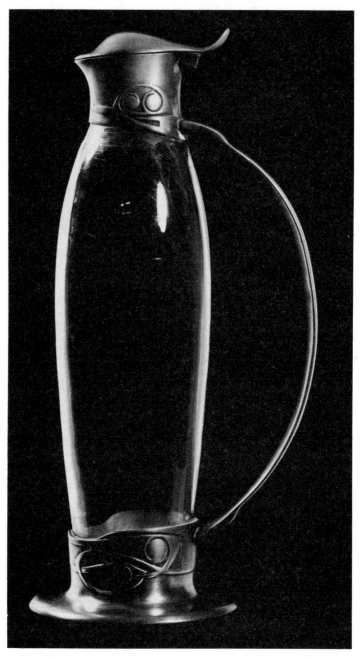

Fig. No. 100. Tudric pewter and Powell glass decanter designed by knox circa 1903. Private Collection London.

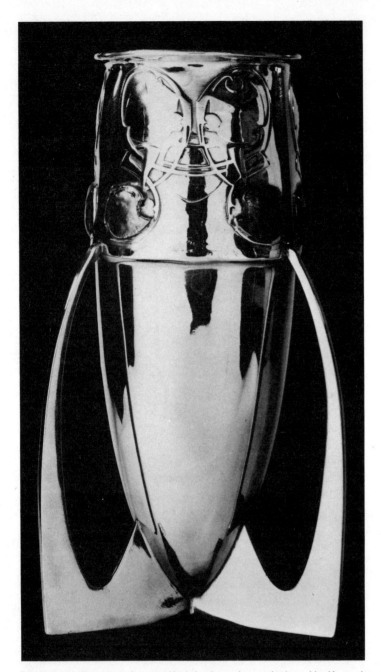

Fig. No. 101. Pewter and enamel bomb-shaped vase designed by Knox circa 1902. A variation on the above had oak leaves as decoration and was designed by Oliver Baker. Private collection London.

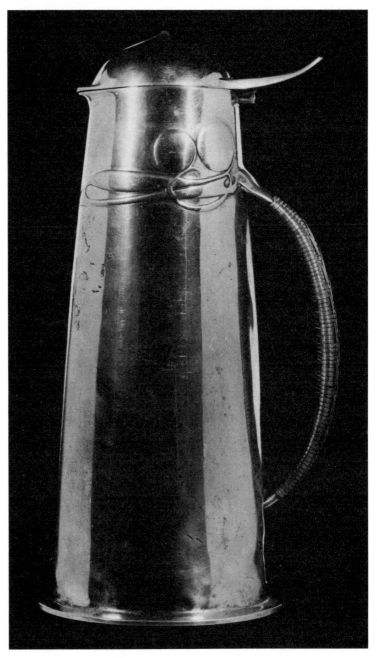

Fig. No. 102. Large Tudric pewter flagon designed by Knox circa 1902.
Private Collection London.

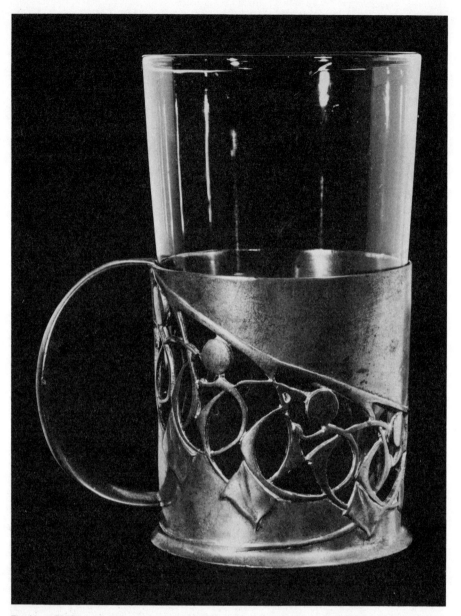

Fig. No. 103. Tudric pewter hot milk holder having a green glass liner made by James Powell and Sons. Probably designed by Knox circa 1901.

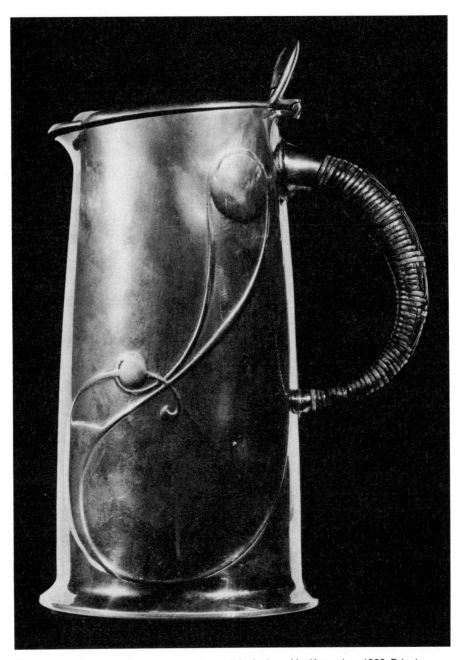

Fig. No. 104. Tudric pewter hot water jug possibly designed by Knox circa 1903. Private Collection London.

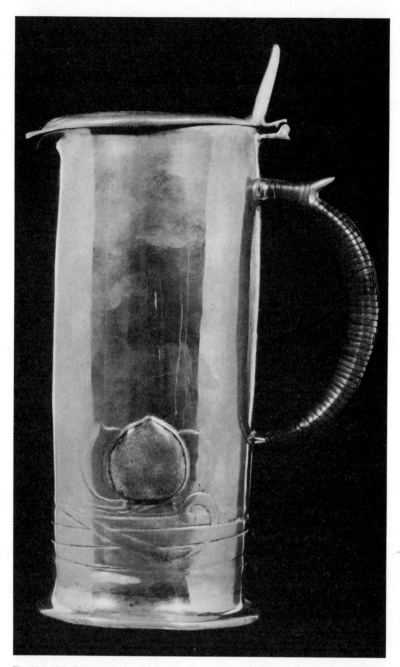

Fig. No. 105. Tudric pewter jug possibly designed by Knox circa 1902/3. Private Collection London.

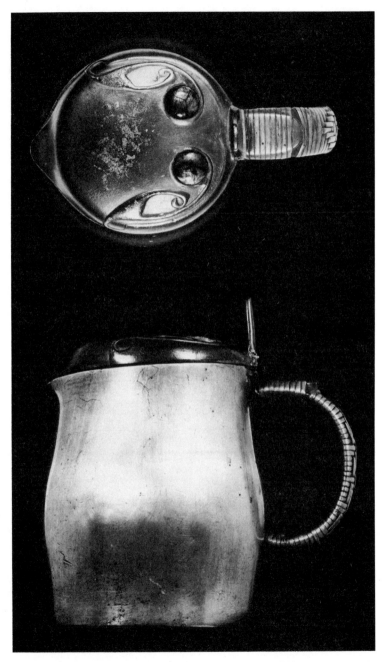

Fig. No. 106. Squat Tudric pewter jug designed by Knox 1902.
Private Collection London.

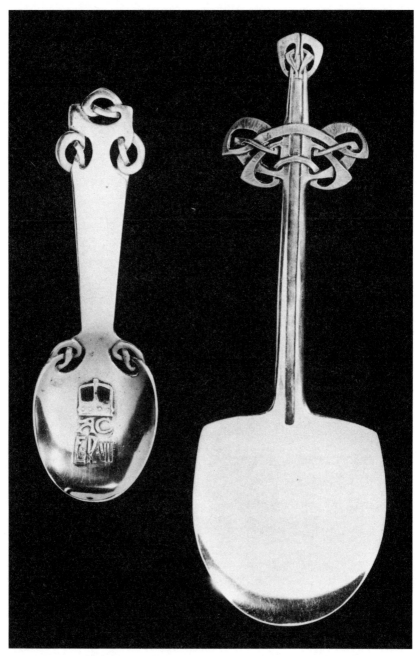

Fig. No. 107 *(left).* Silver Coronation Spoon designed by Knox circa 1901/2
(right) Large Silver cake Slice designed by Knox circa 1902. Private Collection London.

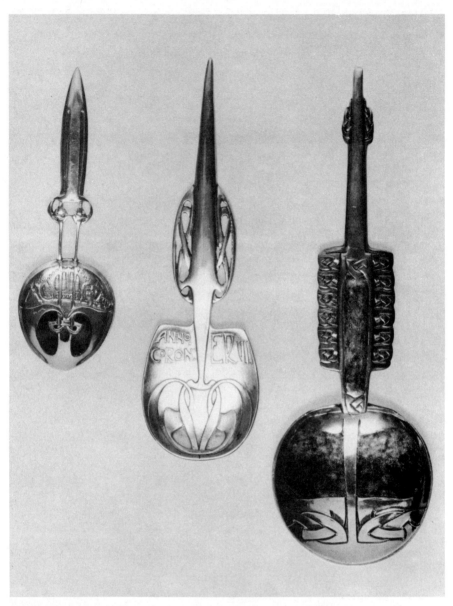

Fig. No. 108. Three differing designs for Coronation spoons, all by Knox circa 1901/2.
Collection John Jesse.

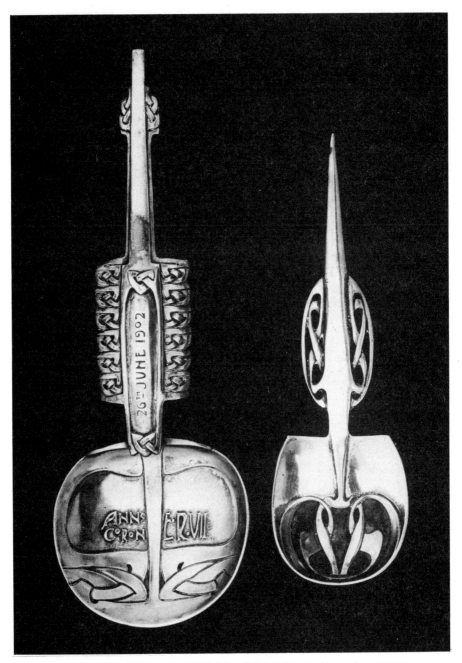

Fig. No. 109. Variations on Silver Coronation Spoons designed by Knox circa 1901/2.
Private Collection London.

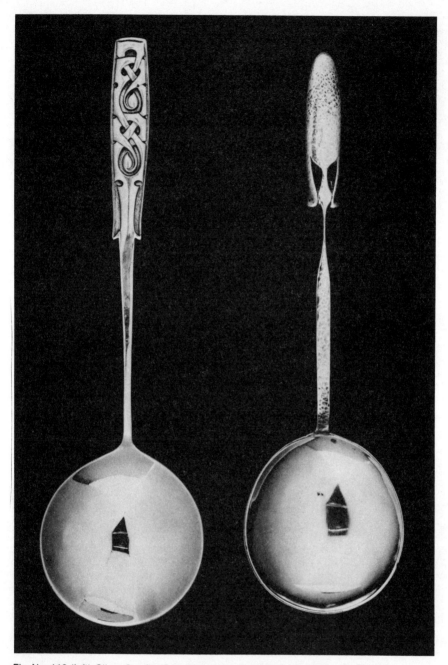

Fig. No. 110 *(left).* Silver Serving Spoon designed by Knox circa 1899. *(right)* Silver Serving Spoon designed by Knox circa 1899. Private Collection London.

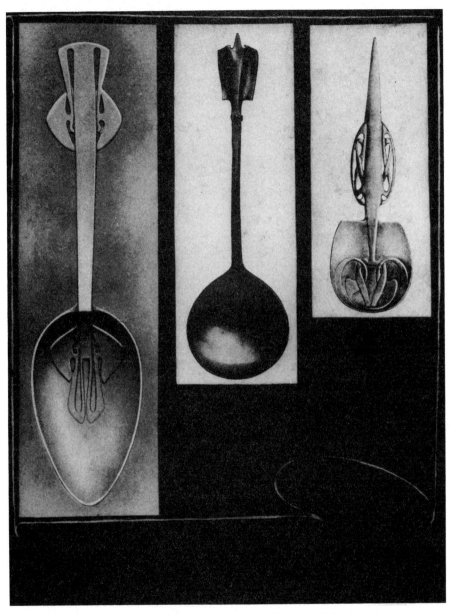

Fig. No. 111. Three silver spoons, the one on the far right was adapted to become a Coronation spoon. Reproduced courtesy Manx Museum.

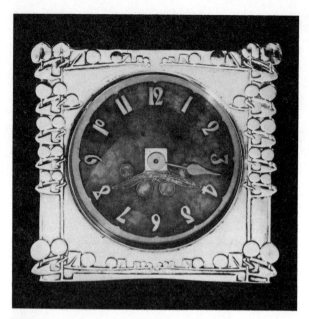

Fig. No. 112. Silver and enamel clock designed by Knox circa 1902/3. Collection Joan Collins.

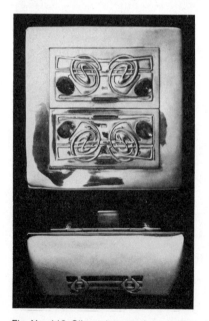

Fig. No. 113. Silver cigarette box designed by Knox circa 1903/4. Private collection London.

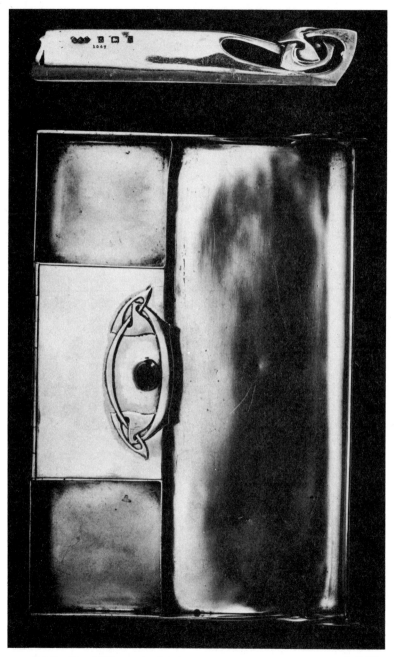

Fig. No. 114. Plan and side view of a silver inkstand designed by Knox circa 1904. Private Collection London.

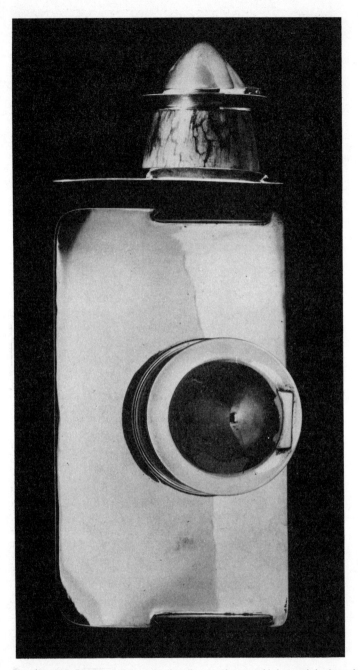

Fig. No. 115. Plan and side view of a silver and enamel inkstand designed by Knox circa 1903. Private Collection London.

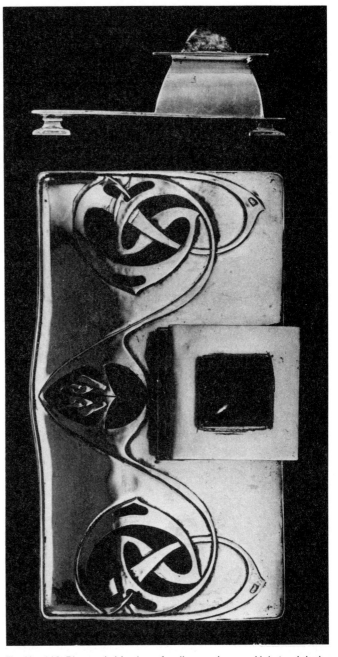

Fig. No. 116. Plan and side view of a silver and enamel inkstand designed by Knox circa 1902. Private Collection London.

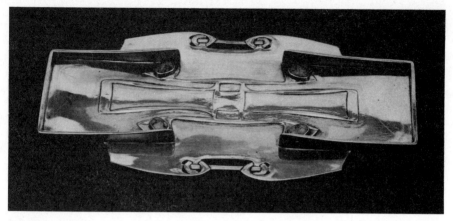

Fig. No. 117. Silver pen tray designed by Knox circa 1904/6. Collection E. Scott-Cooper, Esq.

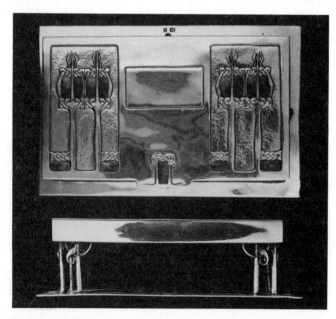

Fig. No. 118. Silver and enamel cigarette box designed by Rex Silver. Collection Joan Collins.

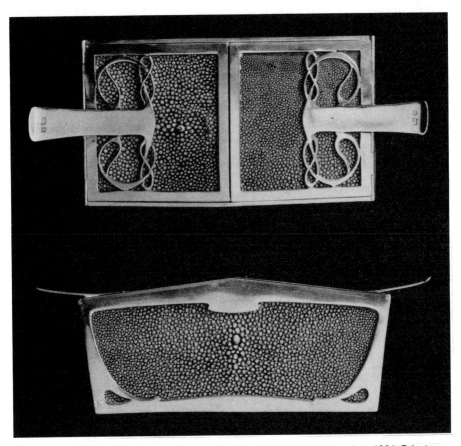

Fig. No. 119. Silver mounted shagreen cigarette box designed by Knox circa 1901. Private collection, London.

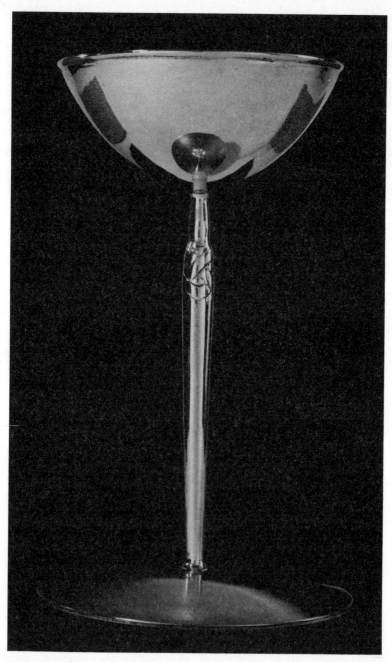

Fig. No. 120. Silver chalice designed by Knox circa 1902/3. Private Collection London.

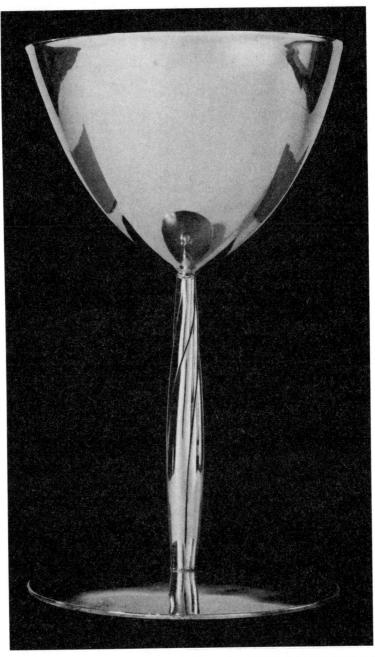

Fig. No. 121. Silver chalice designed by Knox circa 1902/3. Private Collection London.

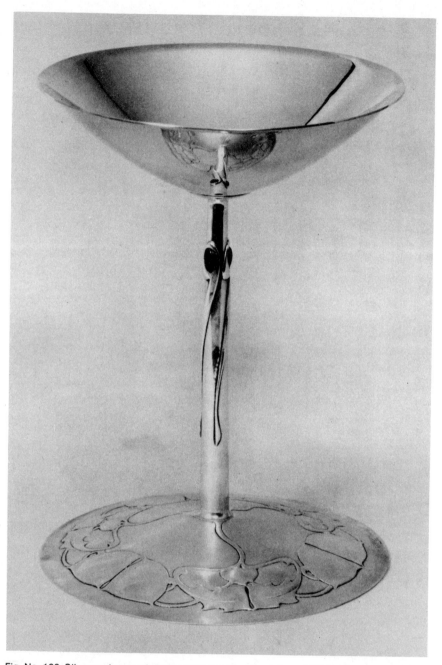

Fig. No. 122. Silver and enamel chalice designed by Knox circa 1902. Private collection, London.

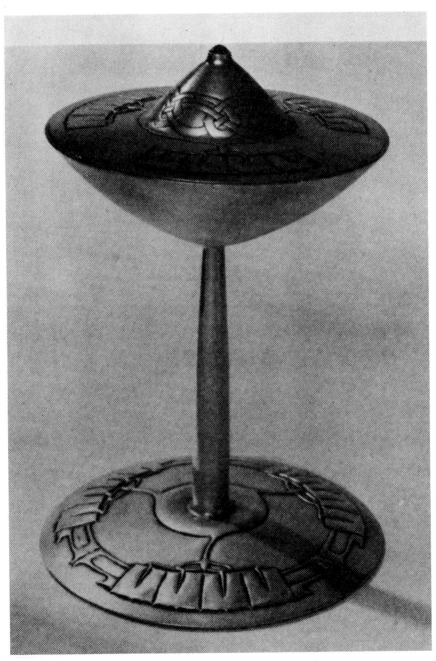

Fig. No. 123. Silver cup and cover designed by Knox circa 1900. Collection Charles Jerilein.

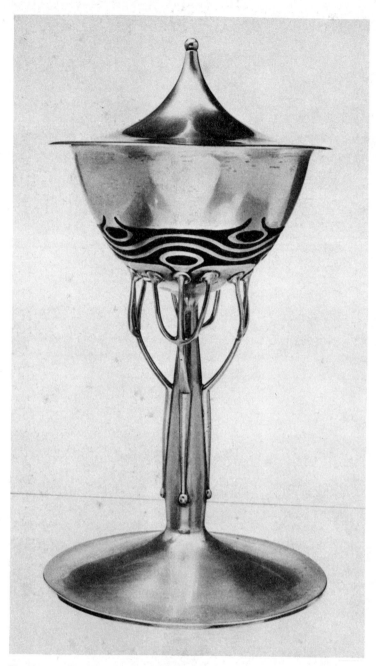

Fig. No. 124. Silver chalice designed by Knox circa 1900. Private collection, London.

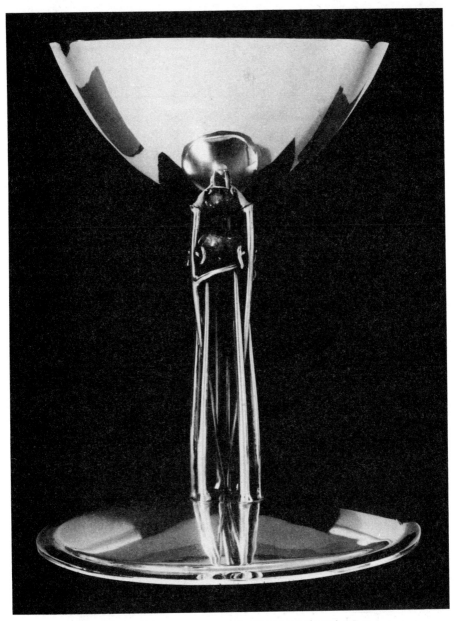

Fig. No. 125. Silver chalice, designed by Knox circa 1903. Private Collection London.

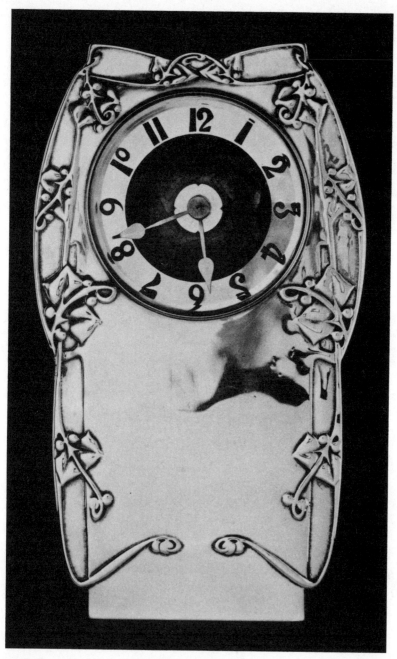

Fig. No. 126. Silver and enamel clock possibly designed by Knox. Private Collection London.

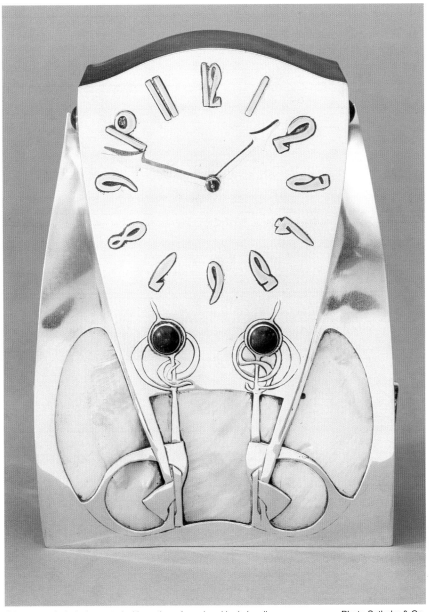

Silver mantel clock decorated with mother of pearl and lapiz lazuli. Photo Sotheby & Co.

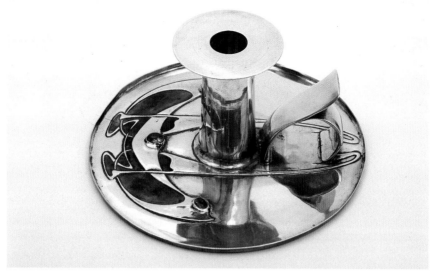

Cymric silver chamber stick, the enamel decoration set with an opal. Photo Sotheby & Co.

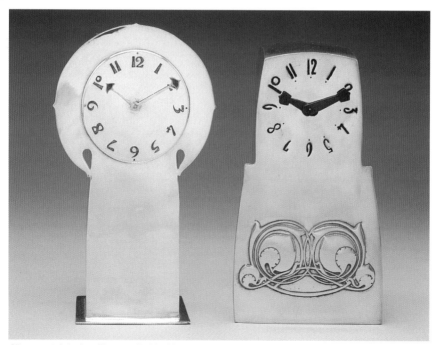

Silver mantel clocks with enamelled Arabic numerals. Photo Sotheby & Co.

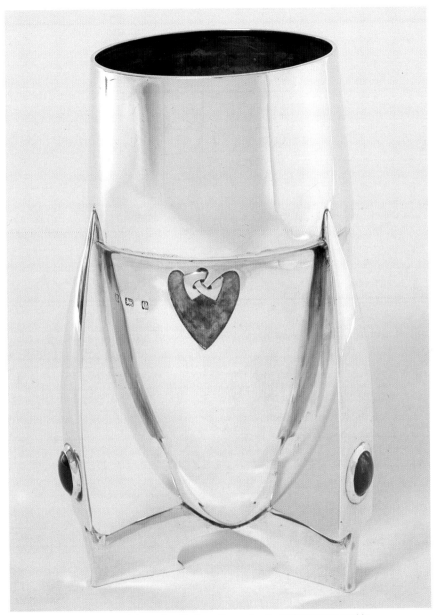

Large silver vase with enamel decoration, the three fins each set with Connemara marble.

Photo Sotheby & Co.

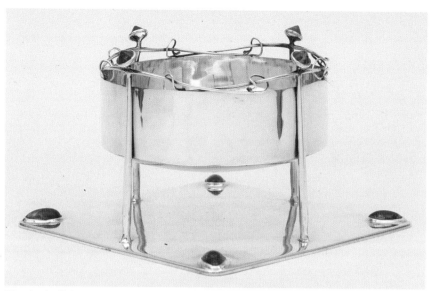

Silver bowl with three-dimensional entrelac decoration supported on four legs.
The whole set with lapiz lazuli.

Photo Sotheby & Co.

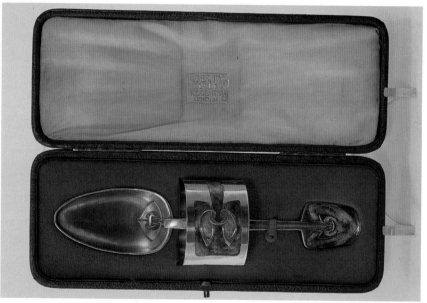

Christening set, the enamelled spoon and serviette ring contained within original box.

Photo Sotheby & Co.

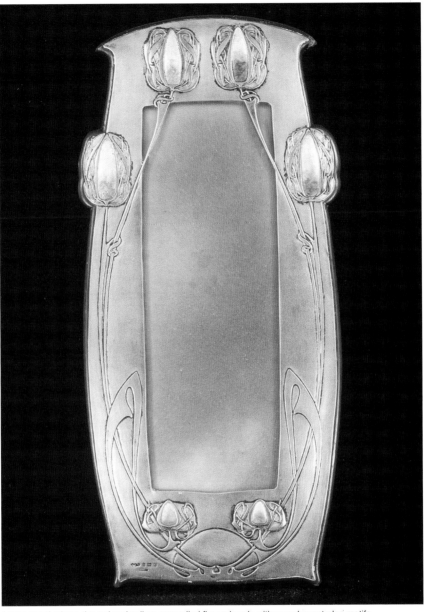

Large easel-mirror, the red and yellow enamelled flower heads with complex entrelac motifs.
Photo Virginia Museum of Fine Arts
Sydney Francis Lewis collection

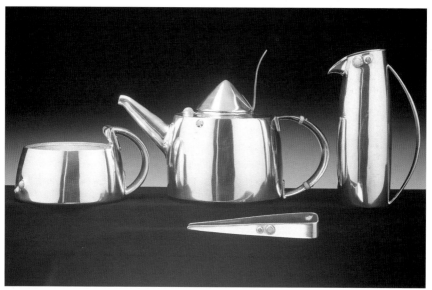

Silver four piece tea-service, each piece set with pairs of fire opals. Photo Sotheby & Co.

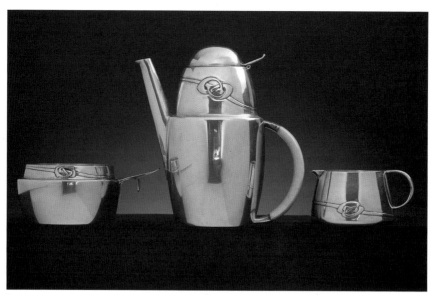

Silver three piece coffee-service decorated with entrelac motifs. The coffee pot with bone handle.
Photo Sotheby & Co.

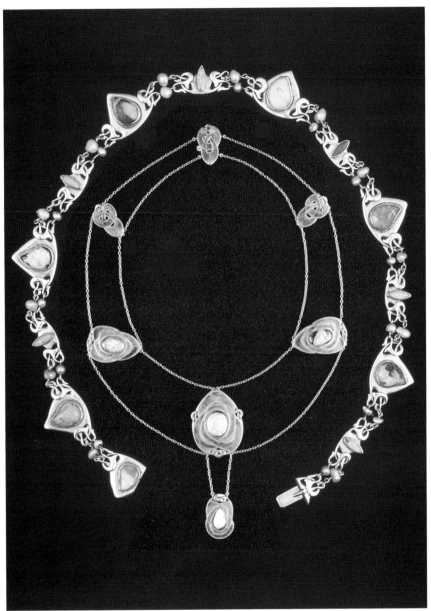

Outer:- Gold necklace set with opals and pearls.
Inner:- Gold necklace with enamel entrelacs set with opals.

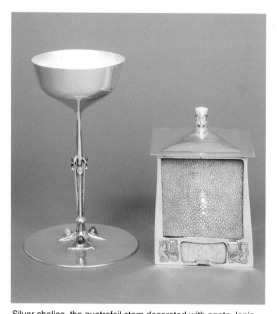

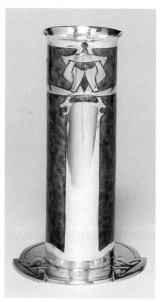

Silver chalice, the quatrefoil stem decorated with agate, lapiz lazuli and Connemara marble.
Silver mounted shagreen box and cover, the entrelacs decorated with Connemara marble.　　Photo Sotheby & Co.

Cylindrical flower vase copiously decorated with red, green and blue enamel.　　Photo Sotheby & Co.

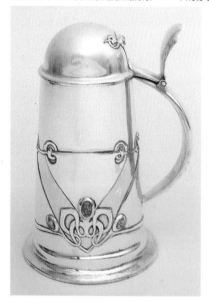

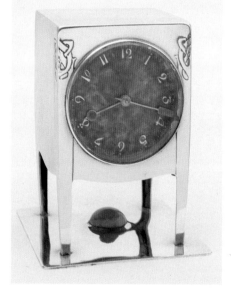

Large inverted trumpet shaped silver tankard, the entrelac motifs set with turquoise matrix.
　　Photo Sotheby & Co.

Small silver carriage clock, the enamelled face with Arabic numerals. the base set with a turquoise matrix.　　Photo Sotheby & Co.

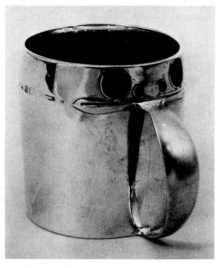

Fig. No. 127. Silver mug dated 1904 designed by Knox. Collection John Jesse.

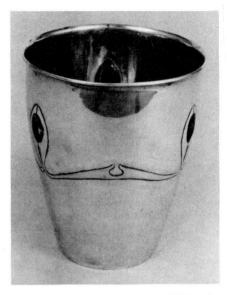

Fig. No. 128. Silver beaker or vase, designed by Knox circa 1902. Collection John Jesse.

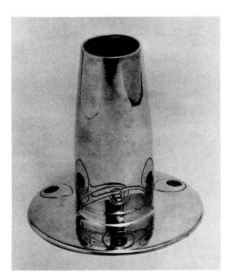

Fig. No. 129. Silver vase designed by Knox circa 1902. Private Collection, London.

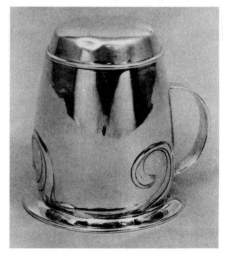

Fig. No. 130. Silver tankard and cover, after a Knox design. Collection John Jesse.

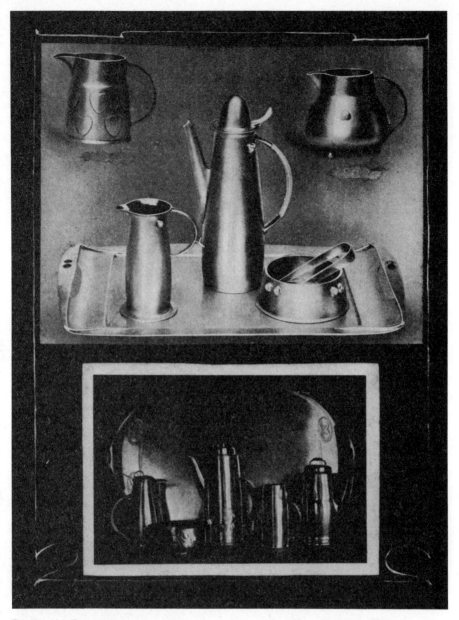

Fig. No. 131. Two photographs of silver tea services attributable to Knox circa 1903-4. Reproduced courtesy Manx Museum.

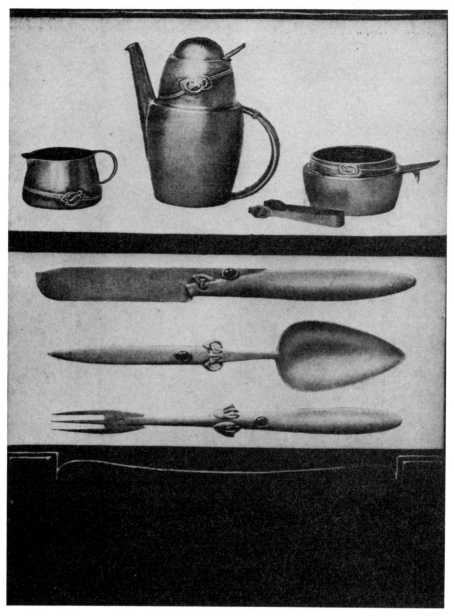

Fig. No. 132 (*top*). Silver three piece tea service designed by Knox. (*bottom*) Silver knife, fork and spoon designed by Knox. Photograph courtesy the Manx Museum.

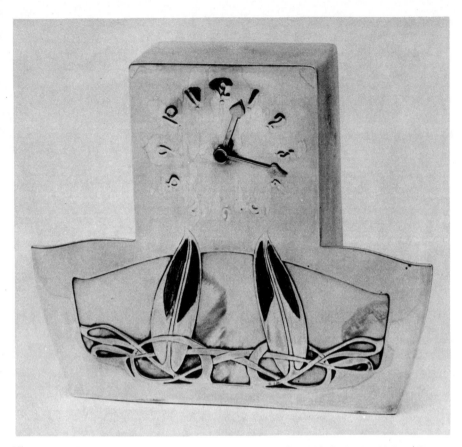

Fig. No. 133. Silver and enamel clock designed by Knox circa 1903. Collection Holland R. Melson Jr. New York City.

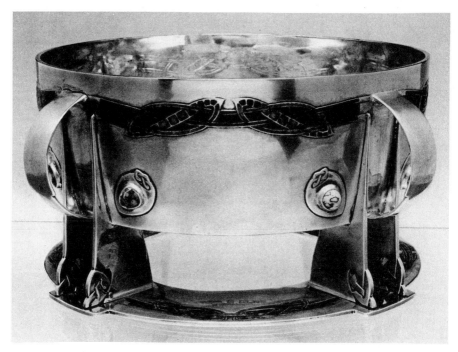

Fig. No. 134. Large silver rosebowl designed by Knox circa 1903. Private Collection London.

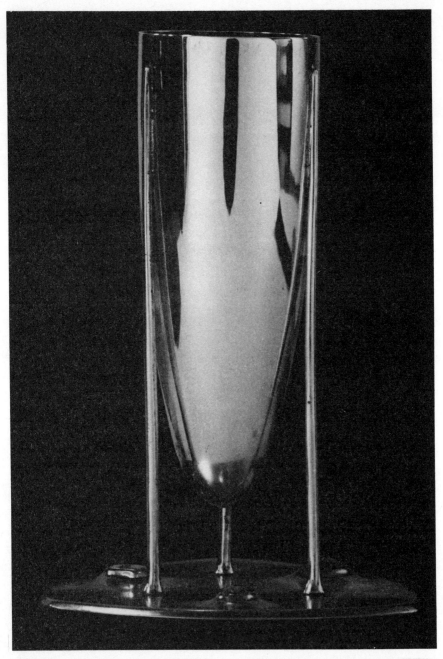

Fig. No. 135. Cone-shaped silver vase supported on three vertical legs designed by Knox circa 1901/2. Private collection, London.

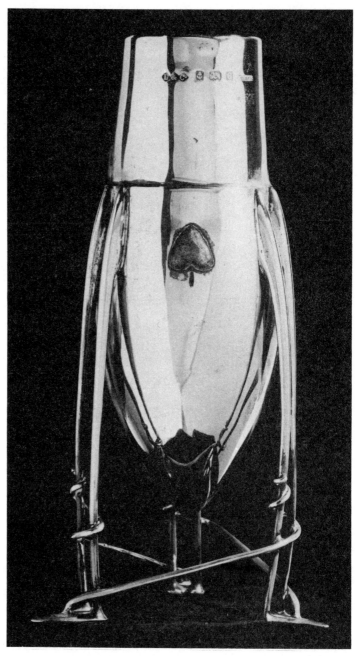

Fig. No. 136. Silver flower vase supported on three stilt-like legs.
Designed by Knox circa 1902. Private Collection London.

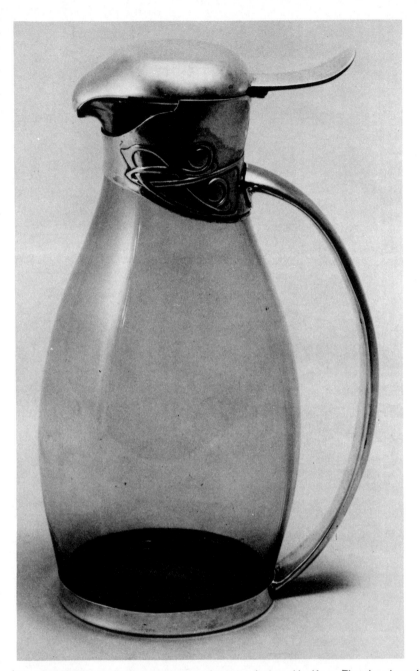

Fig. No. 137. Silver mounted green glass decanter designed by Knox. The glass is probably Whitefriars. Victoria and Albert Museum.

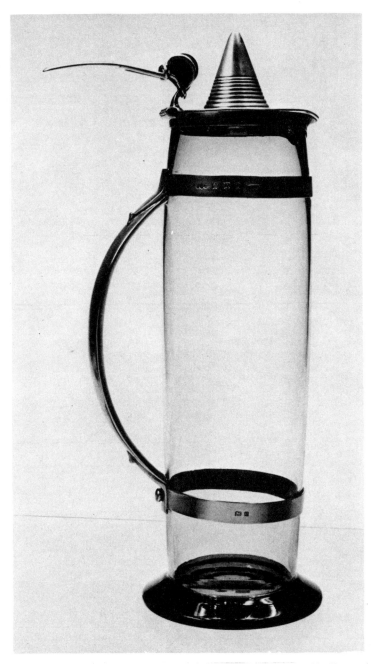

Fig. No. 138. Tall silver mounted green glass claret jug, designed by Knox. Private Collection, London.

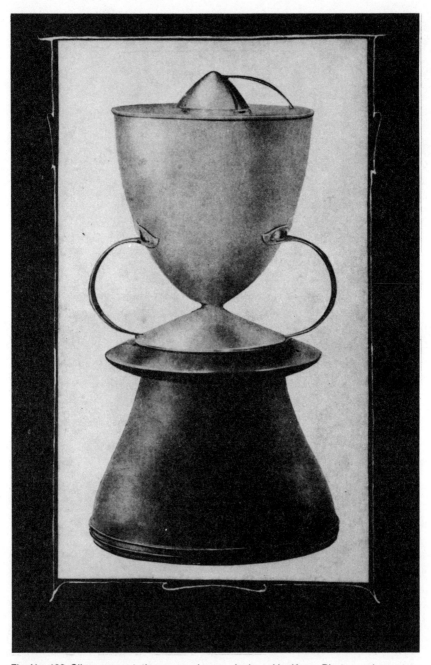

Fig. No. 139. Silver presentation cup and cover designed by Knox. Photograph courtesy Manx Museum.

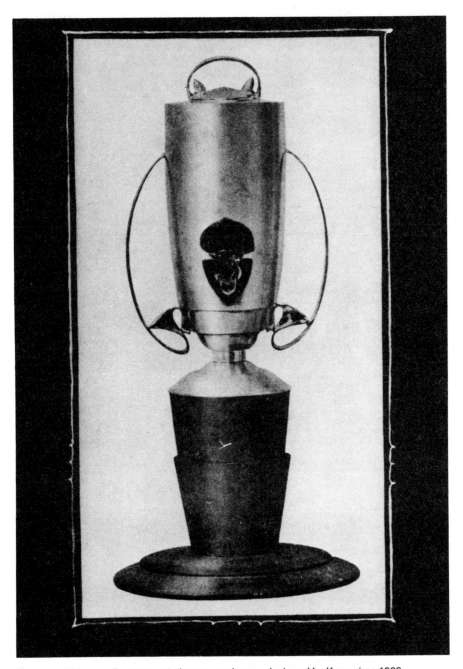

Fig. No. 140. Large silver presentation cup and cover designed by Knox circa 1903.
Reproduced courtesy the Manx Museum.

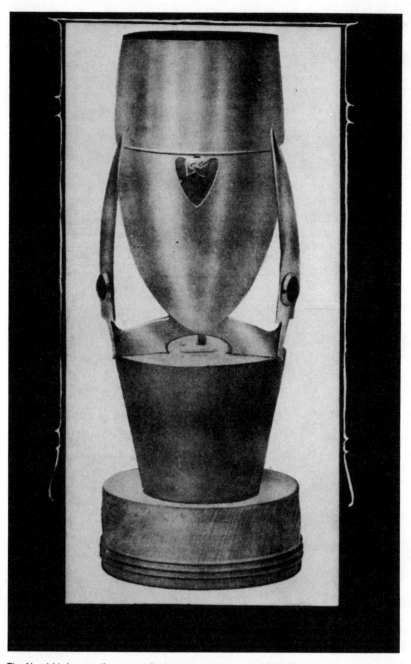

Fig. No. 141. Large silver vase designed by Knox circa 1902. Photograph courtesy of the Manx Museum.

154

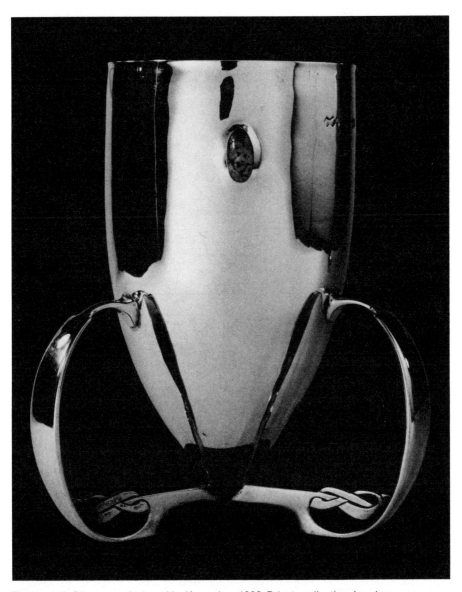

Fig. No. 142. Silver vase designed by Knox circa 1902. Private collection, London.

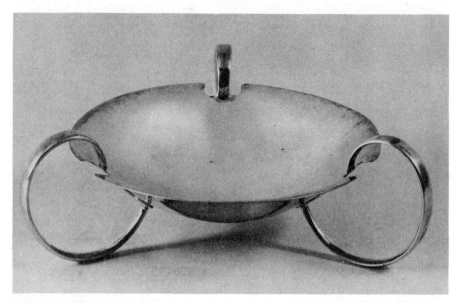

Fig. No. 143. Silver bowl designed by Knox circa 1900. Private collection, London.

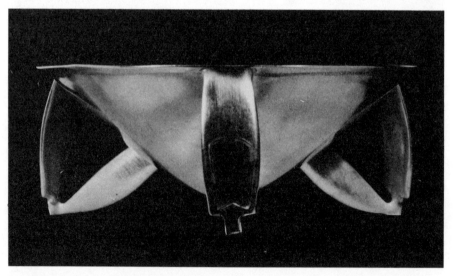

Fig. No. 144. Silver cone-shaped circular dish supported on three spurs designed by Knox circa 1903. Private Collection, London

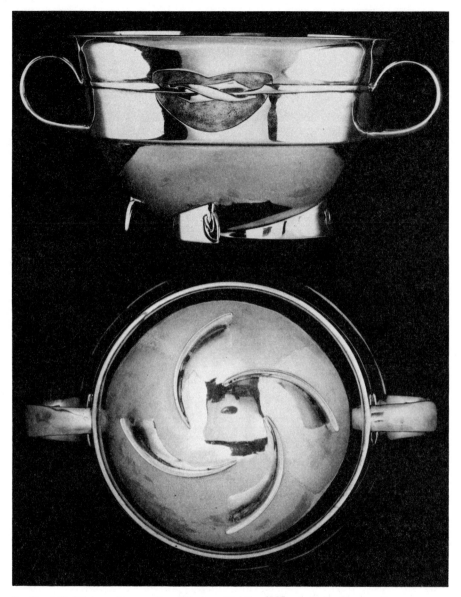

Fig. No. 145. Silver and enamel bowl designed by Knox. Private Collection London.

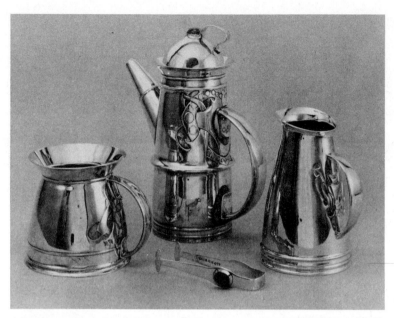

Fig. No. 146. Silver three piece tea service, probably an early design by Knox. Collection John Jesse.

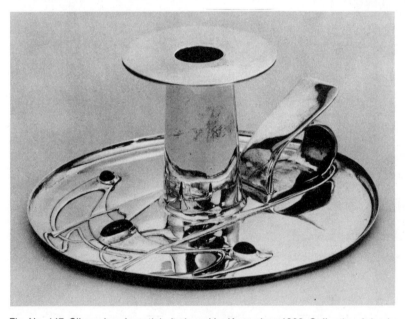

Fig. No. 147. Silver chamber stick designed by Knox circa 1903. Collection John Jesse.

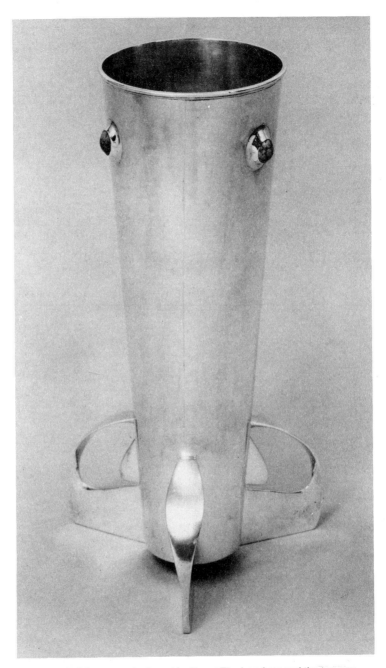

Fig. No. 148. Silver vase designed by Knox. The band around the top was
obviously a requirement of manufacture, and looks out of place.
Christopher Dresser was employing this feature to advantage as early as
1870s. Collection John Jesse.

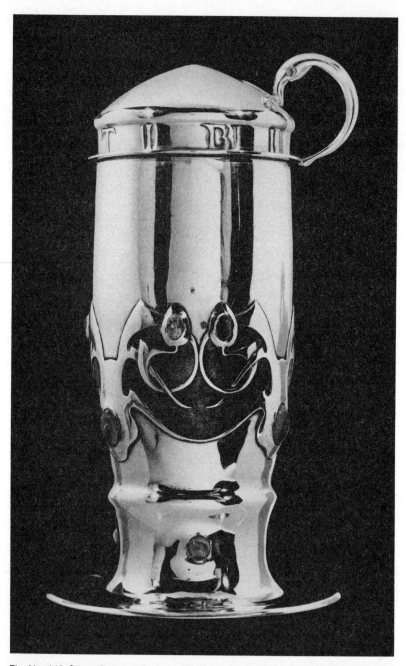

Fig. No. 149. Silver Cup and Cover designed by Knox 1902/3. The cover chased with the motto, 'Long Life to Thee' (TIBI VITAM) Ex. Celtic Art, Grafton Gallery, 1903. Private Collection London.

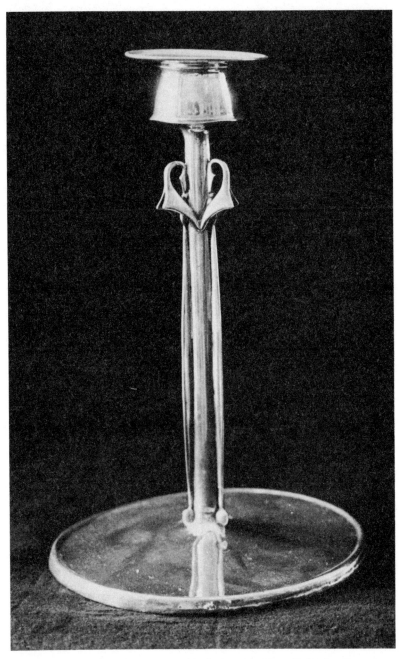

Fig. No. 150. Silver candlestick, probably designed by Knox. Collection Dr. and Mrs. K. Smith.

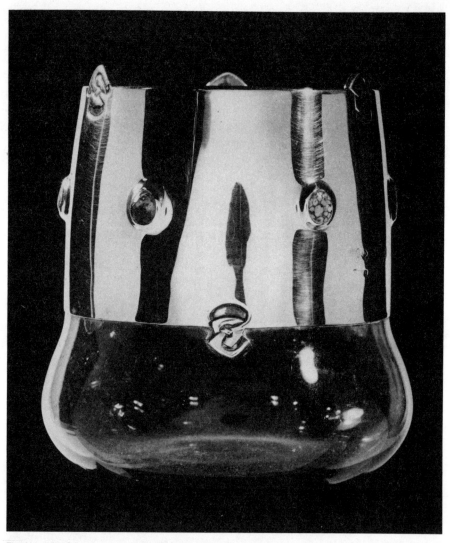

Fig. No. 151. Silver mounted green glass vase dated 1903, designed by Knox. The glass is probably Whitefriars. Collection Mrs. Joan Collins.

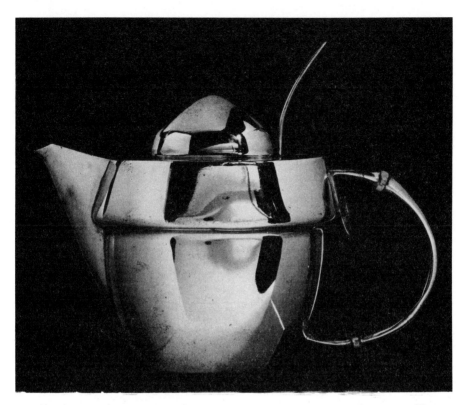

Fig. No. 152. Silver Teapot having cabochon opal set under the handle. Designed by Knox circa 1904. Private Collection London.

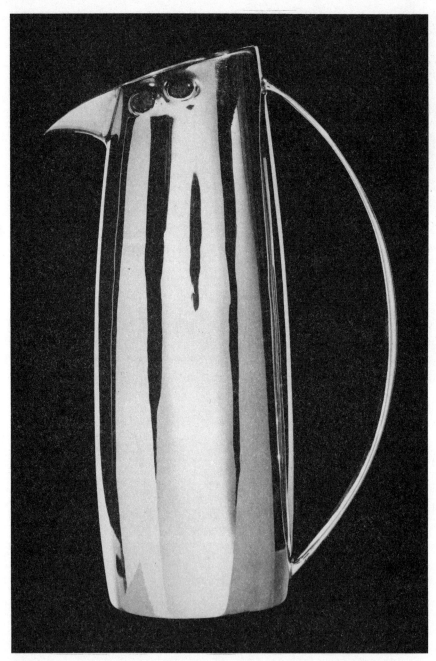

Fig. No. 153. Silver milk jug probably designed by Knox circa 1903. Private collection, London.

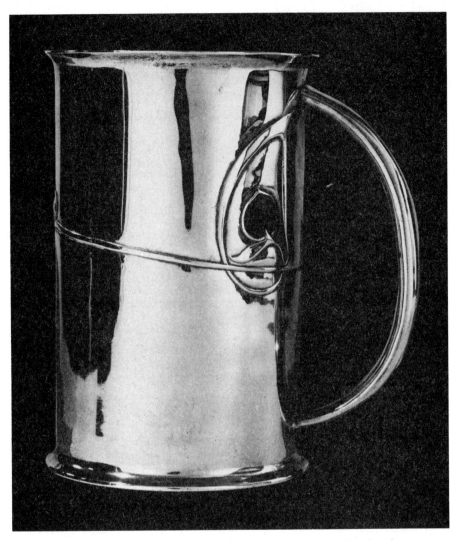

Fig. No. 154. Silver tankard designed by Knox circa 1902. Private collection, London.

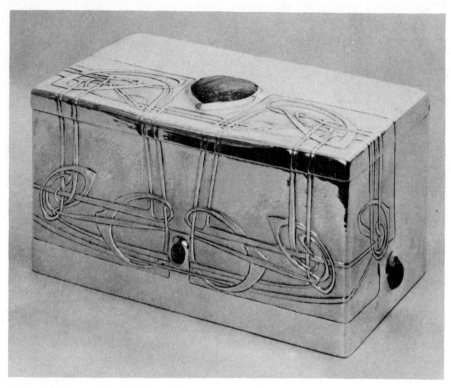

Fig. No. 155. Large silver cigar box designed by Knox for Arthur Lasenby Liberty. Victoria and Albert Museum.

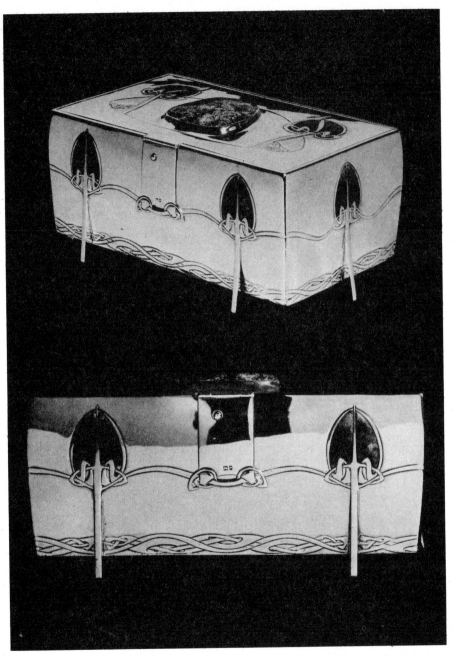

Fig. No. 156. Silver and enamel cigar box possibly designed by Knox. Private collection London.

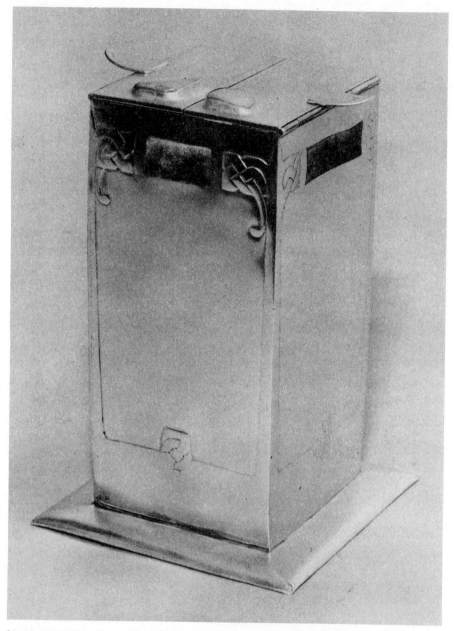

Fig. No. 157. Silver biscuit box designed by Knox circa 1903. Charles and Lavinia Handley-Read Bequest. Reproduced courtesy the Victoria and Albert Museum.

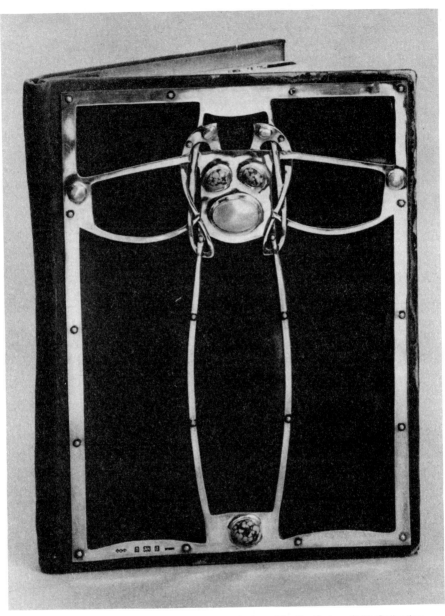

Fig. No. 158. Silver mounted desk blotting book, designed by Knox circa 1902. Collection E. Scott-Cooper.

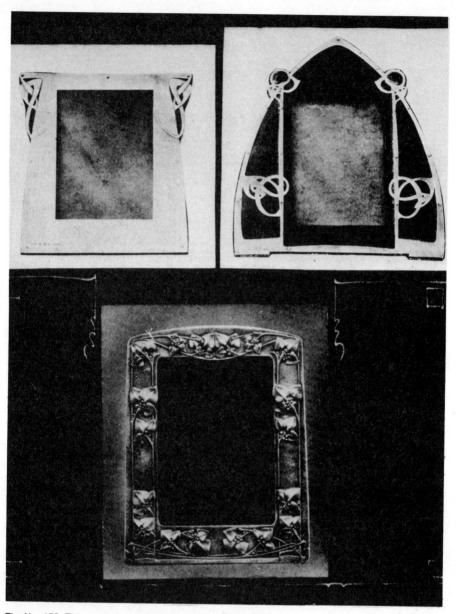

Fig. No. 159. Three photograph frames designed by Knox.

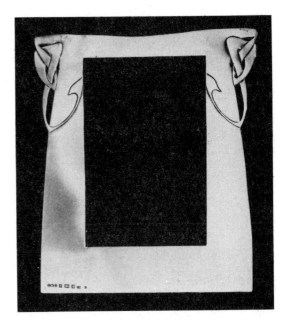

Fig. No. 160. Silver photograph frame designed by Knox circa 1900. Collection Joan Collins.

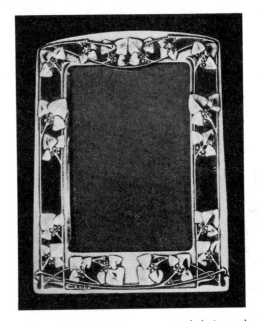

Fig. No. 161. Silver and green enamel photograph frame probably designed by Knox. Collection Joan Collins.

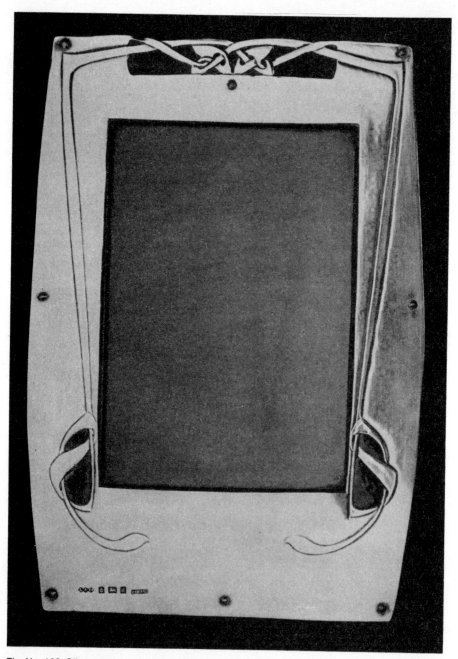

Fig. No. 162. Silver photograph frame designed by Knox, circa 1902/3. Private collection, London.

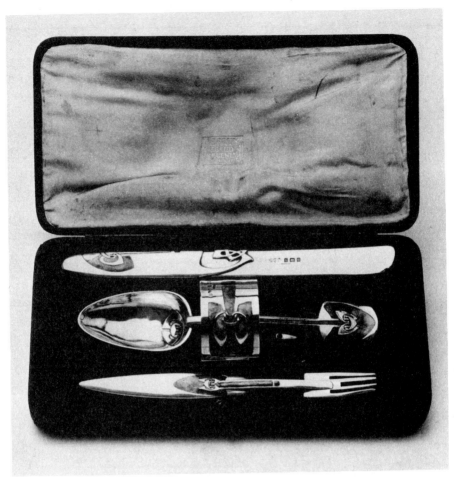

Fig. No. 163. Silver Knife, Fork, Spoon and Napkin Ring designed by Knox circa 1903. Collection J. V. Webb.

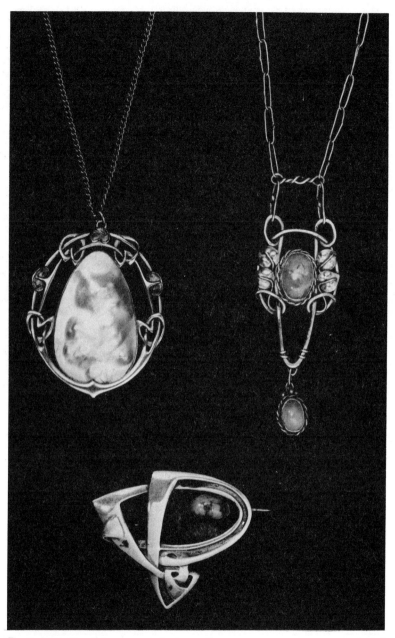

Fig. No. 164. *Top right.* Unmarked silver and agate pendant, showing a simplified use of entrelac motifs.

Fig. No. 164. *Bottom.* Continental silver brooch, showing the influence of the Celtic Revival. This piece is possibly Patriz Huber of Pforzhiem.

Fig. No. 164. *Top left.* Unmarked gold, enamel and mother of pearl pendant designed by Knox.

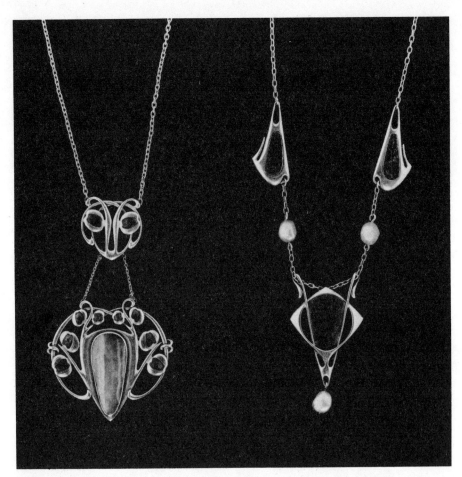

Fig. No. 165 (*left*). Gold pendant, having green enamel, and mother of pearl. Designed by Knox 1903/4.

Fig. No. 165 (*right*). Gold pendant, having enamel and being set with blister pearls. Probably a Murrle Bennett adaption of a Liberty design. Both collection Sally Dennis.

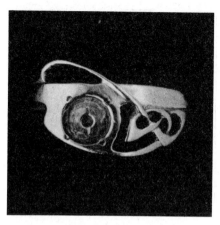

Fig. No. 166. Gold ring designed by Knox circa 1903/4. Collection Sally Dennis.

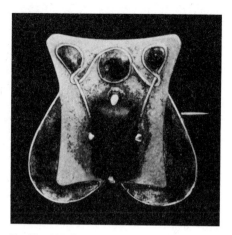

Fig. No. 167. Silver and enamel brooch being set with a carved malachite stone. Private Collection London.

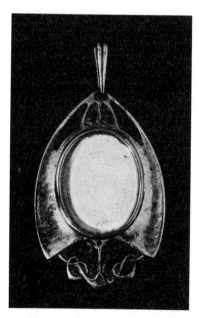

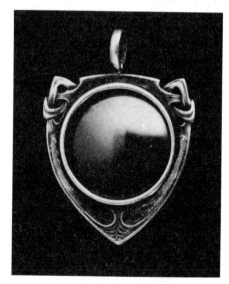

Fig. No. 169. Silver and enamel locket possibly designed by Knox. Private Collection London.

Fig. No. 168. Silver pendant produced by W. H. Haseler, almost certainly a copy of a Liberty design. Collection Rhys Morgan.

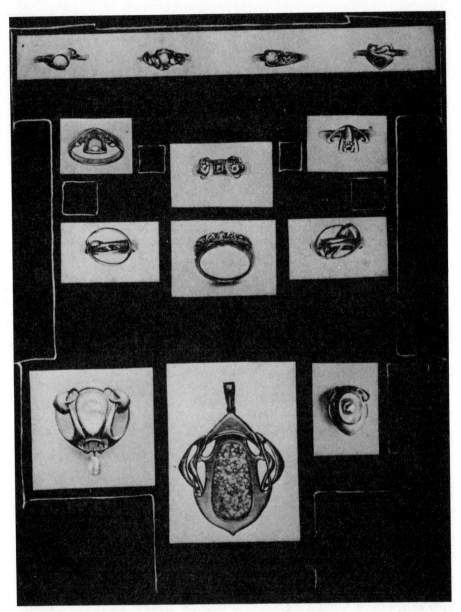

Fig. No. 170. Photograph removed from Knox's studio on his death. All the items of jewellery are therefore attributed to him. Photograph courtesy Manx Museum.

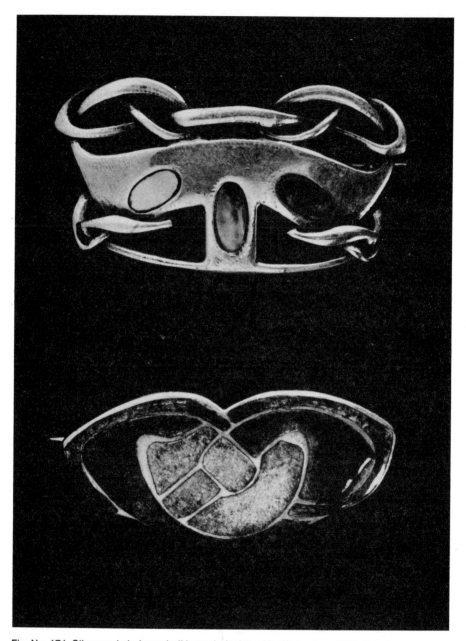

Fig. No. 171. Silver and abalony shell brooch designed by Knox circa 1903. Private
Collection London.

Fig. No. 171. Silver and enamel brooch designed by Knox circa 1902/3. Private Collection
London.

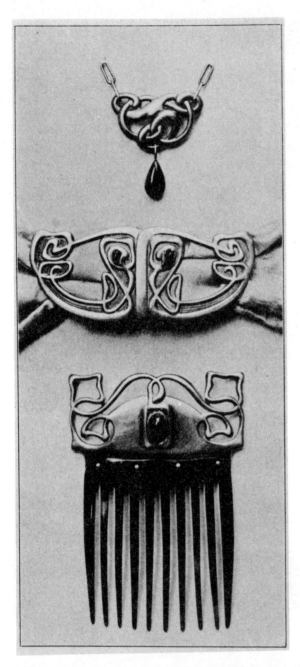

Fig. No. 172. Silver buckle produced by a Dresden jeweller showing the influence that the Celtic revival had on certain continental designs. In Pforzheim where it is believed Murrle Bennett jewellery was produced, the influence was much stronger and in certain cases outright copies appear to have been made (see fig. 181). Photograph Die Kunst 1903.

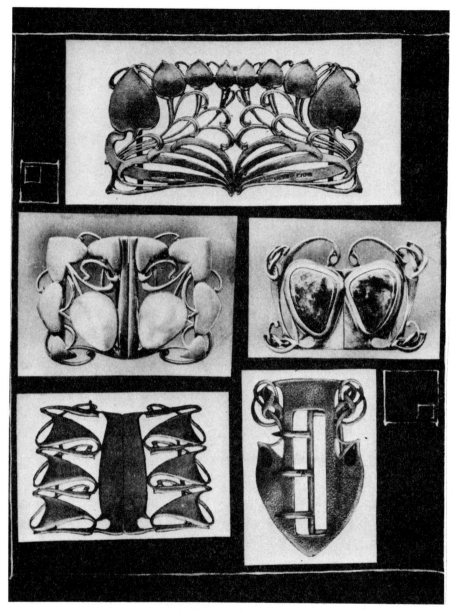

Fig. No. 173. Photograph of buckles designed by Knox. Courtesy Manx Museum.

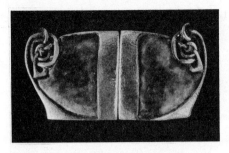

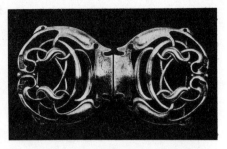

Fig. No. 174. Silver and enamel buckle probably designed by Knox. Courtesy Haslam & Whiteway.

Fig. No. 175. Silver Buckle designed by Knox circa 1899. Collection The Fine Art Society, London.

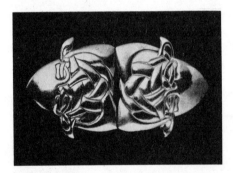

Fig. No. 176. Silver Buckle designed by Knox circa 1902/3. Collection John Jesse.

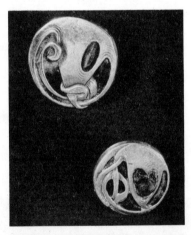

Fig. No. 177. Two variations on a design for a button, both by Knox circa 1901. Courtesy Brighton Museum.

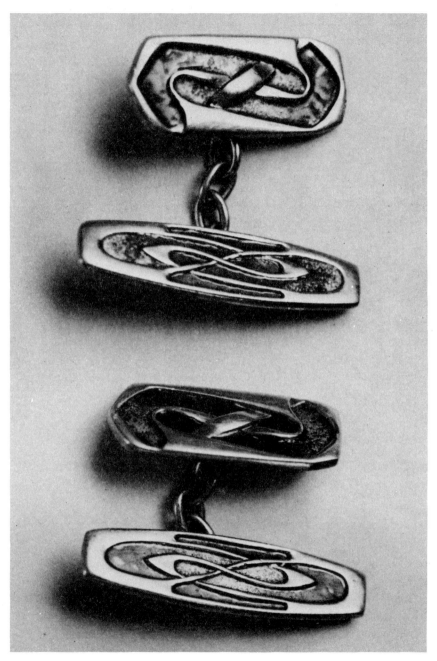

Fig. No. 178. Pair of gold and enamel cufflinks designed by Knox. Photograph courtesy Manx Museum.

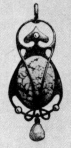
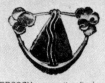
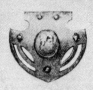
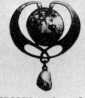
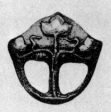

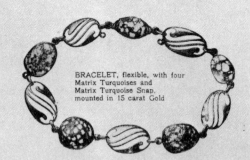
Fig. No. 179. A Murrle Bennett advertisement from "The Studio" circa 1900.

184

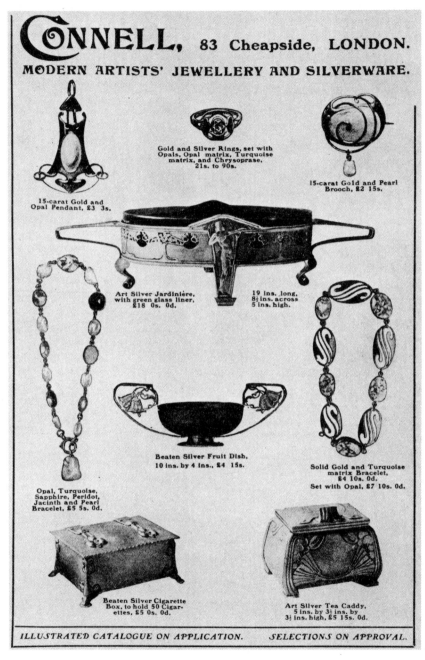

Fig. No. 180. A Connell advertisement from "The Studio" circa 1900, showing the same bracelet featured in a Murrle Bennett advert, see fig. 179.

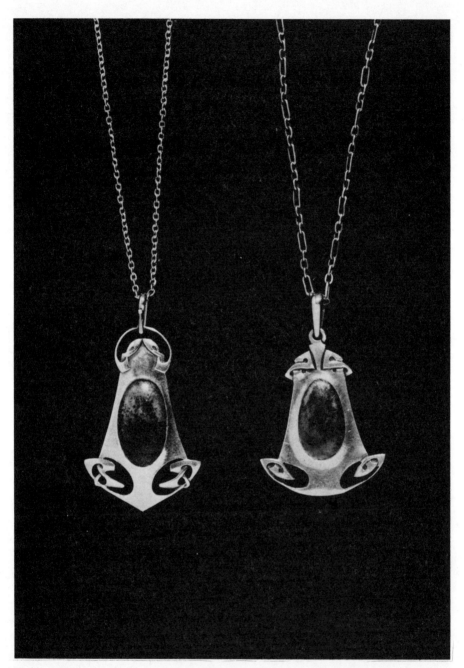

Fig. No. 181. Two pendants both designed by Knox, one marked Murrle Bennett & Co., the other Liberty & Co. W. H. Haseler also produced the same pendant. Private Collection London.

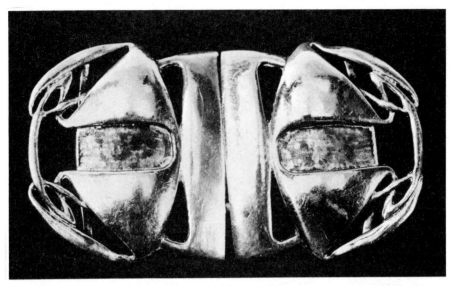

Fig. No. 182. Silver buckle designed by Knox. Collection Joan Collins. Photograph courtesy Brighton Museum.

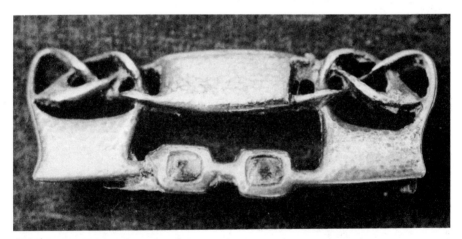

Fig. No. 183. Silver brooch designed by Knox circa 1900. Photograph courtesy Manx Museum.

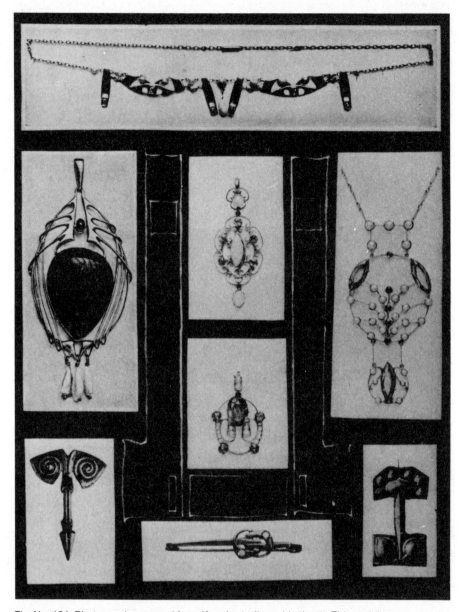

Fig. No. 184. Photograph removed from Knox's studio on his death. This and the upper part of fig. 185 are both later designs circa 1906/7. Photograph courtesy Manx Museum.

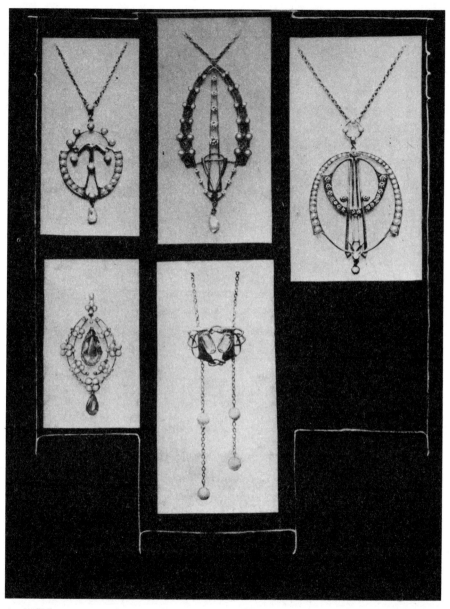

Fig. No. 185. Photograph removed from Knox's studio on his death. Photograph courtesy Manx Museum.

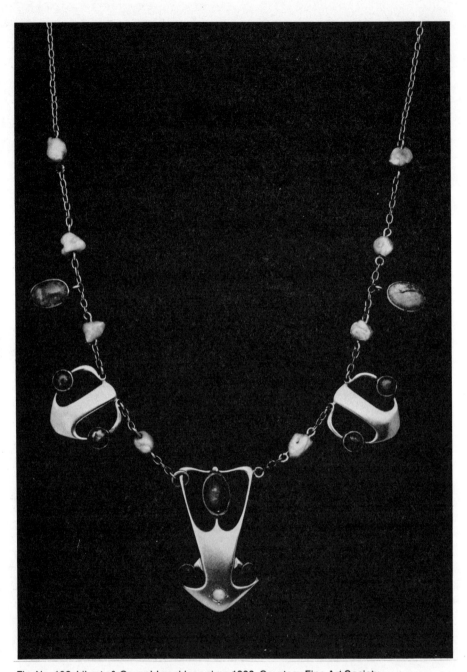

Fig. No. 186. Liberty & Co. gold necklace circa 1900. Courtesy Fine Art Society.

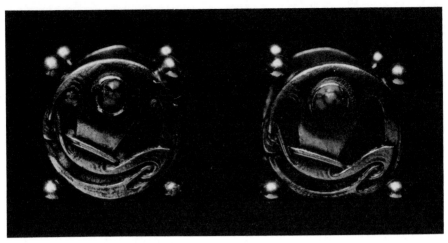

Fig. No. 187. Pair of silver knife rests, decoration rather than shape is by Knox. As with other items the medallion ends were freely adapted in the Liberty studios; resulting in buttons, hatpins, and numerous smaller objects bearing these motifs as the only form of decoration.

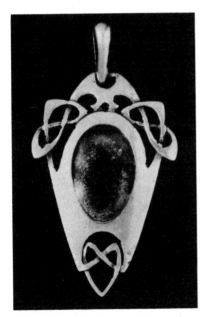

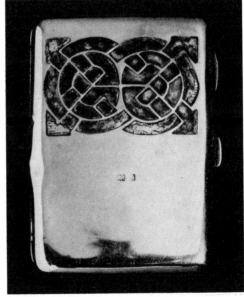

Fig. No. 188. Silver pendant possibly designed by Knox.

Fig. No. 189. Silver cigarette case incorporating a design in enamel by Knox. This kind of cross fertilization was carried out in the studios of the Regent Street building, see also fig. 171. Collection Rhys Morgan.

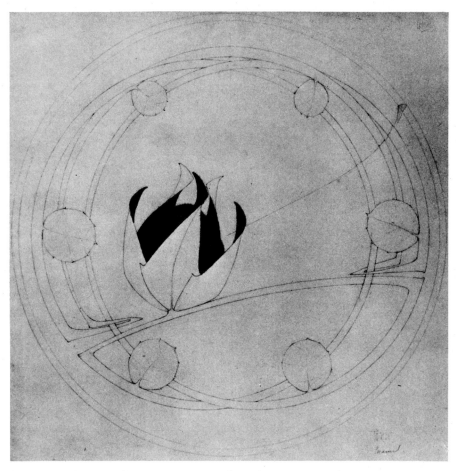

Fig. No. 190. Cat. No. 1. Design for a card tray. Pencil and watercolour.

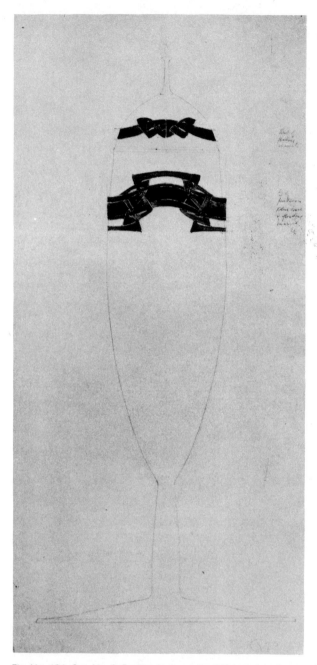

Fig. No. 191. Cat. No. 8. Design for a presentation cup and cover. Pencil and watercolour.

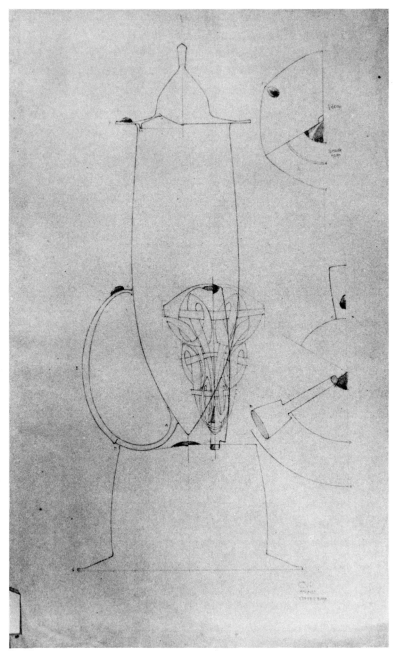

Fig. No. 192. Cat. No. 10. Design for a presentation cup and cover. Pencil and watercolour.

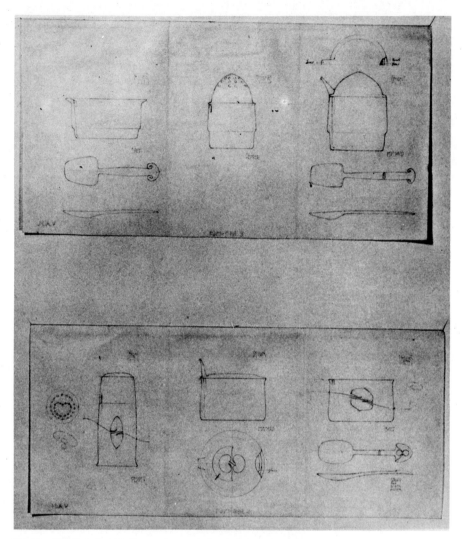

Fig. No. 193. Cat. No. 15. Design for a three-piece cruet set. Pencil.

Fig. No. 193. Cat. No. 16. Design for a three-piece cruet set. Pencil.

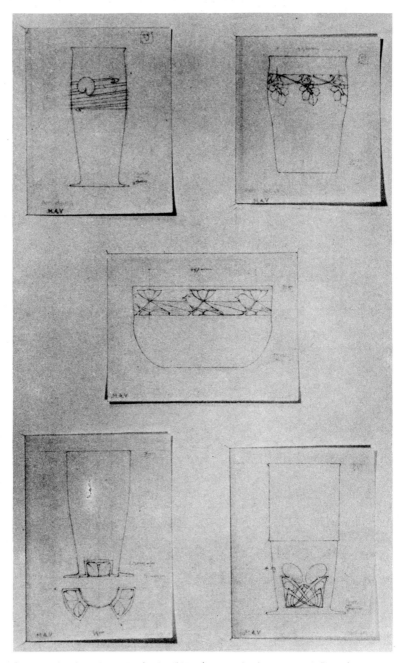

Fig. No. 194. Cat. Nos. 17/18/13/19/11. Designs for flower vases. Pencil.

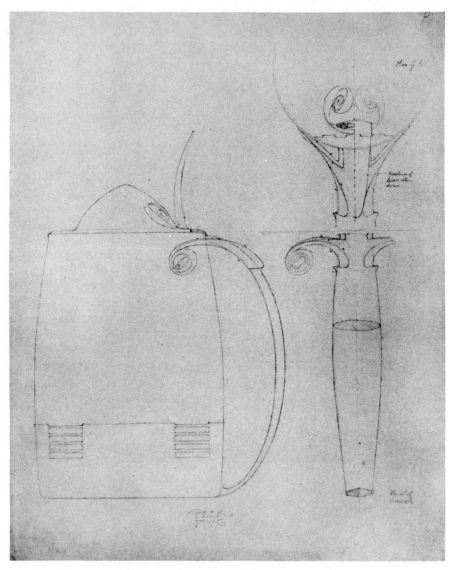

Fig. No. 195. Cat. No. 21. Design for a beer mug. Pencil.

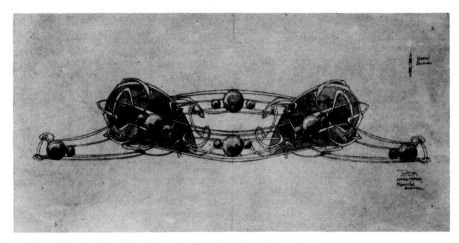

Fig. No. 196. Cat. No. 24. Design for a Tiara. Pencil and watercolour.

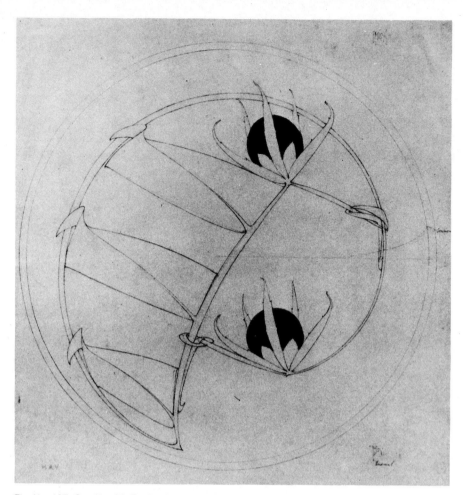

Fig. No. 197. Cat. No. 26. Design for a card tray. Pencil and watercolour.

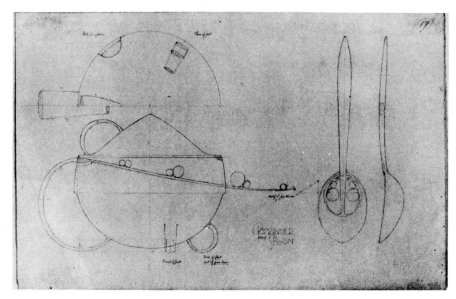

Fig. No. 198. Cat. No. 27. Design for a porringer and spoon. Pencil.

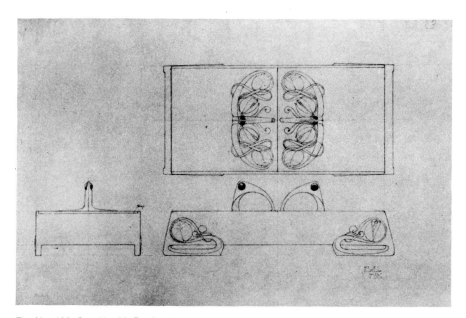

Fig. No. 199. Cat. No. 28. Design for a jewel box. Pencil and wash.

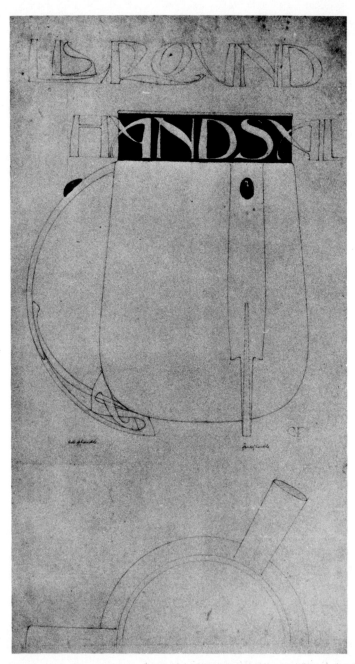

Fig. No. 200. Cat. No. 29. Design for a presentation cup and cover. Pencil and watercolour.

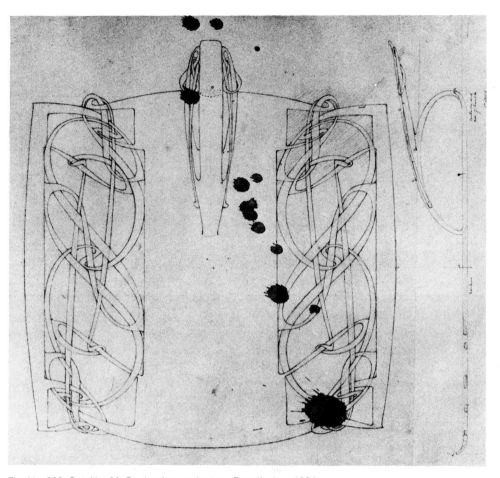

Fig. No. 200. Cat. No. 30. Design for a cake tray. Pencil, circa 1904.

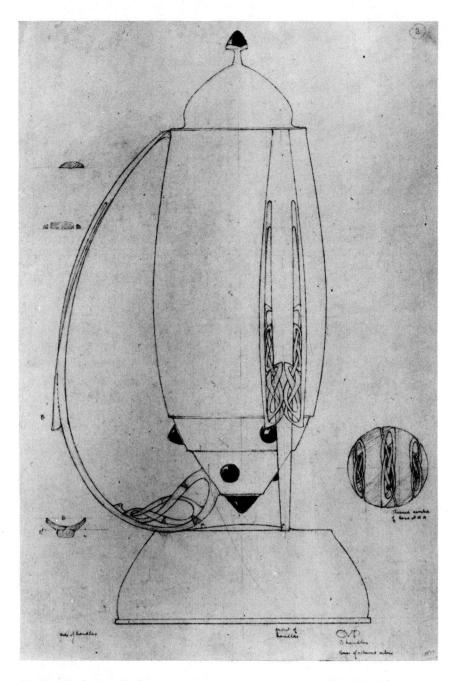

Fig. No. 202. Cat. No. 31. Design for a presentation cup and cover. Pencil and watercolour.

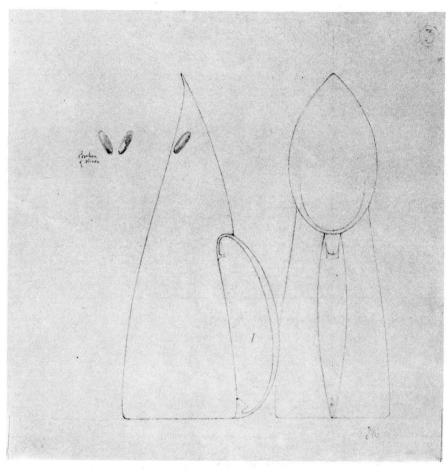

Fig. No. 203. Cat. No. 32. Design for a milk jug. Pencil.

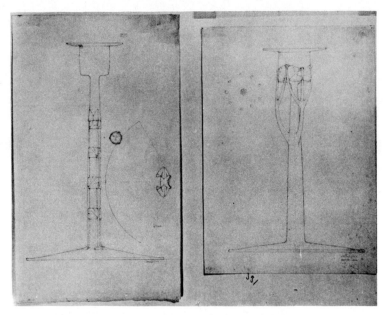

Fig. No. 204. Cat. No. 35. Two designs for candlesticks. Pencil.

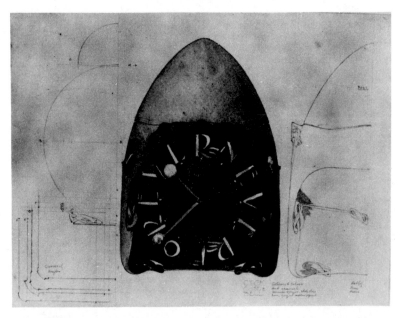

Fig. No. 205. Cat. No. 37. Design for a clock incorporating a bell. Pencil and watercolour.

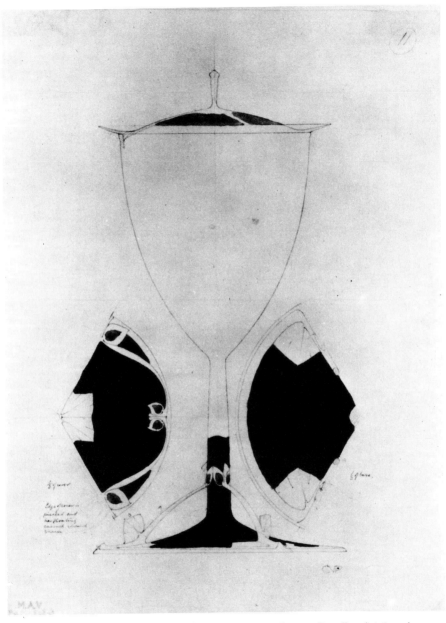

Fig. No. 206. Cat. No. 40. Design for a presentation cup and cover. Pencil and watercolour.

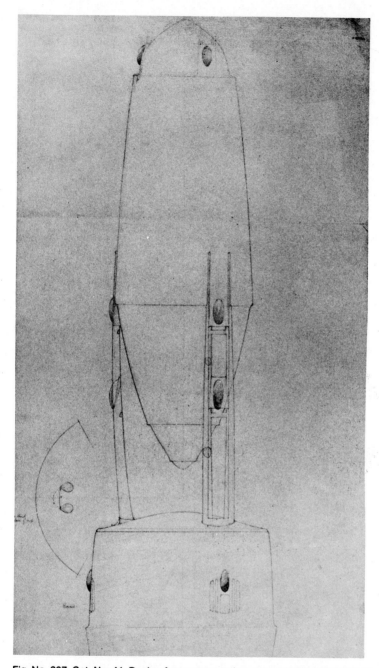

Fig. No. 207. Cat. No. 41. Design for a presentation cup and cover. Pencil and wash.

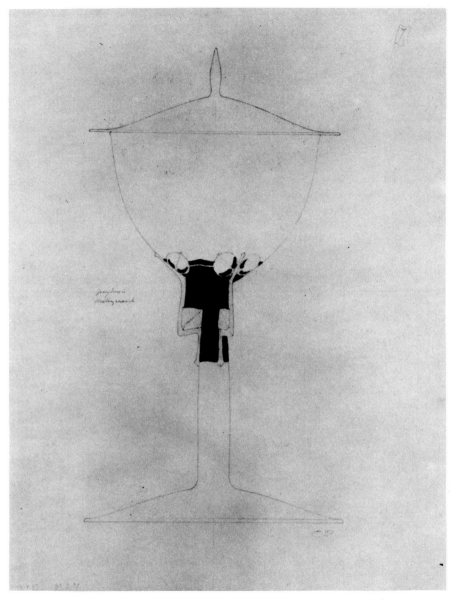

Fig. No. 208. Cat. No. 43. Design for a presentation cup and cover. Pencil and watercolour.

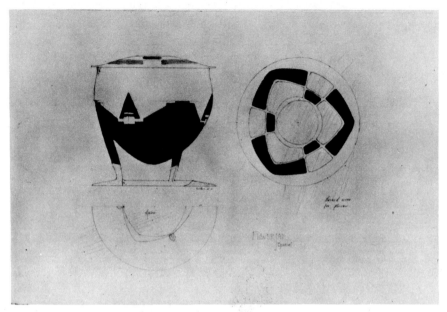

Fig. No. 209. Cat. No. 45. Design for a flower jar. Pencil and watercolour.

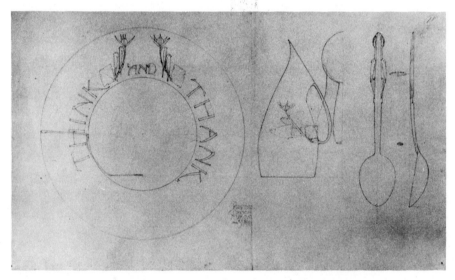

Fig. No. 210. Cat. No. 47. Design for a porridge bason (sic). Milk jug and spoon. Pencil.

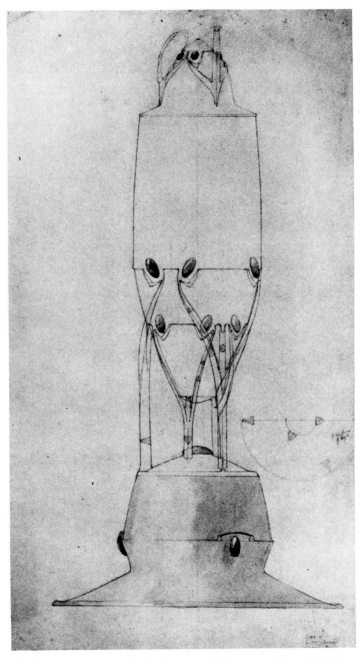

Fig. No. 211. Cat. No. 48. Design for presentation cup and cover. Pencil and wash.

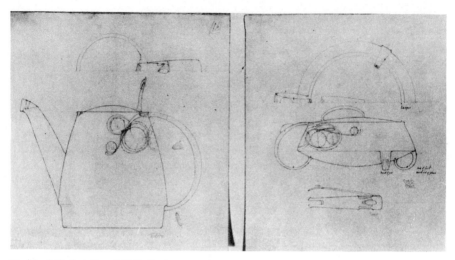

Fig. No. 212. Cat. Nos. 38/52. Design for teapot & bowl. Pencil.

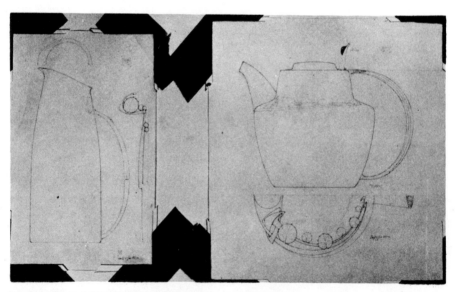

Fig. No. 213. Cat. Nos. 51/53. Design for a jug & teapot. Pencil.

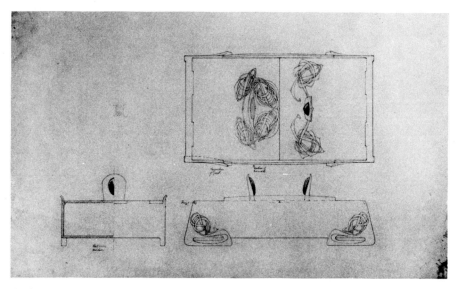

Fig. No. 214. Cat. No. 54. Design for a jewel box. Pencil and watercolour.

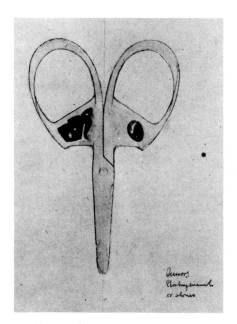

Fig. No. 215. Cat. No. 59. Design for a pair of nail scissors. Pencil and watercolour.

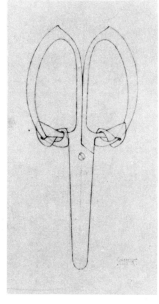

Fig. No. 216. Cat. No. 60. Design for a pair of nail scissors. Pencil.

213

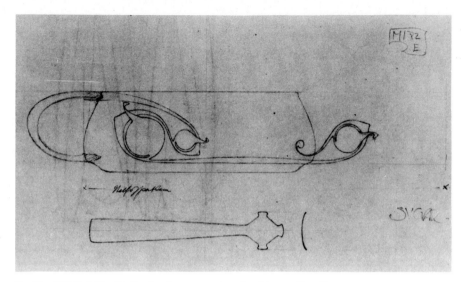

Fig. No. 217. Cat. No. 61. Design for a sugar bowl and tongs. Pencil.

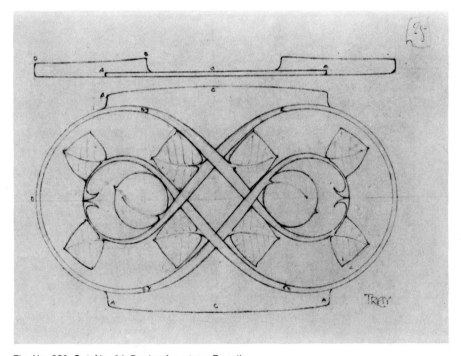

Fig. No. 220. Cat. No. 64. Design for a tray. Pencil.

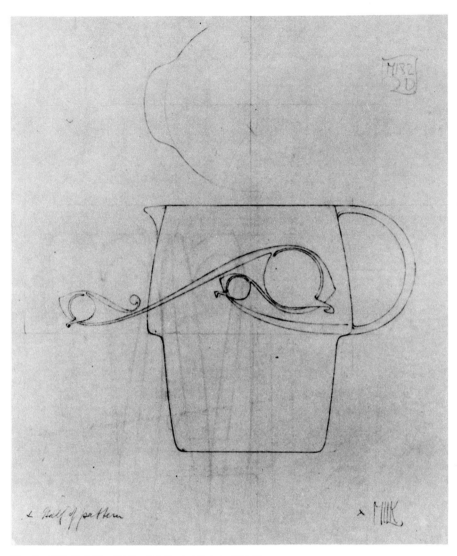

Fig. No. 218. Cat. No. 62. Design for a milk jug. Pencil.

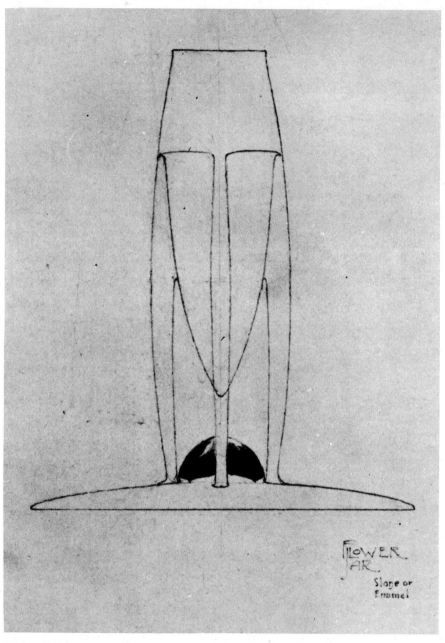

Fig. No. 219. Cat. No. 63. Design for a flower jar. Pencil and watercolour.

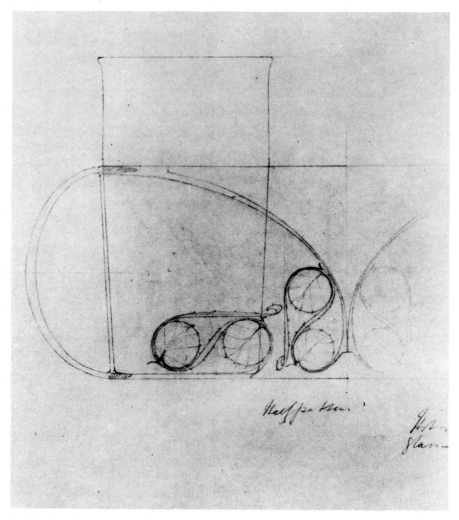

Fig. No. 221. Cat. No. 65. Design for a hot milk holder, intended to have a glass liner. Pencil.

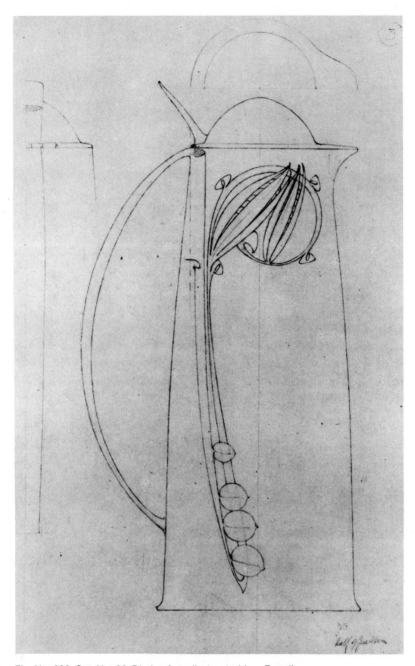

Fig. No. 222. Cat. No. 66. Design for a (hot water) jug. Pencil.

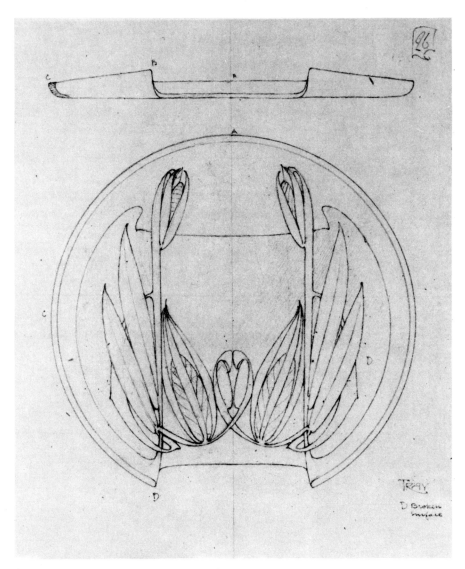

Fig. No. 223. Cat. No. 67. Design for a tray. Pencil.

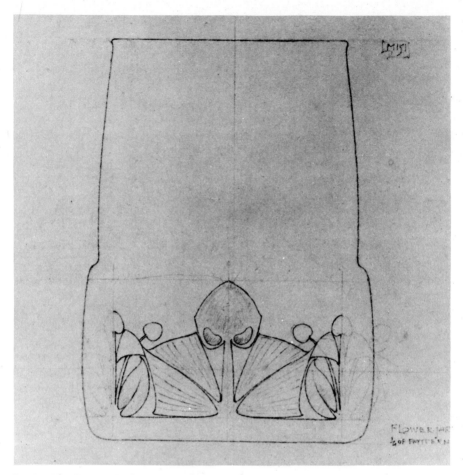

Fig. No. 224. Cat. No. 68. Design for a flower jar. Pencil.

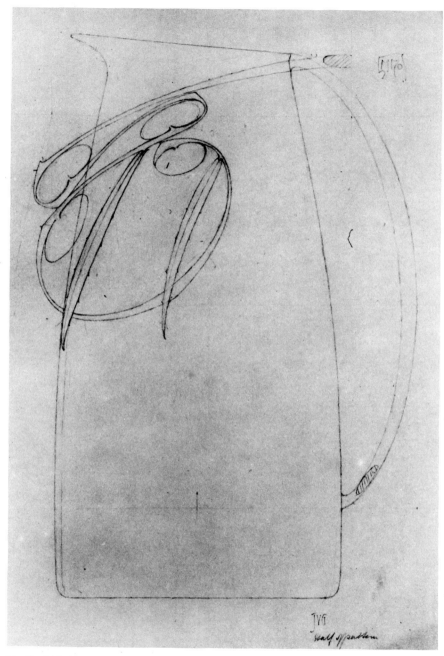

Fig. No. 225. Cat. No. 69. Design for a jug. Pencil.

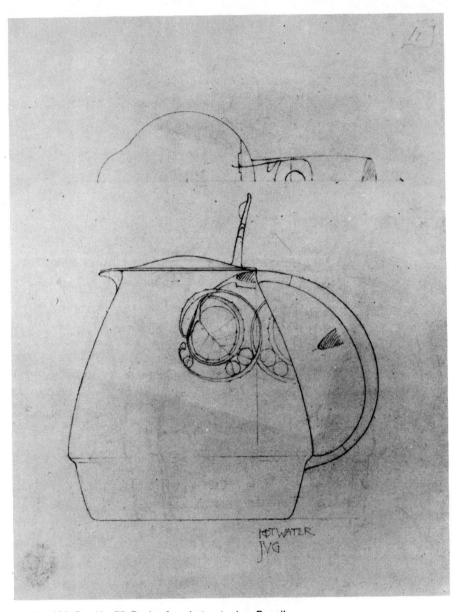

Fig. No. 226. Cat. No. 70. Design for a hot water jug. Pencil.

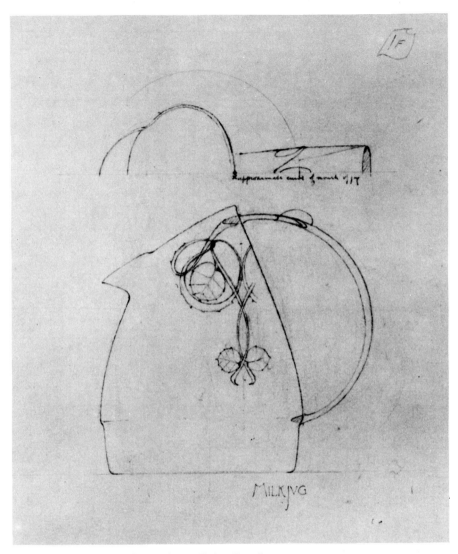

Fig. No. 227. Cat. No. 71. Design for a milk jug. Pencil.

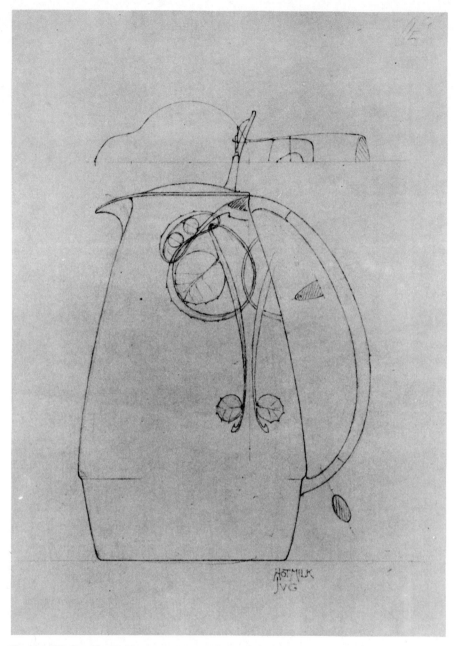

Fig. No. 228. Cat. No. 72. Design for a hot milk jug. Pencil.

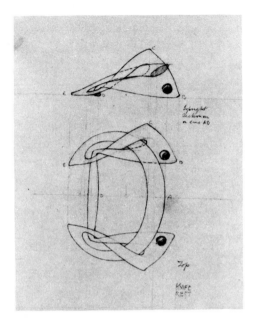

Fig. No. 229. Cat. No. 73. Design for knife rests. Pencil and watercolour.

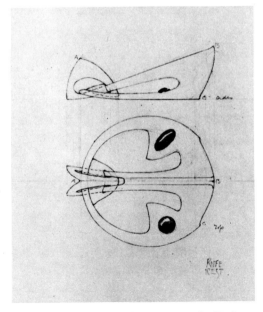

Fig. No. 230. Cat. No. 74. Design for a pair of knife rests. Pencil and watercolour.

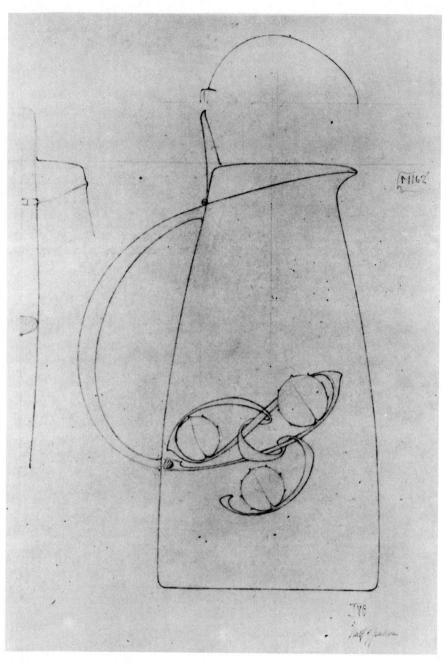

Fig. No. 231. Cat. No. 75. Design for a jug. Pencil.

226

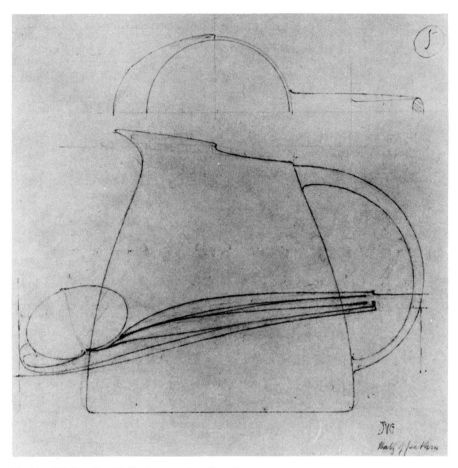

Fig. No. 232. Cat. No. 76. Design for a jug. Pencil.

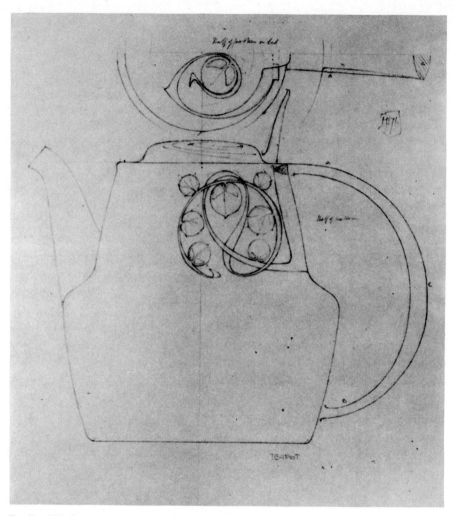

Fig. No. 233. Cat. No. 77. Design for a teapot. Pencil.

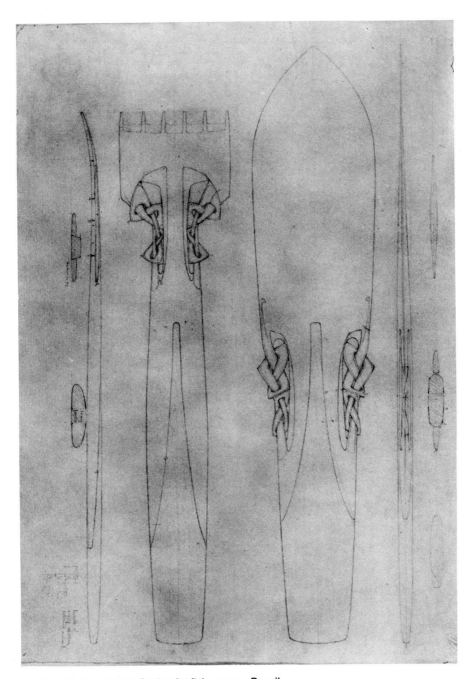

Fig. No. 234. Cat. No. 78. Design for fish servers. Pencil.

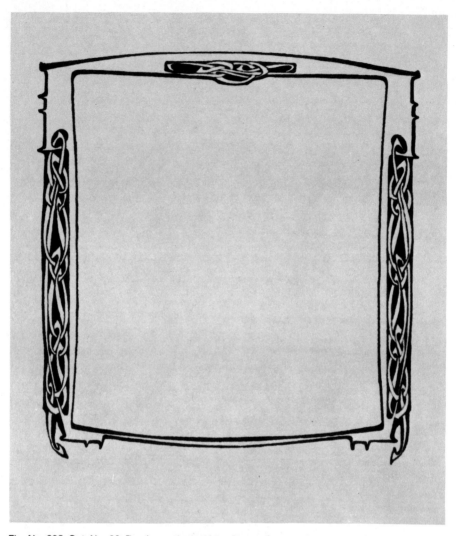

Fig. No. 235. Cat. No. 80. Border or design for a frame. Pen and Ink.

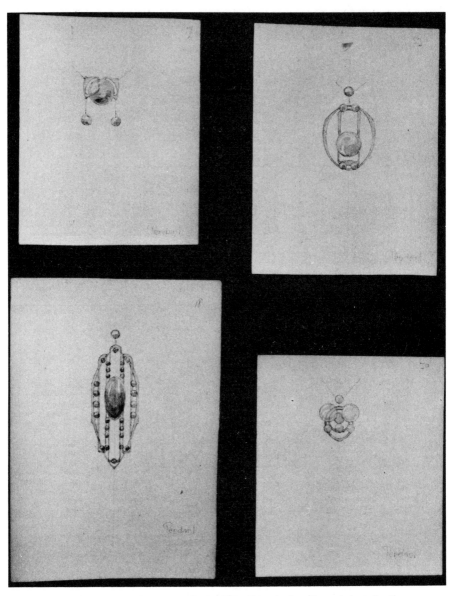

Fig. Nos. 236/237/238/239. Cat. Nos. 81/82/83/84. Four designs for pendants by Knox.
Collection Denise Wren.

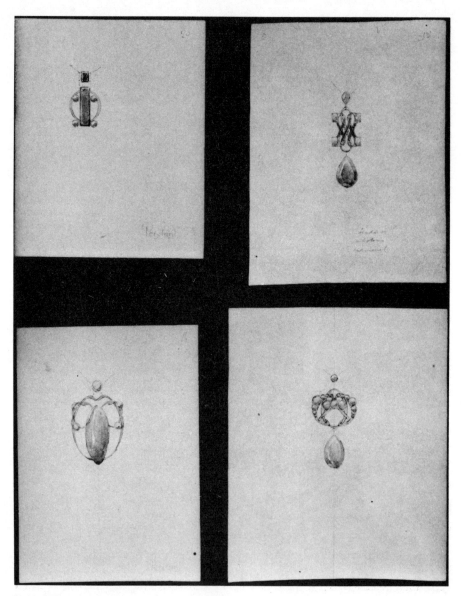

Fig. Nos. 241/240/242/243. Cat. Nos. 86/85/87/88. Four designs for pendants by Knox.
Collection Denise Wren.

232

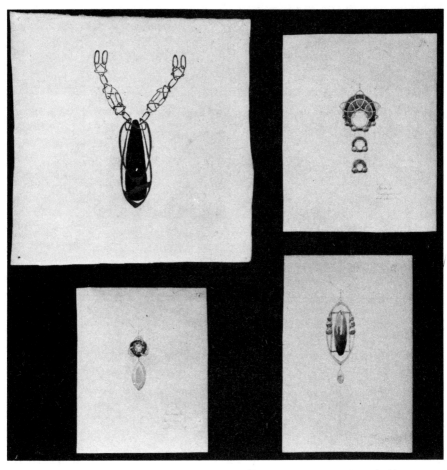

Fig. Nos. 244/245/246/247. Cat. Nos. 89/90/91/92. Four designs for pendants by Knox. Collection Denise Wren.

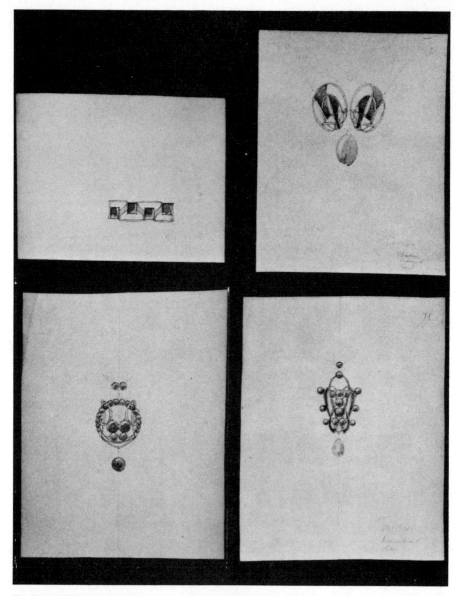

Fig. Nos. 248/249/250/251. Cat. Nos. 93/94/95/96. Three designs for pendants, one for a brooch, all designed by Knox. Collection Denise Wren.

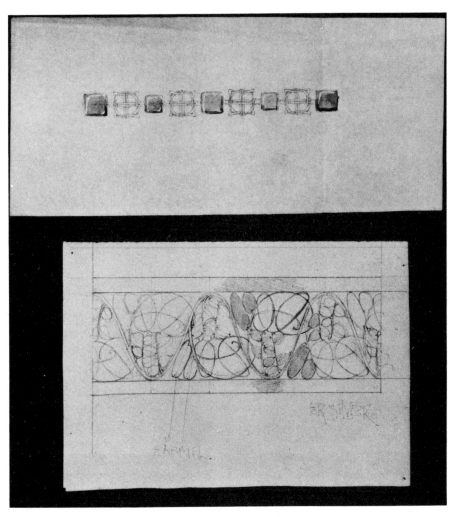

Fig. Nos. 252/253. Cat. Nos. 97/98. Two designs for bracelets by Knox. Collection Denise Wren.

Fig. Nos. 254/255. Cat. Nos. 99/100. Two designs for fabric by Knox. Watercolour. Gift of Miss A. Knox. Photograph courtesy Manx Museum.

Fig Nos. 256/257. Cat. Nos. 101/102. Two designs for fabric by Knox. Watercolour. Gift of Miss A. Knox. Photograph courtesy Manx Museum.

Fig. Nos. 258/259. Cat. Nos. 103/104. Two designs for fabric by Knox. Watercolour. Gift of Miss A. Knox. Photograph courtesy Manx Museum.

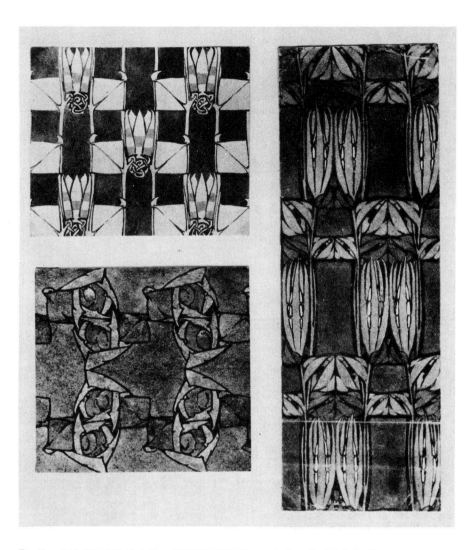

Fig. Nos. 260/261/262. Cat. Nos. 105/106/107. Three designs for fabric by Knox. Watercolour. Gift of Miss A. Knox. Photograph courtesy Manx Museum.

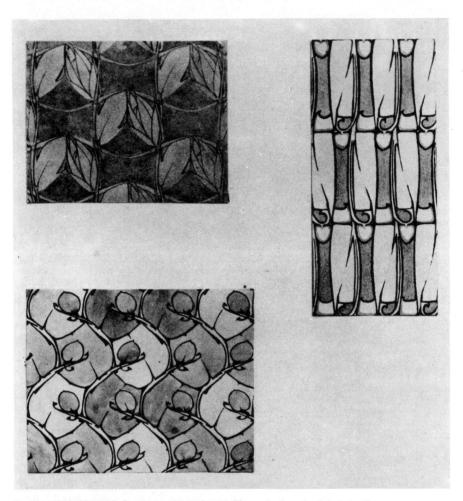

Fig. Nos. 263/264/265. Cat. Nos. 108/109/110. Three designs for fabric by Knox. Watercolour. Gift of Miss A. Knox. Photograph courtesy Manx Museum.

Fig. No. 266. Cat. No. 111. Design for a semi-circular rug. Pencil and watercolour.

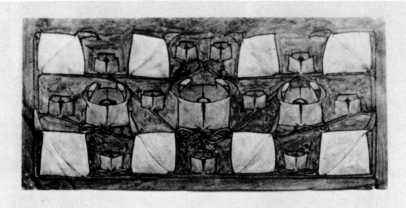

Fig. Nos. 267/268/269. Cat. Nos. 114/115/116. Three designs for rugs by Knox.
Watercolour. Gift of Miss A. Knox. Photograph courtesy Manx Museum.

Fig. Nos. 270–275. A series of 15 designs for chalices and presentation cups entered by Liberty and Co. at the Public Records Office (Registration Section) circa 1903/4. All these designs were obviously traced from the original drawings. They are all designed by Knox. Reproduced courtesy of the Public Records Office, Chancery Lane, London.

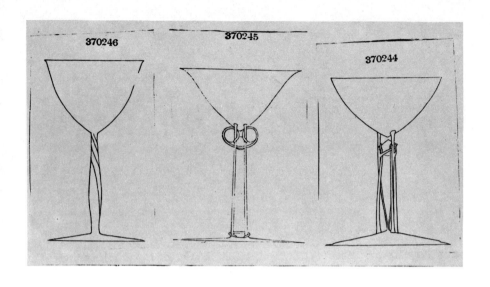

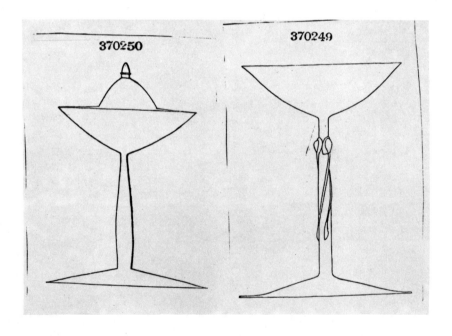

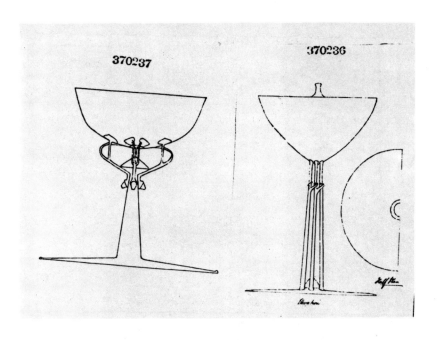

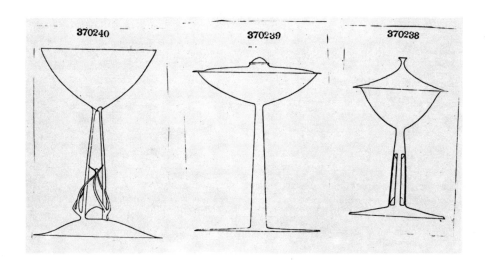

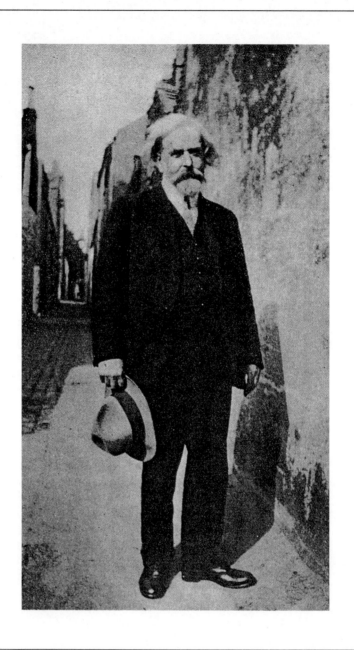

Archibald Knox

Notes on the Catalogue of Designs

This catalogue represents all the Knox designs recorded at this point in time. In the case of Museum ownership, the Folio number is given as a general heading for that particular section. The accession numbers follow the entries. Wherever letters in either upper or lower case appear after the numerals it usually denotes that the item is incomplete in itself (and requires, as in the case of no. 72 and 73, other items to form a complete service).

All the metalwork designs are kept together, thus designs in private collections follow those in public collections. Designs for fabrics, and carpets are grouped together and the same system of entry is applicable. Lastly come the designs for jewellery which included seventeen unrecorded designs.

In every case, the text has followed completely that which was written on the original designs though certain technical observations have been omitted, e.g. "point of handles", or "pierced centre of base at AA".

Finally, the Victoria & Albert Museum has many loose working sketches. These take the form of initial thoughts for designs and in most cases are no more than either unrelated marks, or images that have subsequently been smudged to give an illusion of form; these are not recorded here, though the Victoria & Albert press-marks are listed.

Catalogue of Designs

Folio M.26

1
Design for a card tray with blue enamel. Pencil touched with watercolour. The design is numbered M.160 in the top right hand corner. 1903-04. (See fig. 64 for a similar idea and variations put into practice).
E.306-1969

2
Design for a coffee pot. Pencil. The design is numbered M.182 B* 1902-03. (See fig. 61 for a similar idea put into practice).
E.307-1969

3
Design for a presentation cup bearing inscription – and set with four moonstones (?) Pencil touched with watercolour. The design is numbered 9, having previously been numbered 2. 1903-04.
E.309-1969.

4
Design for jam dish or porringer, bearing the motto, "Strife comes with manhood and waking with day". Pencil. Unnumbered. 1901-02.
E.310-1969

5
Design for a presentation cup and cover, a substantial watercolour, numbered 11 in the top right hand corner. About 1903-04.
E313-1969

6
Design for a coffee pot. Pencil. Numbered lc(M.168). About 1903.
E.314-1969

7
Design for a presentation cup and cover, substantial watercolour, bearing the number 7 in the top right hand corner. About 1903-04.
E.330-1969

8
Design for a presentation cup: a note in Knox's hand states "ball of floating enamel". Pencil and heavy watercolour. Bearing the number 1. 1902-03. (See also No. 29 for similar design).
E.332-1969

9
Design for a circular tray. (Card Tray?). Pencil. Numbered M.158. 1903.
E.333-1969

10
Complex design for a large presentation cup, set with stones and having a copper base. Pencil with some watercolour. Unnumbered about 1904-06.
E.336-1969

11
Design for a flower jar (sic.) (Vase). Pencil numbered 24. About 1902.
E.343-1969

12
Design for a milk jug. Numbered in pencil M.168. This and No. 6 are part of one design for a tea-service comprising 5 pieces. About 1903.
E.344-1969

13
Design for a flower jar (sic). (Vase). Pencil numbered 150. About 1902-03.
E.346-1969

14
Design for oil and vinegar (?) service.
Having glass bottles, and presumably
intended for pewter production. Pencil.
About 1902. (This bears a close
resemblance to similar pieces by Dr. C.
Dresser, see Christopher Dresser, an
Exhibition arranged by Richard Dennis &
John Jesse, fig. 122).
E.347-1969

15
Design for salt (M.166a) – pepper
(M.166b) and mustard (M.166c). Pencil.
About 1902.
E.349-1969

16
Design for salt (M.165a) – pepper
(M.165b) and mustard (M.165c). Pencil.
About 1902.
E.349-1969

17
Design for a flower jar (sic). (Vase).
Pencil numbered 24. About 1902.
E.350-1969

18
Design for a flower jar (sic). (Vase).
Pencil numbered 152. About 1902-03.
E.351-1969

19
Design for a flower jar (sic). (Bowl).
Bearing an unusual design for
metalwork, that of stylised birds. Pencil
numbered 155. About 1902-03.
E.354-1969

20
Design for a hot-water jug. Numbered 4
in the top right-hand corner. Pencil.
About 1901-02.
E.335-1969

21
Design for a beer-mug. Pencil.
Numbered 8 in the top right hand corner.
1903-04.
E.359-1969

22
Design for a cigarette box. Pencil with
blue watercolour wash denoting
enamel. Design bears the number 9 in
the top right hand corner. 1903-04.
E.362-1969

23
Design for a porringer and spoon.
Pencil. Numbered 16 in top right hand
corner. See also Nos. 27 and 32.
E.365-1969

24
Design for a cup and cover, with three
handles, set on a copper base. The lid
and handles being set with stones.
Pencil touched watercolour. About
1904-05.
E.366-1969

25
Design for a Tiara. Enamel and
moonstones; pierced silver-work. Pencil
and heavy watercolour. About 1902-03.
E.303-1969

26
Design for a cup, set with two
moonstones (?). Pencil touched with
watercolour, being numbered 10. About
1903-04.
E303-1969

27
Design for a try 'with enamel' (sic).
Pencil, touched with watercolour, being
numbered M.159. (See also No. 9)
About 1903.
E.325-1969

28
Design for a porringer and spoon.
Pencil being numbered 17. About
1901-02.
E.326-1969

29
Design for a jewel box set on four skid-like feet, having a central hinged lid. (The shape and construction of the design bears a strong resemblance to fig. 114). Pencil touched with water-colour, being numbered 15. About 1903.
E.358-1969

30
Design for a three-handled loving cup, bearing the motto in Celtic-inspired type. "Hands all round", the motto is in relief silver, the background coloured to suggest blue and green enamelling. Each of the handles have a semi-precious stone. Pencil and heavy watercolour. Unnumbered. About 1902.
E.361-1969

31
Design for a cake tray, having a nearly symmetrical repeat design of pierced silver work either side of a centrally positioned handle. Pencil (ink splashes), being numbered 5. About 1903-04.
E.363-1969

32
Design for a three-handled cup and cover. Set with eight turquoise matrices inscribed in Knox's hand, 'base of coloured silver', which is probably a reference to the oxidisation of certain areas of the silver, rather than to enamel. A separate design in the form of a circle is insribed 'pierced centre of base'. Pencil touched with watercolour. Unnumbered. About 1903-04.
E.346-1969

33
Design for a jug. Having two stones either side of a very high thrown back spout. Pencil touched watercolour numbered 3. (For an almost identical design see fig. 210, also for a comparable shape and idea see fig. 153). About 1902-03.
E.367-1969

34
Design for a jewel box, highly finished watercolour study, having the centrally hinged lid (as in No. 28). Pencil and heavy watercolour. Unnumbered. About 1903.
E.368-1969

35
Also under Folio M.26(a) see
E.369-1969 – In Light of Sun,
In Brightness of Snow
E.370-1969 – In splendour of Fire,
In speed of Lightning
E.371-1969 – In swiftness of Wind,
In depth of Seas
Designs for rounds from the illuminated address of 'The Deer's Cry', St Patrick's Hymn, circa 1915-20.

36
Design for a (pair of) candlestick(s) numbered M.173. Pencil. About 1904-05.
E.304-1969

37
Design for a jug. Pencil. About 1903.
E.305-1969

38
Design for a silver and enamel clock case and bell, the minute finger set with a stone (moonstone?), the hour finger with mother of pearl. Lettered on the face, 'Never for Ever'. Pencil and watercolour. About 1904.
E.308-1969

39
Design for a teapot, numbered 1b. Pencil. About 1903.
E.311-1969

40
Design for a teapot bearing the number 182A. A piece obviously intended for the same service is located under Folio 26 Cat. No. 61. (Coffee-pot bearing the number 182B). About 1902-03.
E.312-1969

41
Design for a presentation cup and cover
with enamelled decoration. Pencil and
watercolour, numbered 11. About 1904.
E.313-1969

42
Design for a presentation cup and cover,
again ornamented with moonstones, and
numbered 12. Pencil touched
watercolour. About 1903-04.
E.320-1969

43
Design for a jewel box. Pencil touched
watercolour. About 1903-04.
E.321-1969

44
Design for a presentation cup and cover
with enamelled decoration. Pencil and
watercolour, numbered 7. About 1904.
E.330-1969

45
Design for a (pair of) candlestick(s).
Pencil. About 1900-02, and bearing a
strong resemblance to those by Rex
Silver illustrated in Studio Vol. 19, page
172. (Also see fig. 150).
E.331-1969

46
Designs for flower jar. Pencil and
watercolour. About 1903.
E.334-1969

47
Design for a clock case showing sides
and face. Bearing lettering on the face in
place of figures, '1 Time 6 Enough'.
Pencil. Numbered 1. About 1904-05.
E.335-1969

48
Design for a Porridge basin (sic), milk jug
and spoon. Pencil. About 1902. (For a
similar design compare with Cat. No. 32).
E.337-1969

49
Design for a presentation cup of silver,
having moonstones and a copper base.
Pencil touched watercolour. About 1903-
04.
E.341-1969

50
Designs for flower jar. Pencil and
watercolour. About 1903.
E.342-1969

51
Design for a jug, numbered M. 168.
Pencil. About 1903.
E.344-1969

52
Design for a jug, numbered M.169.
Pencil. About 1903.
E.345-1969

53
Design for a sugar bowl, numbered 1g.
Pencil. About 1903. (This and Cat. No.
51 are intended for the same service).
E.356-1969

54
Design for a teapot, numbered M.175.
Pencil. About 1902-03.
E.360-1969

55
Design for a jewel box, Pencil touched
watercolour. About 1903-04.
E.366-1969

Folio M.8

The following three designs are all based on the same outline shape, the variations occurring in the central panel of ornamentation, and in the termination of these designs at their respective handles.

In Knox's hand the instructions are "to contain one stone each", presumably either turquoise matrix or Connemara marble.

56
Design for hand-mirror. Pencil and watercolour. About 1902-03.
E.327-1969

57
Design for a hairbrush. Pencil and watercolour. About 1902-03.
E.328-1969

58
Design for a hairbrush. Pencil and watercolour. About 1902-03.
E.329-1969

59
Folio M.8 also contains 9 sheets of sketch designs for metalwork, and 60 sheets of tracings. The accession numbers are E.315-319. 338-340. 357-1969 and E.372-435-1969. E.428-1969 respectively.

Designs in Private Collections

60
Design for a pair of nail scissors. Pencil, touched watercolour, a note in Knox's hand stating, "Scissors floating enamels or stones". About 1902.

61
Design for a pair of small scissors. Pencil. About 1902.

62
Design for a sugar bowl and a pair of sugar tongs. Pencil, bearing the number M.182E. This drawing is intended as part of the service E.307-1969. No. 2. E.312-1969 No. 39. Pencil. About 1902-03.

63
Design for a milk jug (sic). Pencil, bearing the number M.182D. This drawing is intended as part of the service E.307-1969 No. 2. E.312-1060 No. 39. Pencil About 1902-03.

64
Design for a flower jar (sic). Pencil, touched watercolour, having either stone or enamel. About 1902. (For a similar object see fig. 135).

65
Design for a large tray (presumably for a tea-service). Pencil, numbered 25. About 1903.

66
Design for a hot milk holder, with a glass liner. (For a similar piece see fig. 103). Pencil. About 1902.

67
Design for a jug. Pencil, numbered 3. About 1902.

68
Design for a card tray. Pencil, numberd
26. About 1902.

69
Design for a flower jar (sic). Pencil,
numbered M.151. About 1902-03.

70
Design for a jug without a lid. Pencil,
numbered M.170. About 1902.

71
Design for a hot-water jug. Pencil. About
1903-04.

72
Design for a milk jug. Pencil, bearing the
inscription 1f. About 1903-04.

73
Design for a hot milk jug. Pencil, bearing
the inscription 1E. This and the
preceding drawings were all intended as
part of the same service. About 1903-04.

74
Design for a knife rest. An inscription in
Knox's hand states 'wrought section on
line A.D.'. Pencil touched watercolour.
About 1904.

75
Design for a knife rest. Pencil touched
watercolour. About 1904.

76
Design for a lidded jug. Pencil numbered
M.162. About 1903.

77
Design for a milk jug. Pencil, numbered
5. About 1902-03.

78
Design for a teapot. Pencil, numbered
M.176. About 1903.

79
Designs for fishservers.
John Jesse.

80
Designs for cutlery.
John Jesse.

81
Design either for an ornamental border
or a mirror frame. Pen and ink.
Denise Wren.

Designs for Jewellery

The following designs, mostly for gold pendants, are untypical of Knox's Celtic style. For this reason and on purely visual assessment a date of about 1906-1909 would suggest itself, particularly when compared with the equivalent Continental designs of the day.

These designs, hitherto unrecored, give a clear insight into the direction adopted by Knox with regard to his designing of jewellery, as well as showing the course that was to be pursued by all the more avant-garde jewellery designers such as Henry Wilson, Edgar Simpson and to a lesser extent the Gaskins, a husband and wife team that had earlier worked for Liberty & Co. Furthermore, the designs themselves add to the existing knowledge of items produced under the aegis of Liberty & Co.; invariably the items of gold jewellery were left unmarked, due to the irreparable damage so often perpetrated by the Assay Offices.

The designs were discovered by Rosemary Wren in November 1970 amongst some papers belonging to her mother, too late, therefore to be included in the Victoria & Albert Museum exhibition devoted to Knox's design work.

All the designs are in pencil and watercolour and are catalogued with the rest of the designs. The one point that perhaps should be reiterated is one made by Charlotte Gere[1], concerning the marking of fig. 254 'For Silver'. She has suggested that the design was intended for the Silver Studio, rather than to denote the metal to be used.

[1] Charlotte Gere is the authoress of Victorian Jewellery Design, and more recently European and American Jewellery.

82
Design for a gold pendant. Pencil and watercolour. Numbered 17.

83
Design for a gold pendant. Pencil and watercolour. Indistinctly numbered (13)?

84
Design for a gold pendant. Being set with seed pearls(?) Pencil and watercolour. Numbered 18.

85
Design for a gold pendant. Pencil and watercolour. Numbered 30.

86
Design for a pendant. Pencil and watercolour. Numbered 20.

87
Design for a gold pendant. A note in Knox's hand states, "Cut stones and enamel". Pencil and watercolour. Numbered 18.

88
Design for a gold pendant. Pencil and watercolour. Numbered 16.

89
Design for a gold pendant. Pencil and watercolour. Unnumbered.

90
Design for a pendant. Watercolour. Unmarked. (It is probable that this design pre-dates the rest of these designs by some 4-6 years).

91
Design for a gold pendant. A note in Knox's hand states, "Floating enamel and stones". Pencil and watercolour. Marked J4.

92
Design for a gold pendant. A note in Knox's hand states, "Cut stones and enamel". Marked J7.

93
Design for a gold pendant. Pencil and watercolour. Numbered 22.

94
Design for a gold bar brooch. Pencil and watercolour. Unnumbered.

95
Design for a gold pendant of Celtic theme. A note in Knox's hand states, "Floating enamel pearl". Pencil and watercolour. Marked J9.

96
Design for a pendant. Pencil and watercolour. Unnumbered.

97
Design for a gold pendant. A note in Knox's hand states "Enamel and stones". Pencil and watercolour. Marked J8.

98
Design for a gold (?) and gemset bracelet. Pencil and watercolour.

99
Design for a pierced enamel bracelet (?). Inscribed "For Silver". Pencil.

Notes on Fabric Designs

All the recorded fabric designs, Cat. Nos. 99 to 110, rely for their impact upon their bold use of counterchange*.

The motifs employed in some cases are directly related to some of the produced metalwork as in the pattern on fig. 80 by comparison with No. 109. In others the use of this style of naturalistic leaf and bud motifs is comparatively unfamiliar being shown only in this facet of Knox's design work. Presumably like the metalwork designs these were intended for Liberty & Co. and possibly designed as early as 1897, they were either rejected by the firm, or never despatched by Knox.

The distinctness of style, the use of counterchange, and the fact that all rely on the same use of either leaf or bud motif for basic effect would suggest that all were created within a relatively short space of time. A realistic date based on their visual appearance would bring them well into the confines of the Art Nouveau period, though when compared with similar designs by A.H. Mackmurdo, they could well have been designed sometime in the early 1890s.

All the designs were the gifts of Miss A. Knox, the designer's niece, to the Manx Museum, they are illustrated as they are to be found at the Museum, that is mounted two or three to a card. The Museum folio number is to be found at the end of each catalogue entry.

*A definition of counterchange is given as "In a repetitive pattern or design, the process of alternately reversing the colours or motifs. E.g. in a diaper pattern, the first section might contain a gold fleu-de-lys on a blue ground and the following section a blue fleur-de-lys on a gold ground, etc. Motifs can be similarly arranged in alternating relationships".

The following twelve designs for fabrics, all by Knox, were exhibited in the Victoria & Albert Museum show devoted to Knox in 1970.

100
Design for a printed textile. "Square leaf".
Watercolour.
64-221D

101
Design for a printed textile. "Folded leaf".
Watercolour.
64-221N

102
Design for a printed textile. "Squared leaf". Watercolour
64-221A

103
Design for a printed textile. "Stem and bud". Watercolour.
64-221B

104
Design for a printed textile. "Rose".
Watercolour.
64-221H

105
Design for a printed textile. "Lillies".
Watercolour.
64-221J

106
Design for a printed textile. "Small lily with interlacing". Watercolour.
64-221J

107
Design for a printed textile. Watercolour.
64-221K

108
Design for a printed textile. Watercolour.
64-221P

109
Design for a printed textile. Watercolour.
64-221C

110
Design for a printed textile. "Honesty".
Watercolour.
64-221E

111
Design for a printed textile. Watercolour.
64-221G

Carpet Designs

Folio M.26

112
Design for a half-circular rug. Body
colour. About 1902-03. This shape and
the geometric formation of this design
are almost identical to that of the crumb
scoop illustrated on page 101 (fig. 77).
E.324-1969

113
9ft x 10ft 6ins, "design for the end of the
carpet repeated" (sic). Border design.
Body colour. About 1902-03.
E.322-1969

114
9ft x 10ft 6ins "design for the end of
carpet repeated" (sic). Border design.
Body colour. About 1902-03.
E.323-1969

115
Design for a handwoven rug.
Watercolour. This and the following two
designs were probably intended for
production by the Carlisle firm of
Alexander Morton & Co.
Manx Museum 64-220A.

116
Design for a handwoven rug.
Watercolour.
Manx Museum. 64-220B.

117
Design for a handwoven rug.
Watercolour. Manx Museum 64-221L.

Notes on Memorial Sculpture

Though this book limits its scope to that period when Knox was designing for Liberty & Co. (1895(?)-1912) it has been felt justifable to include a small section on the Memorial sculpture designed by Knox, for although technically outside the dates previously mentioned (most of the sculpture being designed between 1916-1933) the shape and ornament in many cases relate directly to that found on both Liberty pewter and silver, and, therefore, does have some bearing with regard to attributions (compare Fig. 293 with Fig. 94).

Amongst the best memorial sculptures are the Kirk Michael Parish Church War Memorial, Isle of Man (Fig. 280), the John Millar Nicholson Memorial (Borough Cemetery, Douglas, Isle of Man, Fig. 286), the Lonan Church Memorial, Isle of Man, the memorial stone for Arthur Lasenby Liberty, Lee Church, Buckingham, and finally, the Hall Caine Memorial, Isle of Man, upon which Knox was working when he died. The design was completed by Winifred Tuckfield. (See Fig. 292).

Fig. No. 276. Memorial stone for John and Eleanor Kennaugh designed by Knox.
Photograph courtesy Manx Museum.

In
loving memory,
of my dear
husband

CHARLES
MICHAEL
PARKINSON

who died
January 14th 1919
aged 47 years

also of

ANNIE his
wife
who fell asleep
11th Dec. 1936.

Fig. No. 277. Memorial stone for Charles and Annie Parkinson designed by Knox. Photograph courtesy Manx Museum.

Fig. No. 278. Memorial stone for Thomas and Catherine Quayle designed by Knox.
Photograph courtesy Manx Museum.

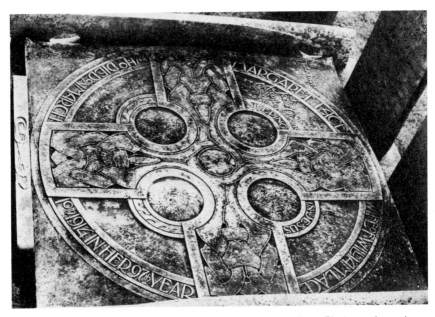

Fig. No. 279. Memorial tablet for Margaret Lace designed by Knox. Photograph courtesy Manx Museum.

Fig. No. 280. Kirk Michael memorial tablet, commemorating the 1914-18 war designed by Knox. Photograph courtesy Manx Museum.

Fig. No. 281. C. E. Killicorn memorial stone designed by Knox. Photograph courtesy Manx Museum.

263

Fig. No. 282. Memorial stone for Robert and Ann Gell designed by Knox. Photograph courtesy Manx Museum.

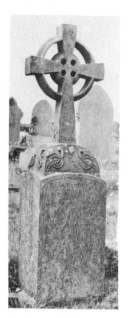

Fig. No. 284. Memorial stone for James Beale Esq, designed by Knox. Photograph courtesy Manx Museum.

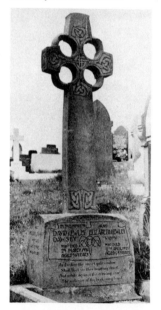

Fig. No. 283. Memorial stone for David and Elizabeth Kewley designed by Knox. Photograph courtesy Manx Museum.

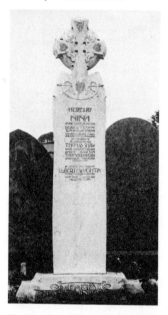

Fig. No. 285. Memorial stone for Nina and Thomas Shaw designed by Knox. Photograph courtesy Manx Museum.

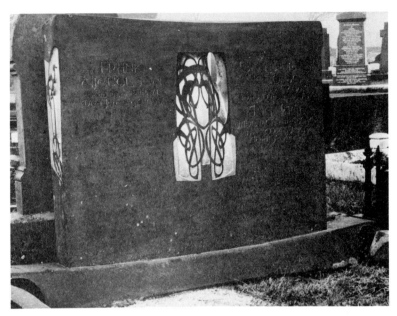

Fig. No. 286. The J. M. Nicholson memorial stone designed by Knox. Photograph courtesy Manx Museum.

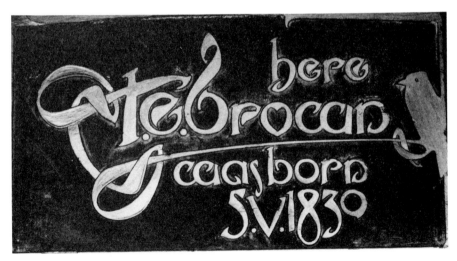

Fig. No. 287. Memorial tablet, commemorating the birth place of the Manx poet T. E. Brown. Photograph courtesy Manx Museum.

Fig. No. 288. Memorial stone for Philip
Cannell designed by Knox. Photograph
courtesy Manx Museum.

Fig. No. 290. Memorial stone for Peter and
Dorothy Milne designed by Knox.
Photograph courtesy Manx Museum.

Fig. No. 289. Memorial stone for Robert and
Kathleen Douglas designed by Knox.
Photograph courtesy Manx Museum.

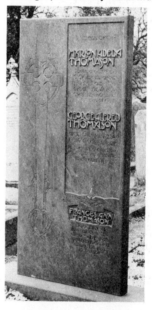

Fig. No. 291. Memorial stone for Marion and
George Thomason designed by Knox.
Photograph courtesy Manx Museum.

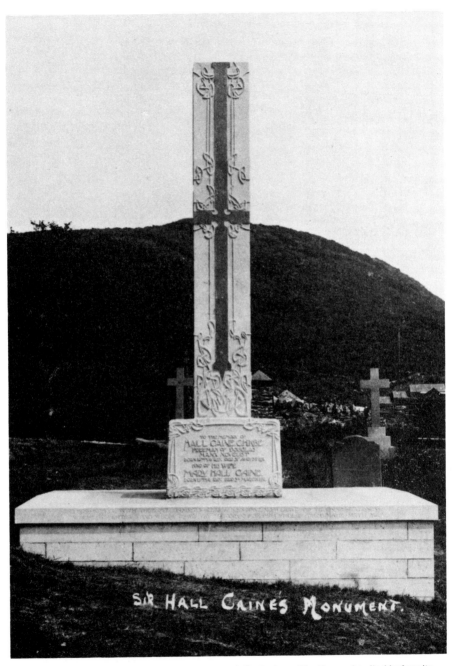

Fig. No. 292. The Hall Caine memorial stone partially designed by Knox who died before its completion; Winifred Tuckfield was asked and accepted the difficult task of finishing the design in the same style. Photograph courtesy Manx Museum.

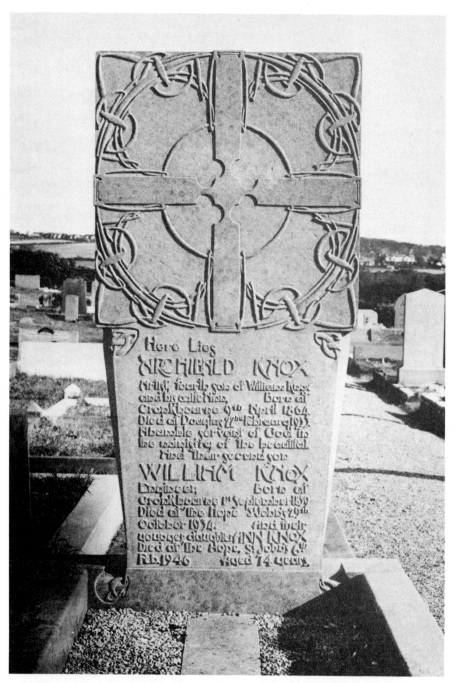

Fig. No. 293. Knox's own tombstone at Braddon cemetery Isle of Man. Photograph courtesy Manx Museum.

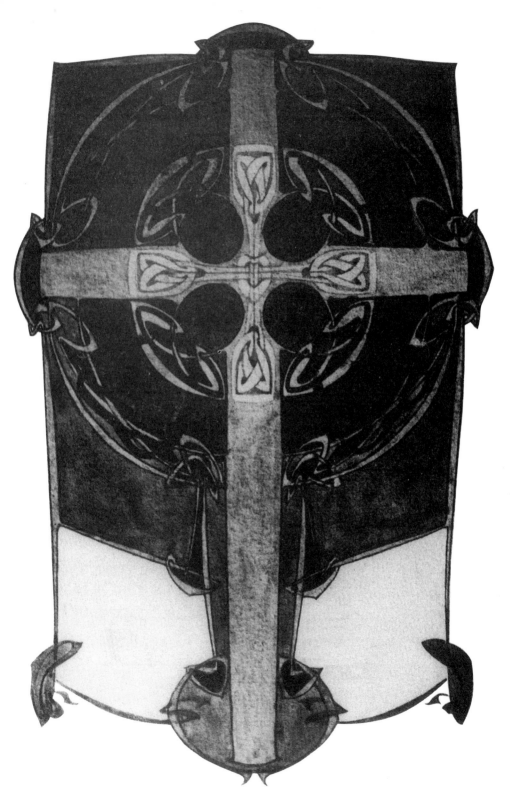

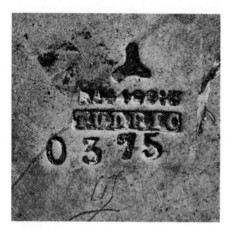

Marks found upon Pewter

This refers to the design of the piece only.

Registration marks had been introduced as early as 1830 to prevent the 'pirating' of an object by a competitor. In 1883 their format was changed from that of a lozenge, to those of a series of digits, the letters Rd. being short for 'Registered'. (All efforts to trace designers via these registrations leads to Liberty and Co.) Often as in figs. 271 to 276 the drawings are tracings of original designs.

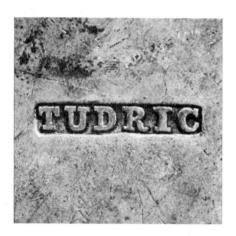

Trade or brand name for the pewter range. (Liberty's had a preference for these Mediaeval-sounding names, i.e. Clutha, Cymric, etc.)

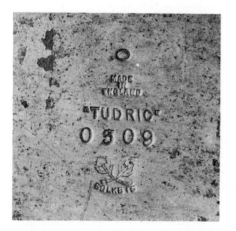

Variation on above.

Mark stamped on one piece of a small three-piece tea set – the type face used being identical to that used in the Tudric name stamp.

Presumably the mould or model number. (Intended for ease of internal ordering and reference.)

Unusual mark occurring normally on large circular salvers or platters, but not solely restricted to these items. (Invariably very crude decoration is applied to these and it is possible that Liberty and Co. had a workshop on the premises where pieces bearing this mark could be observed in manufacture.)

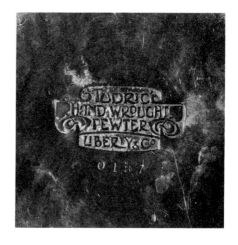

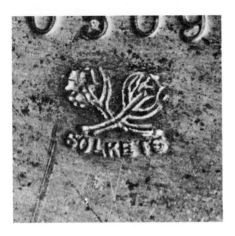

Solkets were the manufacturers of a large amount of Liberty and Co. pewter, though by no means all of it.

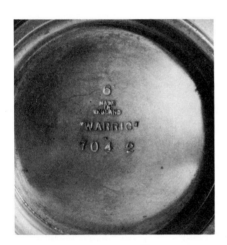

Mark found on pewter bearing decoration identical to that on certain Liberty & Co. items. This mark is presumably a later mark circa 1920, and either signifies yet another Liberty brand name, or that the design had been sold to a company trading under the name of Warriç, the latter would seem more likely.

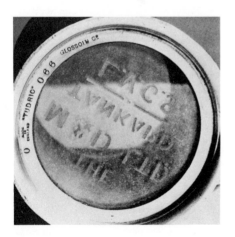

Tudric mark incorporating that of another firm, in this case Glossoid Co.
This usually occurred when a large number of objects was commissioned for a specific purpose, i.e. tankards with golfing medallions to be presented to all the members of a particular golf club.
In this case Glossoid acting as agents commissioned Liberty & Co. to produce objects with their name alongside the brand name.

Gold printed mark often located on the fabric in the top of a jewellery box, or on the lid of a box that would have been intended for presentation.

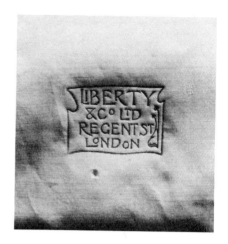

Connell & Co. stamp located on the spur support of fig. 73, though the piece bears the Liberty & Co. mould number and the accompanying "English Pewter" this was presumably because the manufacturers had not altered the moulds when the design ownership changed.

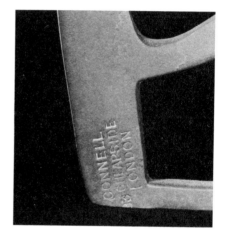

Unusual mark found on pewter pieces manufactured by Liberty & Co. in the 1920s, many of the designs were produced until the early 1930s.

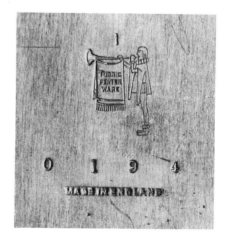

Marks found upon Silver

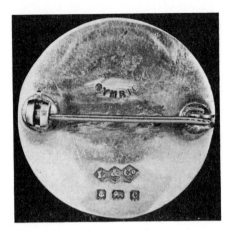

The application of this punch mark seems to have been a purely arbitrary affair. Jewellery, however, often only bears this mark, probably due to lack of space.

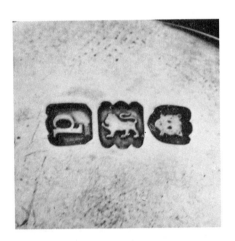

Silver, place and date letter, most of the silver produced by Liberty and Co. appears to have been assayed in either London or Birmingham, suggesting that most of the manufacturing was carried out in either of these two cities.

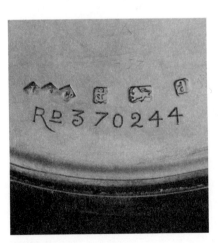

Hand engraved registration number, due to the skill and time involved, these script numerals were restricted to the larger or more expensive items.

Photograph of the bottom of a silver tankard showing the scratched numerals and letters employed by the jewellery trade. This type of record was also used by pawnbrokers.

Liberty and Co. registered silver trade mark.

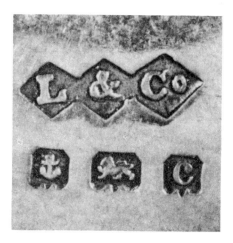

A variation on the above, though this mark does not seem to have been used after 1900.

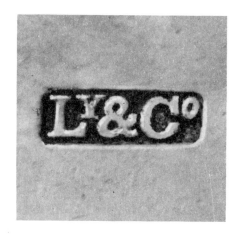

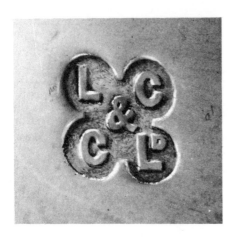

Third variation on the Liberty & Co. mark restricted to the year 1903.

As with the pewter these items were registered at the Public Records Office (see figs. 271 to 276).

Machine punched variation on above.

Designers known to have worked for Liberty & Co.

M. H. Baillie-Scott

Oliver Baker

Mrs Oliver Baker

Eleanor Fortescue Brickdale

Lindsay Butterfield

C. Maud Coggin

Bernard Cuzner

Arthur Gaskin

Kate Harris

Jessie M. King

Archibald Knox

W. R. Lethaby

Sidney Mawson

Harry Napper

E. G. Reuter

Arthur Silver

Reginald "Rex" Silver

Thomas Wardle

Mrs G. F. Watts

Arthur Wilcock

David Veazey

Selected Bibliography

'Christopher Dresser', Catalogue of an exhibition arranged by Richard Dennis and John Jesse (1972).

'Burne-Jones'. Martin Harrison and W. Waters. Barrie & Jenkins. 1973.

'Life of William Morris'. J.W. MacKail. Longmans 1899.

'All Things Bright and Beautiful'. Fiona MacCarthy. George Allen & Unwin. London 1972.

'Kunsthandwerk um 1900 Jugendstil'. Gerhard Bott, Darmstadt. 1973. (2nd Edition).

'A Catalogue of the Great Exhibition 1851'. H.M.S.O. 1950.

'William Morris to Whistler'. Walter Crane. George Bell & Sons. 1911.

'Where the Great City Stands'. C.R. Ashbee. Essex House in conjunction with B.T. Batsford 1917.

'1964 Memorial Exhibition of Archibald Knox'. Manx Museum, Douglas. 1964.

'Liberty and the Modern Style'. Mario Amaya. Apollo, February 1963.

'L 'Object 1900'. M. Rheims.

'Jugendstilsammlung'. Dr. G. Woeckel. (Exhibition at Kassel 1968).

'Art Nouveau in Britain'. Arts Council Catalogue 1965. Introduction by Nikolaus Pevsner.

'Art Nouveau'. Piccadilly Gallery, London. c.1965.

'Art Nouveau'. Robert Schmutzler. Thames & Hudson. 1964.

Liberty & Co. catalogues. 'Yule Tide Gifts'. 'Cymric' Catalogue.

'The Liberty Metalwork Adventure'. Shirley Bury, Architectural Review. (February 1963, pp. 108-111).

'Mannin' (Journal of the Manx Society). Winifred Tuckfield: 'Archibald Knox' No. 7, Douglas 1916.

'Arts & Crafts' Exhibition Catalogue. Fine Art Society in conjunction with M. Haslam and T.M. Whiteway. 1972.

'The Age of Art Nouveau'. Maurice Rheims. Thames and Hudson. 1965.

'Birmingham Gold & Silver'. City Museum. Birmingham. 1973.

Peter and Debbie Gooday kept a record of all the pieces of pewter that passed through their hands during their collecting career. Peter noted the model numbers and gave a brief description of each item. This is his list. The catalogue numbers listed are actually the Liberty & Co. model numbers, found impressed upon the base of each item, omissions in the catalogue numbers reflect the gaps in their collection.

1. Bowl on foot with one large handle and one small. D.14cm.
2. Bowl on foot – 2 raised handles and Connemara studs. D.16cm.
6. Punch bowl on foot. D.37.5cm.
7. Rectangular dish with turned edges enamel plaque. L.19cm W.11cm.
8. Candlestick, large flat base and sconce. Ht.16cm.
9. Large triangular card tray, whiplash design around edge. D.25cm.
10. Old Times Sake Loving Cup. Woodbine spices bowl with 2 handles. Ht.19.6cm.
11. Pen Tray
13. Pin Box – Separate lid, bud and tendril design.
21. Cylindrical box with lid and heart shaped enamels Ht.10cm.
22. Candlestick, wide drip pan and base. Design on column. Ht.18cm. D.17cm.
23. Candlestick. Ht.12.5cm.
24. Candlestick drip pan in four turned sections, short stem round base.
25. Teaset – bulbous with angular feet.
27. Water jug. Ht.23cm.
28. Tulip vase with twist handles. Ht.24.7cm. Planished No. Design.
30. Twist handle vase. Ht.18cm.
33, Vase, oviform. Foliate border. Ht.21.5cm.
35. Owl jug. Ht.20cm.
38. Planished vase set with moonstones. Ht.19cm.
42. Tray. Riveted heart shape handles. 47cm.
43. Tray. L.36cm. W.23cm.
44. Circular dish, enamel centre. D.25.8cm.
50. Tankard see Tilbrook Fig. No.32., P.59
53. Half pint tankard. Des. Edward VIII arms.
54. Large Tankard with lid.

55. Inkwell incorporating pen tray.
59. Biscuit box, 2 handles round. H.17.7cm.
62. Bulbous claret jug. Green Powell glass. Pewter mount. Ht.36cm.
66. Half pint tankard with split handle.
67. Fruit bowl on 4 scrolling legs. D.30cm.
70. Jam dish clear liner heart design, each end and spoon. L.18.5cm
71. Butter dish and knife. D.15cm
76. Rectangular box. L.18cm W.7.5cm
78. Rectangular box with enamel seascape on lid. L.21cm
82. Planished box with turquoise matrix stud. W.14cm
83. Plain rectangular box. L.15cm W.12.5cm
84. Biscuit box, square with copper loops at each corner. 12cm.
105. Round container and lid, lozenges at base and on lid. Ht.11cm D.7.5cm
107. Cylindrical box lid with heart decoration. D.6cm Ht.6cm
109. Round dish set with abalone shell. D.14cm
110. Round 2 handled bowl with standard roses design. D.32cm
114. Round Peacock dish with abalone shell in tail. D.33cm
121. Cigarette box.
124. Rectangular box with heart shapes.
125. Rectangular box set with 3 turquoise studs. L.17cm
126. Cigarette box, square with 3 Connemara marble studs on the lid. 9.5cm.
131. Openwork holder for Clutha glass set with Connemara marble. Ht.9cm W.14cm
140. Inkwell, round form on square base. Ht.7cm

141. Inkstand, square base. W.15.4cm
142. Teaset.
150. Clock decorated with tree. Ht.33cm
162. Round dish with 3 handles honesty design green glass liner. D.14cm
163. Round plate, honesty whiplashes enamel centre. W.22.5cm Also round plate with offset honesty design. see Fig.64 p.91 Also honesty jam dish with green liner. D.18.5cm
164. Inkstand, narrow upper section, wide round base. Ht.10cm
167. Jardinière on foot, 3 handles. Ht.25.5cm D.25.5cm
168. Jam dish, green glass liner.
169. Clock, rectangular copper dial. L.24cm
172. Hand wrought photo frame. Ht.18.5cm
193. Round biscuit box. Ht.12.7cm
194. 'Knox box', square, leaves. W.12cm
207. Oval 2 handled tray, clover leaf design. L.28cm
212. Vase on wide round base, 2 handles. Ht.36cm
213. Cylindrical vase with side handles, irregular base. Ht.34cm
219. Candlestick, wide drip pan leaf design on round base. Ht.10cm
220. Candlestick sconce on inverted cone honesty/ heart design. Ht.17.5cm
221. Candlestick with 3 side spurs. Ht.14cm
222. Short 4 leg 'bullit' candlesticks. Ht.9.5cm
223. Tri-Stem candlestick, design on base. Ht.22.5cm
225. Vase with closed 'bomb' fin feet, honesty design. Ht.16cm D.11.5cm.

226. Fruit bowl, with reticulated honesty design, the 3 legs supporting a Clutha glass liner. Ht.17cm.
227. Inverted trumpet vase on 3 legs. Ht.24cm.
228. Jug with Honesty design. Ht.18cm.
229. Rex Silver rose bowl. W.30cm.
230. Small fruit bowl on three circular legs and enamel honesty design. D.26cm.
231. Knox tea set tray (including round dish) 8 pieces. W.49cm.
234. Knox vase with square leaves around base. Ht.25.5cm.
236. Square Knox box with honesty leaf. Ht.12cm. W.11.5cm.
245. Clock square section. Ht.19cm. Conical top No design.
252. 'Architectural' clock. Ht.16.8cm.
253. Tapering 4 sided clock with pointed top plain. Ht.18cm.
261. Bulbous green glass decanter with stopper by Veasey. Ht.30cm.
263. Claret jug, green glass design by David Veasey.
276. Tri stem fruit bowl with Clutha glass liner. Enamels. Ht.16.5cm. D.20cm.
277. Design as above but on 3 small circular feet. Solid sides.
278. Hot water jug. Ht.14cm. Frieze of leaves/hearts.
280. Hot water jug, design at base with enamel.
281. Hot water jug. Ht.20cm.
283. Ashtray, diamond shape. Design of two poppy heads.
287. Oval dish with 2 handles, clover leaves. L.28cm.
288. Round bowl on 4 looped feet, honesty design. D.10cm. Ht.6.5cm.
290. Clock, copper shaped dial, body set with abalone shell. Ht.25cm.
291. Entrée dish, 2 handles to base. W.29cm.
292. Entrée dish, round conical lid, off set handle. W.24.7cm.
295. Oval entrée dish, design on lid. L.27cm.

303. Tea set with 4 knot motif, 3 pieces.
305. Hot water jug, Knox. Ht.21cm.
306. Tiny hot water jug, honesty lid. Ht.9cm.
307. Hot water jug, swelling conical body. Ht.21cm.
308. Green glass decanter, 'D' handle. Ht.32.5cm.
309. Long tray, 2 handles within design. L.31.5cm.
310. Green glass decanter, malet shaped pewter lid and handle.
311. Oval tray, handles with stylized bead design. L.36cm. W.25.5cm.
313. Circular dish, recessed centre, honesty around edge. D.18cm.
314. Flat jam dish decorated with honesty and raised green glass bowl. L.17cm. W.14cm.
316. Oval dish, foliage design. L.18cm.
318. Large jardinière with openwork design, green glass liner.
319. Openwork bowl on 4 strap leg supports. Green glass liner. W.13cm.
320. Rose bowl with green glass liner. D.25cm.
322. Cone shape spill vase, design at base. Ht.17.5cm.
323. Bottle shaped flower vase.
324. Easel clock base, cylindrical column plus tall Clutha liner. Ht.24cm.
325. Inverted trumpet vase on round foot with leaves. Ht.19.5cm.
327. Vase on foot, tapering cylinder with heart shape design to bottom. Ht. 23cm.
329. Long tray, flower motif. L.45cm.
330. Decanter and glasses, small decanter, olive glass heart design. Ht.17cm.
333. Pair of candlesticks.
334. Pint tankard, 'D' handle with honesty design beneath. Ht.13.5cm.
335. Planished tankard, cylindrical whiplash knot handle Ht.15.5cm.
336. Oval dish on 4 feet.

D.36cm.
337. Planished bowl with 2 split handles. D.25cm.
339. Tray with handle over whiplash design on handle. L.26cm.
340. Vase with flaring neck, flower design at top. Ht.20cm.
347. Cruet set comprising, salt D.5cm. pepper pot. Ht.5.5cm. mustard pot. Ht.4cm.
348. Cruet set comprising, pepper pot. Ht.5cm. mustard pot with 'D' handle 4 hinged lid. Ht.7cm. salt. D.4.5cm.
349. Mustard pot, squat hinged lid. Ht.3.5cm. Salt D.5cm.
350. Jam dish, round green glass liner 'Swan' design D.16.5cm.
351. Half pint tankard, split handle.
354. Vase with Celtic designs. Ht.10cm.
355. Entrée dish with domed lid and water reservoir off-set handle. D.19cm. Ht.12cm.
357. Knox cake tray, handle over. L.31cm.
358. Glass holder with pierced handle. Ht.6.5cm.
359. Oval cake basket, handle over. L.23.5cm.
367. Clock with blue enamel plaque design as 070.
368. Clock, buds and tendrils at top, 3 enamel studs at bottom, copper dial. Ht.19cm.
370. Clock, rectangular arched top, honesty design.
371. Clock, triangular shaped top on rectangular base enamel dial.
374. Tea set, 5 pieces. Wood handles. Coffee pot, milk and sugar.
376. Tray for above pieces 374. L.49cm. W.31cm.
380. Green glass decanter, pewter mounts. Ht.38cm.
382. Clock 'Keyhole' shape, enamel studs. Ht.25cm.
385. Lemon tea glass holder. Ht.6cm.
396. Vase, 2 looped handles round base. Ht.15cm.

403. Ink and pen tray, rectangular. L.23cm. W.8.5cm.
404. Ink well and pen tray, honesty design.
414. Box with enamel seascape by Varley. L.16cm.
441. 'Swan' design holder for flared Clutha glass liner. W.15cm.
445. Water/wine carafe, green glass honesty design, base and stopper. Ht.37cm.
460. Vase, cylindrical column supported above openwork base. Ht.23cm.
482. Square easel clock, 10cm square.
492. Knox design knife rest. W.8.5cm.
505. Rectangular box lid set with turquoise matrix. L.11.5cm. W.4cm.
509. Crumb scoop with design on pan, elongated handle.
521. Inkstand, shallow dome. D.12.7cm.
523. Chamber candlestick, loop handle. W.16.5cm. Ht.3cm.
527. Vase with wavy rim and arrow head design. Ht.9.5cm. D.9cm.
530. Knox candelabra. Ht.28cm.
532. Half moon crumb scoop, honesty design and enamel. L.25cm.
534. Beaker and holder, green glass. H.13.8cm.
535. Oval cake basket, pierced sides. L.25cm.
546. Small round honesty dish D.12.5cm.
547. Small cake tray decorated with leaves and flowers. L.23cm.
548. Tazza with 044 design on top.
565. Small photo frame.
575. Green glass openwork holder on 4 legs. D.12.5cm. Ht.5cm.
586. Box, enamel plaque, orange sunset, ship on water. L.12.5cm.
604. Dish oval openwork, 2 handles green glass liner. L.19cm.
609. Clock with large enamel dial surrounded by leaves. Ht.20.5cm.
626. Soda syphon holder,

design Rex Silver. Ht.16cm. D.11.5cm.
629. Clock 4 sided tapering enamel panel, 'Architectural'. Ht.18cm.
638. Box, square turquoise matrix stud on lid, border design.
643. String box with cutter on lid, honesty design. Ht.15cm.
649. Hinged oval box with turquoise stud. L.8cm.
653. Inkwell, squat cone shaped, decorated with a double knot design.
699. Desk blotter on wooden rocker. L.10cm.
700. Round tobacco box with tamp handle to one side. Ht.14. D.9.5cm.
701. Match box holder on triangular dish. D.12.5cm.
706. Jardinière, 2 handles, scrolling heart design. Ht.19cm. D.20cm.
715. 2 bottle inkstand on pen tray. L.26cm.
716. 6 sided, round card tray border design. D.25cm.
725. Candlesticks, cube shaped candle holder, rectangular base see 0530.
733. Box, enamel sea scape. L.14cm.
754. Double bon bon dish, handle cover pierced, Knox leaf design. L.25cm.
760. Clock, rectangular on square base, copper dial. Ht.11cm.
761. Clock, tapering rectangular form, domed roof, enamel dial. Ht.19cm.
763. Vase with plants and leaves, thorny stems, flowers. Ht.20cm.
787. Rose bowl by Oliver Baker, 4 loop feet, band of leaves, turquoise studs. Ht.18cm. D.30cm.
812. Box, hinged lid and domed top. L.10cm. W.9cm.
818. Small vase, domed base tall thin neck. Ht.15cm.
819. Tapering spill vase, design at base. Ht.15.5cm.
820. Spill vase, inverted trumpet flower design, Ht.15cm.
821. Spill vase as 0820 but

larger.
851. Box with enamel plaque. L.11.5cm.
871. Candlestick, inverted cone on large base, no pattern. Ht.16.5cm.
887. Large rectangular box with sunset treescape, enamel. L.21cm.
898. Ash tray triangular, Knox design.
902. Box with hinged lid, clover shape set with mother-of-pearl. W.7.5cm.
906. Box with domed overhanging lid set with abalone shell. L.12cm.
907. Box, diamond shape set with opal matrix. L.10cm.
919. Napkin ring, turquoise enamel studs on design. L.5.5cm.
920. Napkin ring, purple enamel, Knox design. L.5.5cm.
927. Vase, 3 handles form base, design at top. Ht.30cm.
929. Loving cup, 2 handles with heart design. Ht.10cm.
934. Napkin ring, Celtic knots. Shape as 920. L.5.5cm.
957. Inverted trumpet vase, 3 handles green liner. Ht.22cm.
958. Hot water jug, stylized leaves and stems.
967. Hot water jug, entwined honesty. Ht.15cm.
968. Rectangular box, domed lid. L.18cm. W.9cm. Ht.6.5cm.
970. Trumpet shaped vase, band of honesty. Ht.26cm.
992. Oval planter with 2 loop handles, pierced foliate design. L.30cm. W.15cm.
996. Box with riverscape enamel plaque. W.14cm.
999. Stamp box (part of desk set 141) enamel design on lid. W.9.5cm.

Index